WENCESLAUS HOLLAR

D1225540

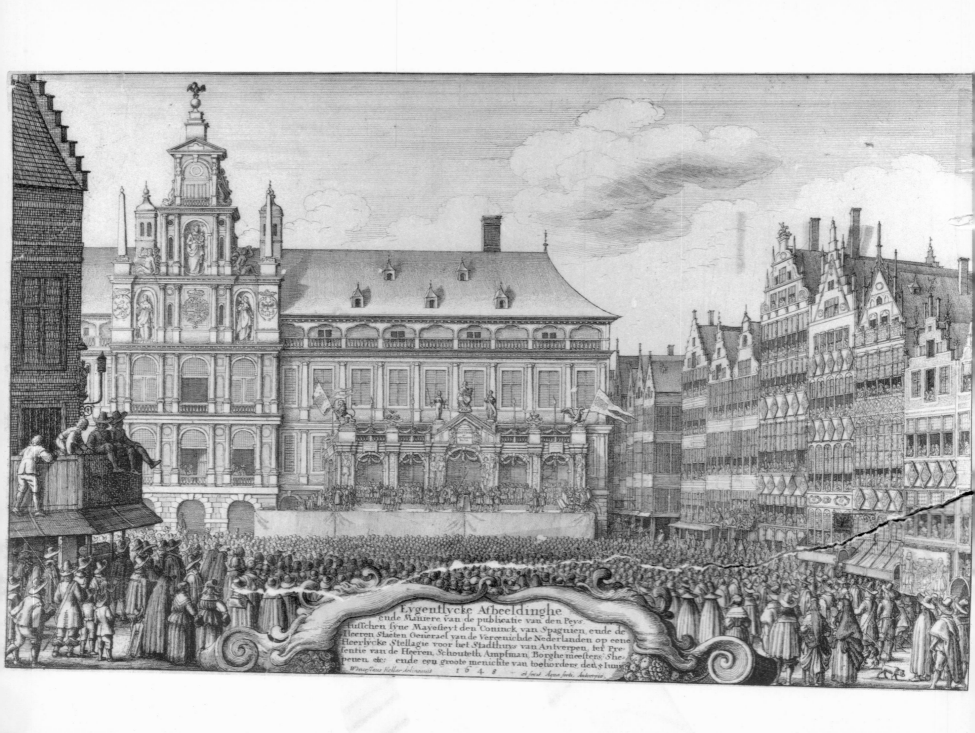

Eygentlycke Afbeeldinghe
ende Maniere van de publicatie van den Peys,
tusschen syne Mayesteyt den Coninck van Spagnien, ende de
Heeren Staeten Generael van de Vereenichde Nederlanden op eene
Heerlycke Stellagie voor het Stadthuys van Antverpen, ter Pre-
sentie van de Heeren, Schouteth, Amptman, Borghemeesters, She-
penen, etc: ende een groote menichte van toehoorders, den 5 Iuny

Wencestaus Hollar delineavit 1 6 4 8 et fecit Aqua forti, Antverpiæ.

WENCESLAUS HOLLAR

Seventeenth-Century Prints

FROM THE MUSEUM BOYMANS-VAN BEUNINGEN, ROTTERDAM

Jacqueline Burgers

Art Services International

Alexandria, Virginia 1994

Participating museums

The Frick Art Museum
Pittsburgh, Pennsylvania

International Gallery, Smithsonian Institution
Washington, D.C.

The Detroit Institute of Arts
Detroit, Michigan

Mary and Leigh Block Gallery
Northwestern University
Evanston, Illinois

This exhibition is organized and circulated by
Art Services International, Alexandria, Virginia.
Copyright © 1994 by Art Services International
All rights reserved

Translator: William H. Skinner
Editor: Nancy Eickel
Designer: Stephen Kraft
Typesetter: BG Composition
Printer: Craft Print

Cover: *Variae Figurae* (cat. no. 74) and
Tangier, Series title (cat. no. 133),
details modified and enlarged
Half-title: *Wenceslaus Hollar* (cat. no. 28)
Frontispiece: *The Peace of Münster* (cat. no. 84)

ISBN 0-88397-108-9
Printed and bound in Singapore

Library of Congress Cataloging-in-Publication Data

Burgers, Jacqueline.
 Wenceslaus Hollar : seventeenth-century prints
from the Museum Boymans-van Beuningen, Rotter-
dam / Jacqueline Burgers.
 p. cm.
 Catalog of an exhibition organized and circulated
by Art Services International, shown at the Frick Art
Museum, Pittsburgh, Pa., and at other museums.
 Includes bibliographical references (p.).
 ISBN 0-88397-108-9
 1. Hollar, Wenceslaus, 1607–1677—Exhibitions.
2. Prints—Netherlands—Rotterdam—Exhibitions. 3.
Museum Boymans-van Beuningen—Exhibitions. I. Art
Services International. II. Frick Art Museum (Pitts-
burgh, Pa.) III. Title.
NE642.H7A4 1994
769.92—dc20 94–26371
 CIP

Photo credits

All photographs from the Narodni Galerie, Prague, are by
Sonia Divisovà.
All other photographs are from the
Museum Boymans-van Beuningen, Rotterdam.

Frequin Photos: cat. nos. 1B, 24C, 45, 70, 75A, 77,
117, 129, 130
Tom Haarsten: fig. 5, cat. nos. 6, 11, 14–21, 23,
25–29, 36, 43, 46/1–7, 54, 69, 107, 122A-C

Table of Contents

7 Acknowledgments

9 Director's Statement

10 Introduction

12 A Biographical Sketch of Wenceslaus Hollar

23 Author's Note

24 Notes to the Catalogue

26 Catalogue of Works

205 Select Bibliography

**Board of Trustees of
Art Services International**

James M. Brown III

Roma S. Crocker

Stephen S. Lash

Jean C. Lindsey

DeCourcy E. McIntosh

Mrs. Richard Mellon

Mark Ormond

Robert D. Papkin

Richard B. Pfeil

Mrs. John A. Pope

Lynn K. Rogerson

David Saltonstall

Joseph W. Saunders

Francesca von Habsburg

Acknowledgments

During the seventeenth century, the exacting art form of printmaking was at its height in western Europe. One of its supreme practitioners, Wenceslaus Hollar, set the standard of artistic and technical achievement that many attempted to emulate. No object, event, or person was too great or too mundane for Hollar's observant eye and keen skill—the sheen of a fur muff, a cityscape viewed across the Thames, and portraits of Charles II in exile all captured his attention. His prodigious abilities, which have rarely been equaled, resulted in a vast output of etchings and engravings, and the Museum Boymans-van Beuningen in Rotterdam possesses one of the world's most extensive collections of his high-quality works. That esteemed institution has granted Art Services International the honor of presenting this exhibition of more than two hundred works by Hollar and his contemporaries, and we extend our formal thanks to Dr. J.R. ter Molen, Deputy Director and Acting Director of the museum. Through this exhibition, American viewers will be momentarily transported to seventeenth-century London and Antwerp, where they, like so many before them, will come to appreciate the genius of Wenceslaus Hollar.

This detailed, scholarly examination of the art, life, and times of Hollar was undertaken by Dr. Jacqueline Burgers, Assistant Curator of the Printroom at the Museum Boymans-van Beuningen. Her untiring fascination with and investigation of Hollar and his milieu join to make this an intriguing look into the oeuvre of a surprisingly modern artist. We commend her devotion to the career of Hollar and her commitment to art history. It has been a true pleasure to work with her.

Others at the Museum Boymans-van Beuningen deserve a special word of thanks for their dedication to this endeavor. A.W.F.M. Meij, Curator of Drawings, and Manfred Sellink, Curator of Prints and Drawings, lent their steadfast support to the exhibition from the outset. Their continuing collaboration and endorsement are warmly appreciated, and we look forward to future projects together.

Kindly agreeing to serve as Honorary Patrons of this survey of Hollar's astounding production as a printmaker are Ambassador Adriaan P.R. Jacobovits de Szeged of the Kingdom of The Netherlands and Ambassador Michael Zantovsky of the Czech Republic. Frans Hulsman, Counsellor, Press and Cultural Affairs, at the Royal Netherlands Embassy, and Dr. Jan Zelenka, Counselor for Cultural Affairs at the Czech Embassy, have been enthusiastic and dedicated supporters in the organization of this exhibition, and we thank them for their commitment. We would also like to thank the Royal Netherlands Embassy for its contribution of a grant to support the exhibition.

The Samuel H. Kress Foundation in New York, and in particular Lisa M. Ackerman, Chief Administrative Officer, played a vital role in the early stages of this international endeavor through support of this scholarly catalogue. Such generosity and interest in ASI is warmly received.

Crucial to the ultimate success of acquainting viewers with the world of Wenceslaus Hollar are

the institutions participating in the exhibition's tour. Our respect and gratitude are extended to DeCourcy E. McIntosh, Executive Director of the Frick Art Museum; Tom L. Freudenheim, Assistant Secretary for Arts and Humanities, and Anne R. Gosset, Director of the International Gallery, Smithsonian Institution; Dr. Samuel Sachs II, Director, and Ellen Sharp, Curator of Graphic Arts, at The Detroit Institute of Arts; and David Mickenberg, Director of the Mary and Leigh Block Gallery at Northwestern University. Their eagerness to join efforts with ASI is gratifying, and we welcome future opportunities for collaboration.

William H. Skinner, Nancy Eickel, and Stephen Kraft combined their individual skills to produce this handsome catalogue, which so aptly conveys the essence of Hollar's prints. As transla-

tor, editor, and graphic designer, respectively, they worked closely to present Hollar's numerous prints to their best advantage. Their efforts were well complemented by Craft Print, which printed the catalogue. We thank them for their energy and perseverance.

We are pleased to thank Mrs. John A. Pope for her involvement in this project at its genesis, and to extend our highest praise to the staff of Art Services International, which daily exhibits its professionalism and saw this project to its completion. Ana Maria Lim, Douglas Shawn, Anne Breckenridge, Kirsten Simmons, Betty Kahler, Patti Bruch, and Sally Thomas have once again pooled their talents to produce an outstanding exhibition. To each of them we offer our congratulations and our heartfelt thanks.

Lynn K. Rogerson
Director

Joseph W. Saunders
Chief Executive Officer

Art Services International

Director's Statement

It is my pleasure to introduce *Wenceslaus Hollar: Seventeenth-Century Prints from the Museum Boymans-van Beuningen, Rotterdam* to the American public. The Printroom of the Boymans Museum has a long-standing tradition of presenting treasures from its famous collection to art lovers all over the world. In cooperation with Art Services International, we have had the honor of presenting several important exhibitions in the United States in the last decade, including a selection of our magnificent collection of nineteenth-century French drawings in 1987 and *From Pisanello to Cézanne*, a selection of master drawings from our Printroom, which was on tour in 1990–1991. In a certain sense these projects reflect the tradition of friendship that exists between the United States and The Netherlands.

Without doubt it is in the spirit of Hollar himself that an overview of his graphic oeuvre, which also has been on display in Rotterdam and in Bochum, Germany, will now appeal to a wider audience in your country. Hollar's international orientation led him to travel throughout Europe, where his technical superiority and his iconographical versatility placed his work in great demand. It seems a fair guess that Hollar would have been pleased to have his works admired on the other side of the Atlantic Ocean.

Of course a traveling exhibition always requires the participation of several people. I would like to thank Art Services International and in particular its directors, Lynn K. Rogerson and Joseph W. Saunders, for all their efforts in realizing this project. Together with their staff, they have, as always, organized this tour in an impeccable manner. Furthermore, I would like to express my gratitude to several members of my own staff. Manfred Sellink, Curator of Prints and Drawings, and Maartje de Haan, Assistant Curator, were responsible for the exhibition's organization. Together with his staff, Dingenus van de Vrie, head of the graphic studio, mounted all the prints and prepared them for shipping. Finally, and most important, I thank Jacqueline Burgers, Assistant Curator of Prints and Drawings. Ms Burgers was responsible for choosing the works and preparing the text for this handsome catalogue. I am sure that through her knowledge and enthusiasm, audiences in America will come to appreciate the talent and genius of Wenceslaus Hollar.

Dr. J. R. ter Molen
Acting Director
Museum Boymans-van Beuningen, Rotterdam

Introduction

Wenceslaus Hollar (1607–1677) holds a special place in the art of printmaking, which was at its height during the seventeenth century. He left an extensive oeuvre of drawings and prints, numbering no fewer than 2,740 works.

In general, the quality of these works is high. Hollar's style and technique are distinctive and easily recognizable. Notably, he refrained from engaging in the baroque theatrical and monumental effects used by most artists of his time. For Hollar, there was no use of chiaroscuro, no emulation of Caravaggio or Rembrandt, whose work Hollar knew and, in some cases, copied (see cat. no. 4). Instead, Hollar was a detached reporter of seventeenth-century life. Only his manner of etching showed his love for a subject, particularly landscapes, animals, and accessories of women's clothing. He was a master of rendering fabric and conveying the feel of certain materials, as is evident in his famous rendering of muffs (see cat. nos. 68–70). Judging from his works, Hollar was never tempted to make the world witness the miseries of the Thirty Years' War, in which he was directly involved. He was more attracted to external appearances and to providing a pleasant portrayal of life. We might call this "wishful etching." Hollar's choice of subjects can be summed up as a yearning for security, which is easy to fathom given the tense conditions in which he was living. Just as he adapted to suit his surroundings, he also changed his name as he moved from place to place. Baptized Vaclav, he altered his name to Wen(t)zel during his stay in Germany, and later changed it again to Wenceslaus while in England. Wenceslaus is the name that appears on most of his prints.

In every area Hollar's work stands out as a source of information on common life in seventeenth-century Europe. It ranges from topography and landscapes, to depictions of local dress from a variety of regions, and print reproductions of art collections of his era. At that time collections were not restricted to a single type of art; rather, interests encompassed all forms of art. The concept of the universal man, the *homo universalis*, still held great significance for those who could afford to indulge in that pursuit. Therefore, important collections consisted of sketches, drawings, (ancient) sculpture, arts and crafts, and exotic plants and animals. Hollar was one of the first engravers to receive a commission to reproduce a collection in both drawings and prints. In addition to this major aspect of Hollar's output, he also produced drawings of just about every subject that he encountered. During his travels he collected a treasure trove of material to which he referred for the rest of his life. Hollar never had reason to complain of a lack of appreciation. He was a highly regarded professional who never had to seek commissions. His contemporaries lavished praise on him, and his artist colleagues copied his prints. His ever-popular prints were sought by major collectors throughout his lifetime.

Works for this presentation were selected from the holdings of the Museum Boymans-van Beuningen in Rotterdam. Some of the prints come from Dr. J.C.J. Bierens de Haan's bequest to the museum in 1952, which forms the core of

the printroom collection in Rotterdam. An unusual aspect of the collection is that Dr. Bierens de Haan was interested in the "lesser" (that is, less well-known) masters of the art of printmaking. With a good eye for print quality, he purchased works mainly from early print runs when the copper plates had not yet been worn down or excessively touched up. In the process of preparing this exhibition, I saw many prints from other Hollar collections, and each time I took delight in the striking clarity of "our" works.

To show why Hollar holds such a special position in the art of printmaking, a selection of prints by engravers from his era has also been included. It is instructive to reconstruct the scenes and visual images that Hollar encountered in the various countries where he worked. Naturally, he was influenced by the publishers for whom he worked over the course of his life. In turn, he inspired a new generation of English artists, particularly with regard to technique, through his manner of etching (see cat. nos. 19–23 and 25–27).

Hollar was not the only foreigner to move to England in the early seventeenth century. To the contrary, it was quite customary that given the lack of indigenous engravers in England, they were recruited from abroad, and from The Netherlands in particular (see cat. nos. 11–18).

It may be difficult to distinguish the works of many seventeenth-century engravers, but this problem does not arise with Hollar. His "handwriting," with its distinctive use of short lines that look more like small tapered points, is instantly recognizable. The line makes a somewhat bumpy impression, and the gradations between light and dark are numerous. The works possess a character all their own. Hollar's technique shows such a love for the medium of etching that his prints have attracted every generation of collectors and art lovers to this day. His works, which are particularly accessible and inspiring, appeal not only to a love of the small and the lifelike, but also to a curiosity about the world of old.

I hope that this exhibition contributes to satisfying that curiosity.

A Biographical Sketch of Wenceslaus Hollar

BOHEMIA AND GERMANY

Wenceslaus Hollar was born in Prague on July 23, 1607, at the beginning of one of the most turbulent eras in European history. It was a period characterized by religious and political wars that began in Bohemia with the Catholic League's quelling of the Bohemian uprising against the new emperor Ferdinand II at the battle of White Mountain. With an ever-increasing number of countries becoming involved, the conflict turned into a large-scale war that caused enormous destruction over three decades and was later known as the Thirty Years' War. At the same time, The Netherlands and Spain were involved in the Eighty Years' War, and in England, too, conflict was raging between Catholics and Protestants, royalists and republicans.

Little is known about Hollar's early years. Even today, the debate concerning the religion practiced in his parents' home continues. Although Richard Pennington, an authority in the field of Hollar's graphic work, thought he had convincingly proven that Hollar had Catholic origins, Vladimir Denkstein has just as convincingly proven that Hollar came from a Protestant home. Hollar never received actual artistic training as such because, according to the subtitle of one of his portraits, his father was opposed to his artistic career (see cat. no. 51, P/P 1419). Those few prints from this period that have survived are copies after Albrecht Dürer. Thereafter, Hollar made variations on prints by Dürer and also copies after Sebald Beham.[1]

Cultural life in Prague in the years when Hollar was growing up was determined by the artists at the court of emperor Rudolf II. In court circles, the desire arose not simply to copy the masterpieces of Dürer but also to paraphrase them. Hollar's interest in reproducing Dürer's prints may well have been piqued by court engraver Aegidius Sadeler, who lived in Prague from 1597 to 1629 and came to serve as Hollar's mentor. Some parts of Sadeler's prints were incorporated completely by Hollar into his own work. As the imperial engraver, Sadeler was also responsible for assembling a print collection for Rudolf I, a collection that included a large number of works by Dürer. In fact, Sadeler contributed to the resurgence of interest in Dürer's works. In his early years, Hollar was also influenced by the work of such sixteenth-century print masters as Maarten van Heemskerck, Philips Galle, and the Wierix brothers.

In addition to study and copy work, young Hollar early on showed a remarkable predilection for topography and map making, as reported by John Aubrey: "That when he was a Schoole-boy he took delight in drawing Mapps; which draught he kept, and they were pretty."[2] Jan Hollar, the artist's father, worked at the land registry office, and his son must have accompanied the surveyors as they went out to map properties around Prague. It was customary to adorn maps with small views of cities or special views of the land. Hollar certainly was aware of this practice and later perfected it at the workshop of Matthaeus Merian.

One of the most telltale indications of Hollar's religious conviction was the portrait of Frederick V that the artist produced while still in Prague. The Protestant king Frederick fled from Bohemia after the battle of White Mountain in 1620. Protestants were severely oppressed, to the extent that emperor Ferdinand II published an edict in 1627 which demanded that all members of the Czech nobility either had to convert to the Catholic faith immediately or leave the country. The population of Bohemia was 90 percent non-Catholic at the beginning of the seventeenth century, and only a small number left the country after 1627. Most of them adapted and practiced their religion in secret. Another argument in favor of Hollar's Protestant affiliation is that his mother, Margareta von Löwengrün, came from a noble family in the predominantly Calvinist Upper Palatinate. Aubrey notes that Hollar's father was "a knight of the Empire and a Protestant, and either for keeping a conventicle, or being taken at once, forfeited his Estate, and was ruined by the Roman Catholiques."[3] It is probable that Ferdinand's edict and the opposition to a career as an artist that Hollar's father displayed eventually led the young man to consider leaving Prague. In addition, Ferdinand had moved his court to Vienna, which proved a major setback to cultural life in Prague.

Significantly, after his move from Prague in 1627, Hollar initially stayed only at Protestant strongholds. From November 1627 to the spring of 1629 he visited pietistic Stuttgart, and in 1629–1630 he was in Protestant Strasbourg (fig. 1), where he worked as a draftsman and engraver for publisher Jacob van der Heyden. The series of prints on the Strasbourg seasons date from this period, when he also became acquainted with the work of Jan van de Velde II, of which he made various copies (see cat. nos. 1–6). In 1631, he went to Frankfurt, another Protestant city, where he worked and studied with Swiss engraver and publisher Matthaeus Merian. While there, he made prints of many works by other artists, and he also learned how to compose panoramic landscapes. Hollar trained in the specialties of topography and cartography, which were an important part of Merian's business. But then, from 1632 to 1636, Hollar lived in Catholic Cologne (fig. 2). That is not as strange as it may appear, since Cologne had remained neutral during the Thirty Years' War, and many sought refuge there.

During his stay in Cologne, Hollar found work with the publishers Abraham Hogenberg and Gerard Altzenbach. At that time it became clear that Hollar possessed an exceptionally realistic view of the world. In this context "realistic" means that Hollar worked mainly from nature and actual life, and that his inclinations did not run to theatrical, mystical, or religious subjects. He was not, however, realistic in the sense that he factually depicted the atrocious scenes of the burned-out villages and slaughtered men that he must have seen during his travels through Germany. Also while in Germany, he found in landscape art a reflection of late sixteenth-century Dutch realism when he came into contact with the art of Flanders and The Netherlands. In the long run, he opted for the Dutch style. His first journey to the north, which occurred in 1634, brought him into contact with the Dutch landscape and its artists. Hollar felt a strong sense of kinship with the realistic landscape art for which the Dutch artists prided themselves. The result of his first trip was published in 1635 by Hogenberg in a series of twenty-four prints entitled *Amoenissimae aliquot locorum in Diversis Proncijs iacntiu effigies* (cat. no. 10), meaning "the loveliest views of places in various provinces." Drawings and sketches from this period, as well as the impressions that Hollar gathered during his subsequent journeys, provided him with material for prints for the rest of his life. Often these sketches were made into prints many years later, a fact that Hollar usually noted on the print, stating, for example, that he had drawn (*delineavit*) the scene in 1636 and had etched it (*fecit* or *sculpsit*) in 1646.

While still in Cologne, Hollar's *Reisbüchlein* was published in 1636. This volume contained studies for portraits, mainly based on his own drawings, intended for young draftsmen to use in producing their own work (see cat. nos. 7, 8).

An important year for Hollar was 1636, when his life took a radical turn after he met the English diplomat Thomas Howard, Earl of Arundel (1585–1646). The earl had been sent by Charles I on a hopeless diplomatic mission to emperor Ferdinand II. The purpose of the journey was to guarantee the succession to the Palatinate for the children of the ousted elector Frederick and of Elisabeth of Bohemia, the sister of Charles I (called "the winter queen" since her glory lasted

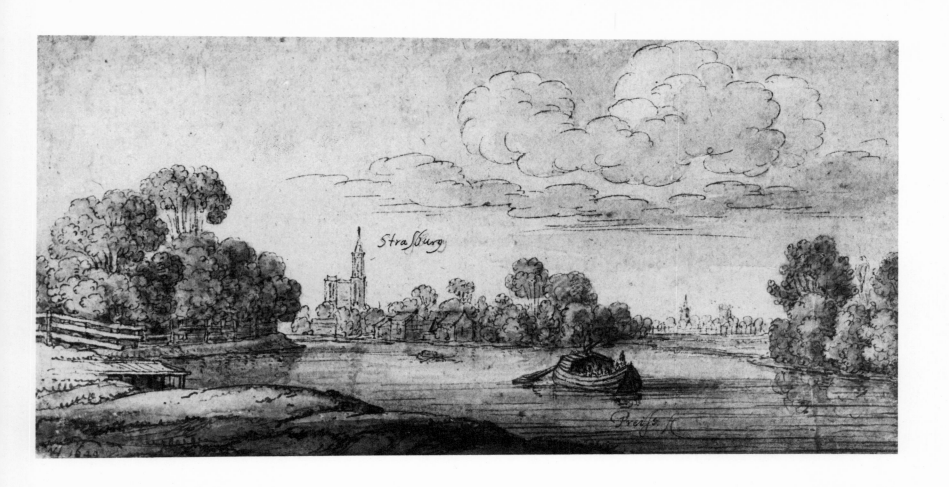

Figure 1
Strasbourg from the Ill
Pen in black ink with wash
Preparatory drawing to P/P 723
Sprinzels 1938, no. 114
In design: Strasburg
Lower L: WH 1629
Lower R: Preis fl'
8.9 x 17.6 (shown enlarged)
Narodni Galerie, Prague (Inv. K. 31222)

but one winter). Arundel traveled with an entourage to match that of any sovereign. He considered everything he undertook to be important enough to be entered in a written record, and the well-known diarist William Crowne was hired for that purpose. In contrast to Hollar, Crowne did render an account of the evils of war. It is not as though Hollar never etched a battlefield or an execution, but even these prints are pleasant upon close inspection. They do not depict actual involvement in human suffering; Hollar did not display a sense of drama.

Crowne was not the only reporter on the journey. The company also included a sketch artist to provide a visual record. Initially, Cornelis van Dalen, who was serving as the engraver of Arundel's collection (see cat. no. 18), was asked to fill this position, but when Arundel, a connoisseur, saw Hollar's work, Van Dalen was unceremoniously pushed aside. On one occasion Arundel wrote about Hollar to his confidant and art agent William Petty in a letter from Nuremberg dated May 27, 1636, "I have one Hollarse with me whoe draws & eches printes in strong water quickely and wth a pretty spirite."[4] On the basis of this letter, it may be assumed that Arundel and Hollar met in Nuremberg. Just as there is no absolute certainty concerning the matter of Hollar's religion, the question of where Arundel actually met Hollar has not been answered either. Most authors believe that Hendrik van der Borcht the Elder, an artist, art expert, and art dealer, introduced Hollar and Arundel. After his training, the son of Van der Borcht, also named Hendrik, was asked to document Arundel's collection in drawings and to assume the role of curator (see cat. nos. 85, 86). Hollar, who was a friend of the Van der Borcht family, was presumably then brought into contact with the English diplomat and patron of the arts.

On the road for seven months on its mission to Ferdinand, the English group traveled over land and by boat on the rivers. Hollar produced some seventy drawings during the journey. While in Arundel's retinue, Hollar visited Prague once again, and for the last time, in 1636 (fig. 3). On his travels Hollar naturally saw many works of art during Arundel's visits to collector friends, including Archduke Leopold Wilhelm, son of Ferdinand II, who held one of the most important collections. Hollar made a print of the archduke's painting by Veronese, depicting Esther before Ahasverus (see cat. no. 63).

In late 1636, Hollar accompanied the embassy back to England, where he remained until Arundel's death in 1646 and even thereafter. Deeply involved with the earl's unparalleled art collection, Hollar reproduced most of it in print form.

ENGLAND

The diplomat and connoisseur Thomas Howard, Earl of Arundel, was a patron of the arts of Peter Paul Rubens and Anthony van Dyck, among others. What contributed to the importance of Arundel's collection was that he had such great respect for drawings, and even for sketches. Hol-

lar was the first engraver to receive a commission to make a print of a sketch. Hendrik van der Borcht was hired as a draftsman and an administrator of the collection, which was a difficult task as the rooms were open to the public. It was important that prints were made of the drawings, as such works on paper are fragile and fade quickly. Through these prints Arundel wanted to preserve the drawings for posterity while providing a catalogue of his holdings. On his arrival Hollar did drawings of the entire collection, which ran the gamut from applied art to caricatures by Leonardo. Later, he took these drawings to Antwerp, where they were etched onto plates. Hollar held a privileged position in Arundel's house. He enjoyed the patronage of the family but remained free to do whatever he wanted. That he did not work exclusively for Arundel is clear from the publication of illustrations, portraits, and prints with city views that he did for others, and the fact that he dedicated some of his works to other noble persons. Evidently Hollar also had the opportunity to portray country houses, landscapes, individuals, and anything that caught his fancy. From the store of drawings done in England, Hollar managed to accumulate material for prints when he was forced to flee to the Continent as a result of the English Civil War.

In the seventeenth century many "foreign" engravers were working on English soil. Hollar met mainly Dutch artists who excelled in the art of portraiture. These artists included, as earlier mentioned, Cornelis van Dalen, Hollar's predecessor with Arundel and an artist specializing in portraits of prominent Englishmen, Abraham Blooteling (cat. no. 12), Lucas Vorsterman (cat. nos. 13, 14), and the brothers Simon and Willem de Passe (cat. nos. 15, 16). Jacob van Voerst also engraved portraits of the English nobility. Such Dutchmen as Johannes Kip and Jan Griffier (cat. no. 17) worked together on a magnificent series of prints of birds after drawings by the English artist Francis Barlow. The art of the print in England developed under the influence of foreigners. Engravers close to Hollar in terms of quality included William Faithorne, George Glover, Francis Place, and Robert Gaywood (cat. nos. 19–22). Most of Hollar's prints from his first English period were published by Peter Stent and culminated in the series of seasons from 1641 and 1644 (cat. no. 24).

In London, Hollar found a world whose philosophical ideas grew from the Protestant world view so familiar to him from his own upbringing. He cannot have remained impassive in the face of the empirical science of Thomas Hobbes and Francis Bacon and the rationalism of René Descartes. The friendship between Hollar and diarist John Evelyn (1620–1706), one of the founders of the Royal Society, began in London as well. In 1662, the Society was elevated to the role of an official institute for the study of the natural sciences. That same year Evelyn published a study on the history of printmaking, entitled *Sculptura, or the history and art of chalcography and engraving in copper*. Hollar profited greatly from the detailed studies that he had done during his English period, such as the series of drawings of butterflies

Figure 2
Nude Woman
Pen in black ink with wash
Sprinzels 1938, no. 12
Inscribed on paper pasted to drawing: Dieses mach ich zu gutter und immerwehrender Gedächtniss / in Cöllen, den 31 July A° 1633 / Wentzeslaus Holar von Prag.
17.1 x 10.4 (shown enlarged)
Narodni Galerie, Prague (Inv. K. 31216)

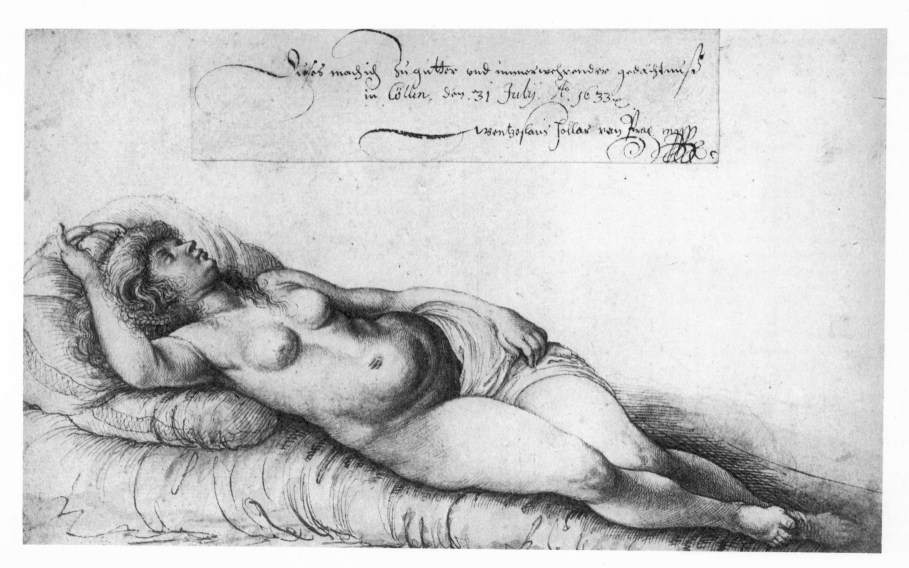

in Arundel's collection (cat. nos. 75, 76). His accuracy was prized highly. Evelyn wrote, "We can justly say of Hollar's works that no series could be more useful or instructive."

ANTWERP

In 1642, Lord and Lady Arundel accompanied princess Mary Stuart to her spouse William II in Holland, and they never returned. A few months later, civil war broke out in England. Arundel was witness to the defeat of Charles I's military expeditions and of the campaign to Scotland. The anti-royalists gained the upper hand after Charles dissolved Parliament and began to rule as an absolute monarch. Arundel obviously had little confidence in the royalist cause, as he brought his enormous collection of art treasures across with him to the Continent.

What Hollar did in the years of Arundel's absence is not well documented. Only six prints from this period are devoted to the Arundel collection. He published a series of eight plates with landscapes, *Amoenissimi Aliquot locorum Prospectus*, and he produced portraits of important figures in the civil war, royalists and republicans alike. Of the 139 prints that Hollar did during the years prior to going to Antwerp, more than half depict women's clothing. In small format, they were published in a series entitled *Theatrum Mulierum* (see cat. nos. 93–95). Meanwhile, Hollar had married a woman known as Miss Tracy and had one son. Within a short time he is said to have

obtained the patronage of the Duke of York, the future King James II. However that may be, in 1644 Hollar also went to Antwerp to join his friend and colleague Hendrik van der Borcht and his very important source of work, the "Collectio Arundeliana." During the Antwerp period, which was to last eight years, Hollar experienced his most productive period as an etcher, creating 350 prints for eleven different publishers. In 1644 or 1645, he was registered in the St. Luke Guild in Antwerp as a "plate cutter." In Antwerp, too, he finally converted to Catholicism.

As the center of printmaking in The Netherlands, Antwerp was home to many print publishers who specialized in a specific genre. For Frans van den Wijngaerde, Hollar etched prints after Italian paintings; for Johannes Meyssens, portraits of artists; for Pieter van Avont, landscapes; and for Hendrik van der Borcht, subjects that dealt with England. In doing so, he referred to the drawings of the Arundel collection that he had done in London. The high point of this period was the publication of *The Long View of London* in 1647 (cat. no. 46). Hollar had etched parts of it in London, and he completed it in Antwerp with the help of his drawings. This publication was accomplished thanks to Cornelis Danckerts, who dedicated the panorama to Mary Stuart, princess of Orange. Moreover, the series with reproductions of drawings of butterflies and insects are particularly attractive (cat. nos. 75, 76). Hollar must have traveled through the Low Countries as well, judging from cityscapes made during this time (fig. 4).

Figure 3
The Great Panorama of Prague
Pen in black ink with pencil in brown, blue, green, and red
Preparatory drawing to P/P 880
Sprinzels 1938, no. 273
In design: PRAGA BOHEMIÆ METROPOLIS
Below: W Hollar delin. in Augusto 1636
12.0 x 55.5
Narodni Galerie, Prague (Inv. K. 33360)

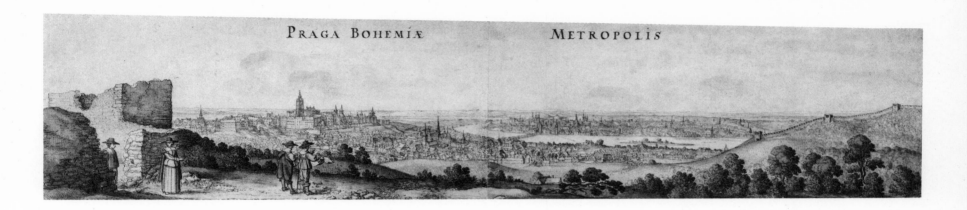

PRAGA BOHEMIÆ METROPOLIS

Hollar remained a convinced royalist, expressing his views through the many portraits of the future Charles II that he did while still in Antwerp (cat. nos. 52–55). *Image de Divers Hommes d'Esprit Sublime*, a collection of portraits with biographies of the most important artists of his time, was published in 1649. For this series Hollar produced eight portraits, including one of himself. The most biographical information available concerning Hollar is given in the text under his portrait in the print's fourth edition (cat. no. 51).

Gentilhomme ne a prague l'an 1607, a esté de nature fort inclin pr l'art de meniature principa / lement pour esclaircir, mais de beaucoup retardé par son père, lan 1627, il est party de prague aijant / demeure en divers lieux en Allemaigne, il ç est addonne por peu de temps a esclaircir et aplicquer / leau forte, estant party de Coloigne avec le Compte d'Arondel vers Vienne et dillec par Prage / vers lAngleterre, ou aijant esté serviteur domestique du Duc de Iorck, il s'est retire de la cause/ de guerre a Anvers ou il reside encores. / Ie Meyssens pinxit et excudit.

Johannes Meyssens, the publisher, wrote that Hollar had a natural inclination for miniatures and illustrations, that he had been held back by his father, and that in 1627 the artist had left Prague and lived in various German cities, where within a short time he was occupied with illustrating and etching. Meyssens also described Hollar's journey with Arundel to Vienna and Prague, and mentioned that Hollar went to England where he worked for the Duke of York. He concluded that Hollar subsequently left England because of the civil war and went to Antwerp, where he was still living.

In 1648 the wars came to an end when the Peace of Westphalia was reached and signed in Münster. Hollar, a witness to the proclamation of peace in Antwerp, made a print of the solemn occasion that was held in the square in front of the city hall (cat. no. 84). It was an unparalleled event that Spain, the greatest power in Europe at the time, had at last acknowledged the independence of the United Provinces.

ENGLAND AGAIN

In 1652, Hollar returned to London and recorded many of its buildings on copper plates. Thanks to his diligence, a visual description of what London looked like before the Great Fire of 1666 exists. Much of his production after his return from Antwerp consists of illustrations for books on history and architecture. He befriended Sir William Dugdale, whose examination of early

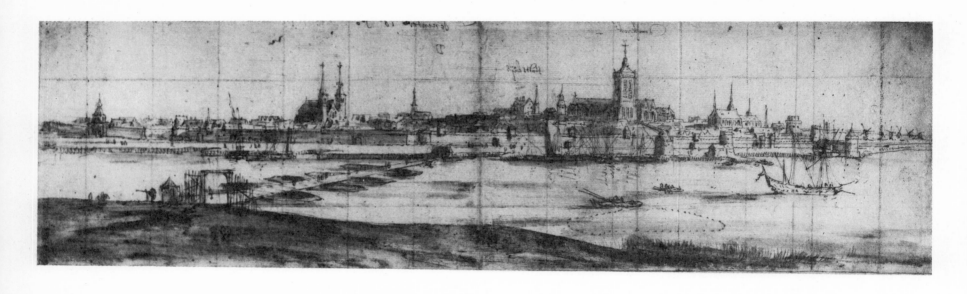

Figure 4
View of Deventer
Pen in black ink with watercolor in blue and gray
Sprinzels 1938, no. 349
In design: Deventer 1650 / Domkerk / Stadhuys
11.3 x 39.4
Narodni Galerie, Prague (Inv. K. 31198)

sources of history laid the foundation for the writing of modern English history. Through Dugdale, Hollar met Elias Ashmole, whose *History of the Order of the Garter* he illustrated. During the 1650s, Hollar was occupied with illustrating three books by Dugdale on the history of English monasteries. He drew churches, castles, monuments, tombs, and floor plans of old buildings that were already lying in ruins. On the interior of the old St. Paul's Cathedral, he wrote the following text in Latin under the print: "Wenceslaus Hollar of Bohemia, depictor and admirer of this church which everyday threatens to collapse, thus preserved its memory" (cat. no. 113). In 1654, Hollar produced a forty-four-page set of illustrations

for publisher John Ogilby for his translation of Virgil's *Georgics*.

Oliver Cromwell ruled over England as Lord Protector from 1653 to 1658, but the monarchy was restored in England in 1660 and Charles II was officially crowned king of England and Scotland. During the plague epidemic of 1665, Hollar lost his son, who had inherited his father's talent for drawing. His wife had died previously. In the same year, he married Honora, a young girl whom he had adopted during the epidemic.

Hollar was quickly on the scene when the Great Fire ravaged London in 1666. Even as the flames were destroying buildings, Hollar was attempting to capture it all on paper. Later, he published

prints in which London before the fire was compared with London afterward. In the same year, 1666, Hollar obtained with some difficulty the title "scenographer to His Majesty." Samuel Pepys (1633–1703), the renowned diarist, noted in his journal on November 22, 1666:

Up and to the office where we sat all the morning. And my Lord Brouncher did show me Holle's new print of the city wthe a pretty representation of that part which is burnt, very fine indeed. And tells me that he was yesterday sworn the Kins servant, and that the King hath commanded him to go on with his great map of the City which he was upon before the City was burnes, like Gombout of Paris; which I am glad of.

In his new position Hollar took part in an expedition to Tangier in the entourage of Thomas Howard, the grandson of Arundel. As usual, he documented this great journey in drawings, of which he did a series of prints after his return (cat. nos. 134, 135). This is the last series of quality that Hollar did.

Wenceslaus Hollar died on March 25, 1677, while still working on an important commission, that of illustrating *The Antiquities of Nottinghamshire*. In 1676 and 1677, he completed fifty-four etchings for it. He was sixty-nine years old and apparently succumbed to the great effort. Three days after his death he was buried at St. Margaret's Church in London.

The first monograph on Hollar was included in *Brief Lives* by John Aubrey (1626–1697). In this manuscript, with annotations on Aubrey's contemporaries, he described Hollar as "a very friendly goodnatured man as could be, but shift-

lesse as to the world, and dyed not rich." In his working methods Hollar "was very shortsighted . . . and did work so curiously that the curiosity of his work is not to be judged without a magnifying-glass. When he took his landscapes, he, then had a glasse to help his sight."[5] Richard Symonds, the antiquarian, wrote the following on Hollar's technique:

I saw Mr. Hollar etching, & he laid on the water wich cost him 4s pound. & was not half an hour eating. it bubled presently, he stirres it with a feather, he lays on the wax with a clout & smooths it with a feather. he makes a Verge to keep in the water after it is cutt with Yelow wax & Tallow melted together. & layd it on wth a pencil he always Stirrs the Aqua with a feather.[6]

In his *Sculptura* (1662), the diarist John Evelyn included lists of prints by Hollar. In his diary as well he described Hollar as a good friend. The most distinguished source for art historians is George Vertue, who, in 1745, wrote the first biography of Hollar, supplemented by a catalogue of his works. Vertue obtained a great deal of material from Francis Place, the engraver who had the most involvement with Hollar. In a letter to Vertue, Place commented that Hollar "did all by the hour, in which he was very exact, for if anybody came in, and kept him from business, he always laid the hour glass on one side till they were gone. He always received 12d an Hour."[7] The famous musing concerning Hollar's character also comes from the letter that Place, writing at an advanced age, sent to Vertue: "Mr. Hollar was a very passionate man easily moved. He has often told me, he was always uneasy if not at work." Such

"uneasiness" may have posed a problem for Hollar in his personal view, but his own generation and those that followed have always been most grateful to him for it.

TECHNIQUE

Hollar executed two types of landscape drawings: spontaneous sketches in ink, sometimes with a little chalk or even wash, which he did on site; and carefully composed works based on these sketches. He colored most of his drawings softly with watercolor in shades of blue, green, brown, and gray.

His innate talent for printmaking is clear from the manner in which he treated his drawings. Contrasts of light and dark are indicated on the drawing just as precisely with wash as they were later to be done in the print. For the darker parts of the drawing Hollar used hatch marks in the etching that cross over each other several times. The deeper and more remote the area, the thinner the line becomes.

All of Hollar's prints are etchings, most filled in with a few small lines using a burin. In Hollar's time, copper plates, already polished and made to measure, could be purchased. Before etching the plates they were heated and covered with a layer of varnish by using a swab. Either a hard or a soft varnish was applied, with the hard varnish being chosen if the print were to give the impression of being an engraving. Artists such as Rembrandt and Hollar opted for a soft etching ground, since

21

they wanted to make a clearer etching. The varnish could be covered with a white layer of chalk on which the subject was drawn as though it were on paper. After being prepared in this way, the plate could be worked with the etching needle, and the exposed lines cut by emersion in corrosive acid. This was done in stages, with the plate being exposed to the acid for varying amounts of time to produce different effects. The resulting prints, made at various times to check progress, are called states and are numbered sequentially. Whenever the length of exposure was insufficient, the satisfactory portions could be once more covered with varnish, and the remaining parts of the plate could be re-emerged in the corrosive acid. When this process was complete, the plate was cleaned and inked, covered with a moist sheet of paper, and placed into the press. If the print still needed improvement, the copper plate was usually corrected directly with a dry point or burin.

For Hollar, the difference in states is not a question of artistic pursuit for the best possible effect. For the most part, they are new issues where names, inscriptions, and subtitles have been changed. Most of these modifications were not made by Hollar. Wear was another reason for retouching the plate.

Most plates were sold to publishers and stayed permanently in their workshops unless the copper plates were again sold or passed to the next generation of printers.

Most of Hollar's oeuvre consists of portraits (589 prints) and topographic scenes (645 prints). Then, in descending order, come religious themes (266 prints), costumes (249 prints), sport scenes and plant zoology (205 prints), architecture (181 prints), heraldry, coins, and ornaments (129 prints), and title pages (87 prints).

COLLECTIONS OF HOLLAR'S PRINTS

Highly motivated collectors of Hollar's prints were active in his own lifetime. First among them was the French connoisseur Michel Abbé de Marolles, who bought Hollar's prints as soon as they were published. His collection is now in the Cabinet d'Estampes at the Bibliothèque Nationale in Paris. In the eighteenth century, publisher/collector Pierre Jean Mariette continued to collect prints by Hollar. Much of the print collection of John Evelyn, a contemporary English collector, has been dispersed, but what remains is on permanent loan from the family to the library of Christ Church College, Oxford, England. Samuel Pepys collected Hollar's works as well, both drawings and prints. His interest did not focus so much on Hollar's art as it did on depictions of topography and famous individuals. The Sloane collection, which forms the core of the Hollar collection in London's British Museum, was donated by Sir Hans Sloane, who purchased the prints from Hollar's widow.

Today, the largest collection of prints by Hollar is housed in the Thomas Fisher Rare Books Library at the University of Toronto. Other large collections are found in the Royal Library, Windsor (much of which comes from the Towneley collection), the library of the British Museum in London, the Bibliothèque Nationale in Paris, and the Hollaraeum in Prague. Although the collection at the Museum Boymans-van Beuningen may not be the largest, it certainly does contain the best quality prints, which will permit viewers to see Hollar at his finest.

1. For a complete list of these prints see Craig Hartley, "Hollar in Prague. A Group of New Attributions," *Print Quarterly* 8 (1991): 3.

2. Aubrey, *Brief Lives*, 241.

3. Aubrey, *Brief Lives*, 241.

4. Springell 1963, 240.

5. Aubrey, *Brief Lives*, 241.

6. Richard Symonds, *Notebooks*, Walpole Society Publications, Oxford, 18:112.

7. Place's letter is quoted in volume 18 of Vertue's *Notebooks*.

Author's Note

In 1990 I curated an exhibition in Rotterdam on Wenceslaus Hollar, and it has been very rewarding to be asked to repeat that experience for audiences in the United States. I would like to thank Art Services International for the opportunity to produce this fully illustrated catalogue and for assisting me in my research journey to Prague. I am grateful to Lynn Rogerson and Joseph Saunders for being so understanding and patient.

In preparing this catalogue, I had much help and support from my colleagues in the Printroom of the Museum Boymans-van Beuningen. I wish to thank them all, and I am especially grateful to Maartje de Haan, who performed all sorts of tedious but vital tasks during the preparation of this manuscript. I would also like to acknowledge the assistance I received from the staffs of the Narodni Galerie and the Kinsky Museum in Prague.

There is one person, however, without whom it would have been impossible to complete this project. Michiel Nijhoff, a librarian at the museum, has been a great help in both intellectual and practical matters. He never complained as he shuttled papers, photographs, and several heavy packages between Amsterdam and Rotterdam.

Finally, I would like to express my gratitude to everyone who in one way or another contributed to this book.

Jacqueline Burgers
Assistant Curator of the Printroom
Museum Boymans-van Beuningen, Rotterdam

Notes to the Catalogue

To the extent possible, works in this catalogue have been arranged chronologically. Prints are divided into four groups: Hollar's first period in Germany, his years in England, the time he spent in Antwerp, and his second stay in England. Prints by artists other than Hollar are included to help situate Hollar more clearly within his own period. Unless indicated otherwise, all prints are by Wenceslaus Hollar.

Dimensions are given in centimeters, height before width. Plate size precedes sheet size. Works are shown no larger than their actual size.

All the prints in the exhibition are the property of the Museum Boymans-van Beuningen in Rotterdam.

The main sources used for object entries in this catalogue are Gustav Parthey's *Kurzes Verzeichniss der Hollar'schen Kupferstiche* (Berlin, 1853) and Richard Pennington's *Descriptive Catalogue of the Etched Work of Wenceslaus Hollar 1607–1677* (Cambridge, 1989). Each print is assigned a Parthey/Pennington number, abbreviated as P/P. Other bibliographical references are abbreviated as follows. A select bibliography on Hollar and his contemporaries appears at the end of this book.

Amsterdam 1988
> De Jong, M., and I. De Groot. *Ornamentprenten in het Rijksprentenkaninet I 15de & 16e eeuw*. The Hague, 1988.

Bartsch
> Bartsch, Adam. *Le Peintre-graveur*. 21 vols. Vienna and Leipzig, 1803–1831.

Berlin 1984
Mielke, Hans. *Wenzel Hollar. Radierungen und Zeichnungen aus dem Berliner Kupferstichkabinett.* Exh. cat., Kupferstichkabinett, Berlin, 1984.

Braunschweig 1987
Heusinger, Christiaan von. *Das gestochene Bild, Von der Zeichnung zum Kupferstich.* Exh. cat., Herzog Anton Ulrich-Museum, Braunschweig, 1987.

Brussels 1965
Le siècle de Rubens. Exh. cat., Royal Museum of Fine Arts of Belgium, Brussels, 1965.

Fagan
Fagan, Louis. *A descriptive catalogue of the engraved work of William Faithorne.* 1888.

Franken
Franken, D. Dz. *L'Oeuvre gravé des Van de Passe Catalogue raisonné des estampes de Crispijn Senior et Junior, Simon, Willem, Magdalena et Crispijn III van de Passe, graveurs Néerlandais des XVIe XVIIe siècles.* Amsterdam and Paris, 1881. Reprint, 1975.

Franken-van der Kellen
Franken, D. and J.Ph. van der Kellen. *L'Oeuvre de Jan van de Velde. Graveur hollandais, 1593–1641.* Amsterdam and Paris, 1883.

Hind 1922
Hind, Arthur Mayger. *Wenceslaus Hollar and his views of London and Windsor in the seventeenth century.* London, 1922.

Hind 1952
Hind, Arthur Mayger. *Engraving in England in the sixteenth and seventeenth centuries.* Cambridge, England, 1952–1955.

Hirschoff 1931
Hirschoff, Alexander. *Wenzel Hollar. Strassburger Ansichten und Trachtenbilder aus der Zeit der dreissigjährigen Krieges.* Frankfurt, 1931.

Hollstein 1949
Hollstein, F.W.H. *Dutch and Flemish Etchings, Engravings, and Woodcuts, ca. 1450–1700.* Vol. I. Amsterdam, 1949.

Hollstein 1954
Hollstein, F.W.H. *German Engravings, Etchings and Woodcuts ca. 1450–1700.* Vol. I. Amsterdam, 1954.

Hymans
Hymans, H. *Catalogue raisonné de l'oeuvre de L. Vorstermann.* Brussels, 1893.

Le Blanc
Le Blanc, Ch. *Manuel de l'amateur d'estampes.* 3 vols. 1856–1888.

Lieure
Lieure, J. *Jacques Callot,* 5 vols. Paris, 1924–1927.

London 1987
White, Christopher, and Lindsay Stainton. *Drawings in England from Hilliard to Hogarth.* Exh. cat., British Museum, London, 1987.

London 1989
Gombrich, E.H., Martin Kemp, and Jane Roberts. *Leonardo da Vinci.* Exh. cat., Hayward Gallery, London, 1989.

M.-H. 1956
Mauquoy-Hendrickx, Marie. *L'Iconographie d'Antoine van Dyck. Catalogue raisonné.* 2 vols. Brussels, 1956.

M.-H. 1991
Mauquoy-Hendrickx, Marie. *L'Iconographie d'Antoine van Dyck. Catalogue raisonné.* 2 vols. 2nd ed. Brussels, 1991.

Paris 1979
Berge, Maria van. *Wenzel Hollar 1606–1677, Dessins gravures cuivres.* Exh. cat., Exposition Institut Néerlandais, Paris, 1979.

Paris 1989
Berge, Maria van. *Elogue de la navogation Hollandaise au XVIIe siècle, Tableaux, Dessins et gravures de la Mer et de ses Rivages dans la collection Frits Lugt.* Exh. cat., Exposition Institut Néerlandais, Paris, 1989.

Rotterdam 1973
Duitse grafiek 1450–1700. Exh. cat., Museum Boymans-van Beuningen, Rotterdam, 1973.

Rotterdam 1990
Van Pisanello tot Cézanne, Keuze uit de verzameling tekeningen in het Museum Boymans-van Beuningen. Exh. cat., Museum Boymans-van Beuningen, Rotterdam, 1990.

Springell 1963
Springell, Francis C. *Connoisseur and diplomat. The earl of Arundel's embassy to Germany in 1636.* London, 1963.

Springell 1964
Springell, Francis C. "Unpublished Drawings of Tangier by W. Hollar," *Burlington Magazine* 106 (1964), p. 69.

Sprinzels 1938
Sprinzels, F. [Francis C. Springell]. *Hollars Handzeichnungen.* Vienna, 1938.

Wurzbach
Wurzbach, V. *Niederlandische Künstler-Lexicon auf Grund archivalischer Forschunger bearbeit.* 3 vols. Vienna and Leipzig, 1906–1911.

Wüthrich 1966/1972
Wüthrich, Lucas Heinrich. *Das druckgraphische Werk von Matthaeus Merian D. AE.* 2 vols. Basel, 1966, 1972.

Catalogue of Works

The Strasbourg Seasons

Wenceslaus Hollar continued a longstanding tradition in the graphic arts when he devised his series of the four seasons. In the sixteenth century, learned artists in all branches of the visual arts devised intricate allegories and personifications that referred to the seasons. This topic was favored because, among other reasons, it provided a comparison with the four ages of man. Little of the ancient traditions was changed. One very direct way of portraying the seasons was through the life of a farmer, who, by nature, depends on changes throughout the year. Figures of women in clothing appropriate to a specific season derived from earlier personifications (see cat. no. 24). In some of Hollar's series, clothing is the only indication of the season being depicted. Texts beneath the prints clarify his intent (see cat. nos. 5, 24, and 34).

Hollar produced six series of etchings of the seasons. In the earliest, in 1628, he based his prints on works by Jan van de Velde II, dated 1617, showing the daily pursuits of farmers (see cat. nos. 5, 6). The second series (cat. nos. 1, 2), with views of Strasbourg, was published in 1629. His choice of city views, in which the season can be deduced from the daily pursuits of the people, is quite unusual. Then in 1641, he began a print series of seasons depicted by women's costumes. Three times Hollar chose figures of women with their accessories to personify the seasons: first as three-quarter-length figures (P/P 610–613, cat. no. 24), then in full-length views (P/P 606–609), and the third time as half-length figures (P/P 614–617, cat. nos. 33–36). Hollar's copies of the prints with small landscapes (P/P 626–629) by Cornelis Saftleven after Jan van Almeloveen are undated.[1]

1A

Spring: The Shooting Range

P/P 622 1st state of two
Etching
1629/1630
In design, lower L: WHollar
Bottom C: VER
Lower R: Zu Strasburg / 1. / bey Jac. vonder Heyden
10.2 x 24.2
10.6 x 24.5

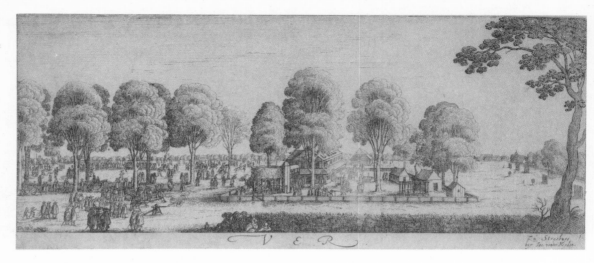

In 1629–1630 Hollar lived in Strasbourg, where he made many sketches that provided suitable material for prints over the years.[2] This series of views of Strasbourg may have been commissioned by Jacob van der Heyden, the publisher whose name appears both on the series after Jan van de Velde II (cat. nos. 5, 6) and on Hollar's *Tower with Clock in Strasbourg* (P/P 893).

Hollar portrays springtime most unusually by a shooting range for archery. From Easter to the end of September, the field was used for various games. The archers' clubhouse is visible at the center.

The preparatory sketch for this etching is in the Narodni Galerie in Prague.[3]

1B

Summer: The Bathing Place

P/P 623
Etching
1628/1629
Bottom C: ÆSTAS
Lower R: 2
10.1 x 24.2
10.5 x 24.6

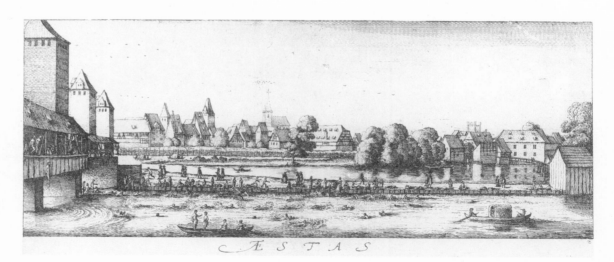

During the hot summer months young boys and men commonly swam in the river Ill. In this scene, Hollar apparently refers to a print dated 1622 by Matthaeus Merian the Elder (see cat. no. 9), in which the artist depicts the month of June with people swimming in the Rhine.[4]

The covered bridges (see cat. no. 123A) connect the banks where the Ill divides into four branches. The tanners' and millers' district, with the church of St. Pierre-Le-Vieux at the center, appears on the far bank.

2A
Autumn: The Wine Market

P/P 624 1st state of two
Etching
1629/1630
Bottom C: AUTUMNUS
Lower R: 3
9.5 x 23.9
10.5 x 24.7

Autumn was represented by wine, specifically by the shipment of barrels and the wine market.

 The toll house, built in 1358, here serves as a storage depot for wines from Alsace. The cathedral in Strasbourg is visible in the background (see also cat. no. 106).

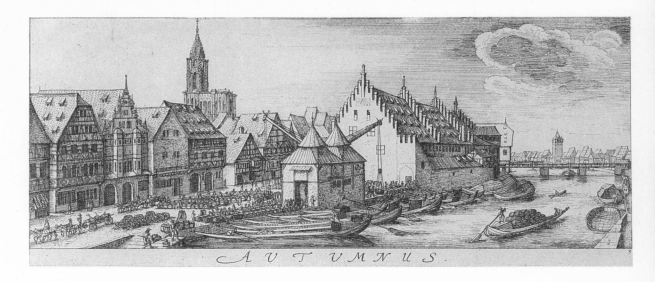

2B
Winter: The Parade Ground

P/P 625
Etching
1629/1630
In design, lower R: WH
Bottom C: HYEMS
Lower R: 4
9.5 x 24.1
10.5 x 24.8

A long row of sleighs glides across Barfüsserplatz ("Barefoot Square," now called Place Kléber), a square originally named for the mendicant friars whose conventual buildings stood there until they were demolished in the eighteenth century.

 The Kupferstichkabinett of the Museum in Berlin-Dahlem owns a print by Hollar of this square viewed from a different angle (no. 3174).

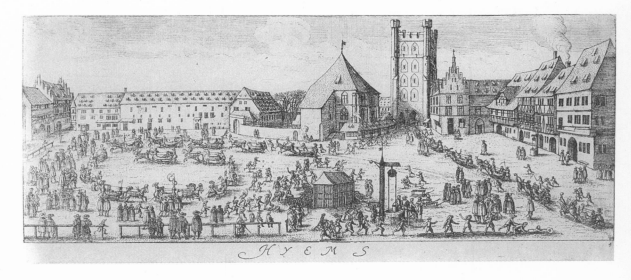

29

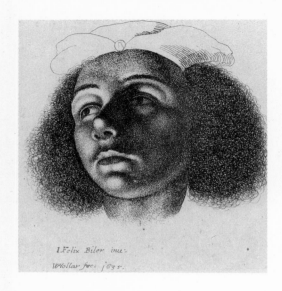

3
Woman's Head
after Jan Bijlert (1603–1671)
P/P 1529
Etching
1635
In design, lower L: I. Felix Biler inu: / WHollar fec:
1635
6.6 x 6.2

The name "Felix" is a mistake on Hollar's part–
he misread the signature. Hollar made four addi-
tional prints after works by Jan Bijlert: *Head of a
Laughing Man* (P/P 1528), *Portrait of a Young
Woman with a Lace Collar* (P/P 1654), *Young
Woman with a Scalloped Ruff* (P/P 1656), and
Woman Wearing a Crown of Cherries (P/P 1682).
All these prints after Bijlert date from 1635 or
1636, the period when the *Reisbüchlein* was pub-
lished (see cat. no. 7). These prints are stylistically
related to the works in the *Reisbüchlein*, which,
like the prints from this period, were mainly
studies. The subtle use of line and the sensitive
attention to the texture of the frizzy hair show
Hollar at his best.

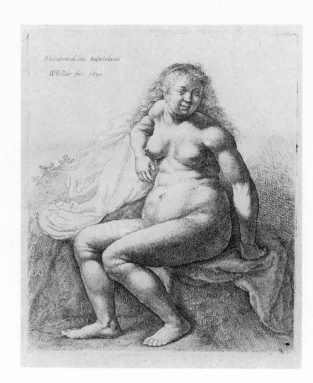

4
Naked Woman
after Rembrandt van Rijn (1606–1669)
P/P 603
Etching
1635
In design, upper L: Rheinbrand inu: Amstelodami /
WHollar fec: 1635
7.8 x 6.7
9.2 x 7.5

According to Ludwig Münz,[5] this etching after
Rembrandt (see Bartsch, no. 198) was done in
1631, the year in which Rembrandt moved to
Amsterdam. The reverse-image copy by Hollar is
dated one year after his trip to The Netherlands in
1634. Therefore, it is possible that he saw the
etching in Amsterdam. During that stay, Hollar
probably copied another of Rembrandt's prints,
Bust of Saskia (see Bartsch, no. 347, and P/P
1650), as well. Significantly, Hollar made
remarkably few prints after works by Rembrandt.
His name is associated with Rembrandt only con-
cerning his etching *Christ Heals the Sick*.[6]

In 1744, Johann Heinrich Heucher, curator of
the Rembrandt etchings in Dresden belonging to
Augustus III of Saxony, noted that this print by
Rembrandt was sold to Hollar for £100.00.[7]
Referring to this sale, Heucher called it the
"Hundred Guilder Print," a name by which the
print commonly became known, although for
various reasons. J.P. Mariette, the eighteenth-
century collector, wrote in his *Abecedario* (pub-
lished in 1857–1858) that Rembrandt bought the
print back for 100 "livres." Mariette adds that a
Dutchman had told him that the print earned the
nickname because Rembrandt had asked 100
guilders for the first sheets.

For additional similarities between prints by
Rembrandt and Hollar see cat. nos. 75 and 76.

5
The Seasons
after Jan van de Velde II (1593–1641)

Hollar's prints of the seasons after Jan van de
Velde II are small-format, reverse copies of four
scenes of farm life, dated 1617 (see cat. no. 6).
These scenes were probably sold through the
print publishing house of Jacob van der Heyden,
which distributed many of Hollar's works.[8]

Hollar's views of *Summer* and *Autumn* are in
the Landesstiftung Coburg (Fortress Coburg) in
Germany. Hollar copied not just the image but
the texts as well, as they appeared beneath the
prints by Van de Velde. In 1628 and 1629, he
produced a series of images of the twelve months,
again after Van de Velde (P/P 630–641).

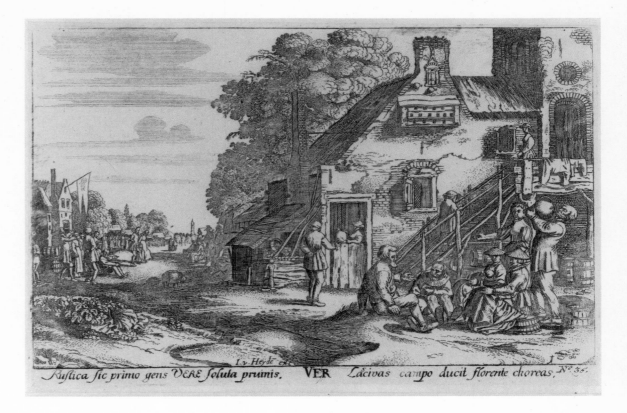

5A
Spring
after Jan van de Velde II
P/P 618 3rd state of three
Etching
1629
In design, lower L: WH
C: I.v.Heyde exc
Lower R: 1
Below: Rustica sic primo gens VERE soluta pruinis.
VER Lascivas campo ducit florente choreas N° 35
10.0 x 15.0
10.3 x 15.4

This print shows a village scene featuring a house
with a long flight of outside stairs that lead to a
tower. Six farmers sit or stand before the house,
drinking. A couple dances in the street.

5B
Summer
after Jan van de Velde II
P/P 619 3rd state of three
Etching
1629
In design, lower L: WHollar 2
Below: Cum vero arva coguit savis ardoribus ÆSTAS
ÆSTAS Agricolis magis umbra placet frondosa,
cibusque
10.1 x 15.1
10.4 x 15.4

A group of farmers casually converses before the
front of a house. In the background, a man stand-
ing on a podium addresses the crowd.

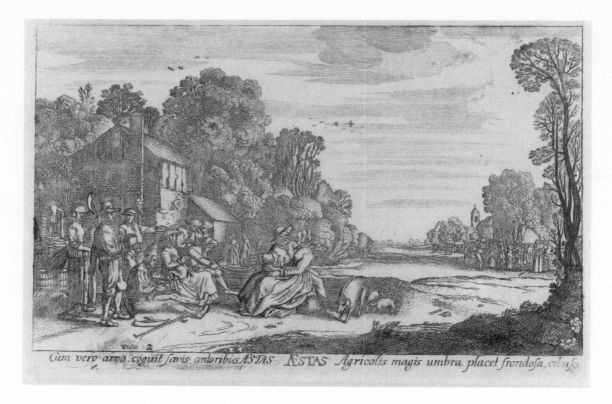

5C
Autumn
after Jan van de Velde II

P/P 620 3rd state of three
Etching
1629
In design, lower L: WHollar / 3
Below: Vinifer AUTUMNUS, CERERIS, BACCHI-
que benigni AUTUMNUS Dona tulit gaudet merces
GENS vendere pingues
10.3 x 15.2
10.4 x 15.3

Heavy drinking is the order of the day in the vil-
lage street. Farmers sit at a table, celebrating the
arrival of the new wine. In Hollar's time, peasants
such as these were considered to be of a low moral
standard.

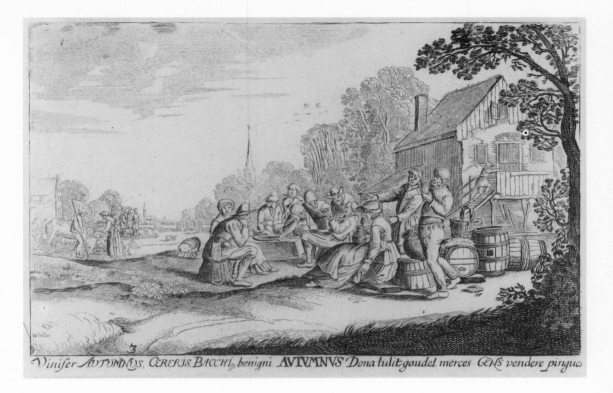

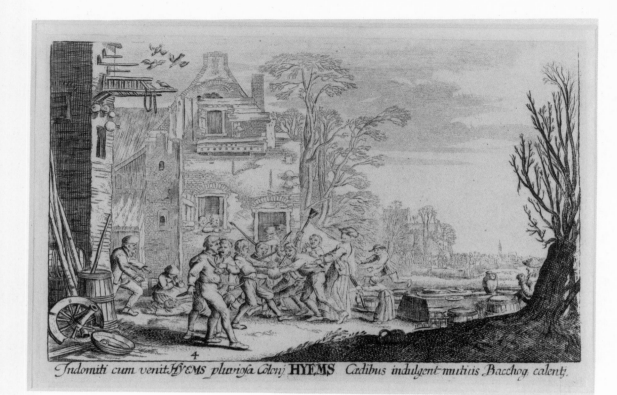

Indomiti cum venit HYEMS pluviosa Colonj. HYEMS Cædibus indulgent mutuis Bacchog. calentj.

5D
Winter
after Jan van de Velde II

P/P 621 3rd state of three
Etching
1629
In design, bottom C: 4
Below: Indomiti cum venit HYEMS pluviosa Colonj.
HYEMS Cardibus indulgent mutuis Bacchog calentj.
10.3 x 15.3
10.5 x 15.4

Here, a fight among farmers is heating up. The series as a whole gives a very negative picture of the peasant class. They are drunk all the time, do practically nothing, and are quick to reach for their knives.

6
Spring
by Jan van de Velde II (1593–1641)

2nd state of six
Franken/van der Kellen 142
Hollstein 1949, XXVIII, p. 18, no. 26
Etching
1617
In design, bottom: 1 Ian vanden velde fecit / Hh /
excudit 1617 Cum privill IVV (as monogram)
Below: Rustica sic primo gens VERE soluta prujnjs,
VER Lacivas campo ducit florente choreas.
28.8 x 45.6

Jan van de Velde II was the nephew of the landscape painter Esaias van de Velde and son of the master artist Jan van de Velde I (1568–1623). He met Hendrick Goltzius, Jacob Matham, and Willem Buytewech in Haarlem, where they shared the common bond of searching for a new interpretation of the landscape. Goltzius (1568–1617) gave his drawings a new impulse by depicting the landscape more realistically than had his predecessors. Landscapes composed with a great deal of fantasy gave way to "portraits" of the surrounding land. His manner of drawing with increasingly swelling lines, the so-called whiplashes, was also adopted by Van de Velde, and through him it came to influence Hollar strongly. For Hollar, detailed copying of what he actually saw before him was more important than concocting scenes from his imagination (see also cat. no. 118).

 Jan van de Velde II was registered in the St. Luke Guild in 1614 as a plate cutter. His specialty was Dutch landscapes, which he sometimes treated allegorically. His landscapes are always full of figures. As an etcher, he worked with small, short strokes, stipples, and agile shading. It is believed that he usually made his etchings without doing a preliminary drawing.

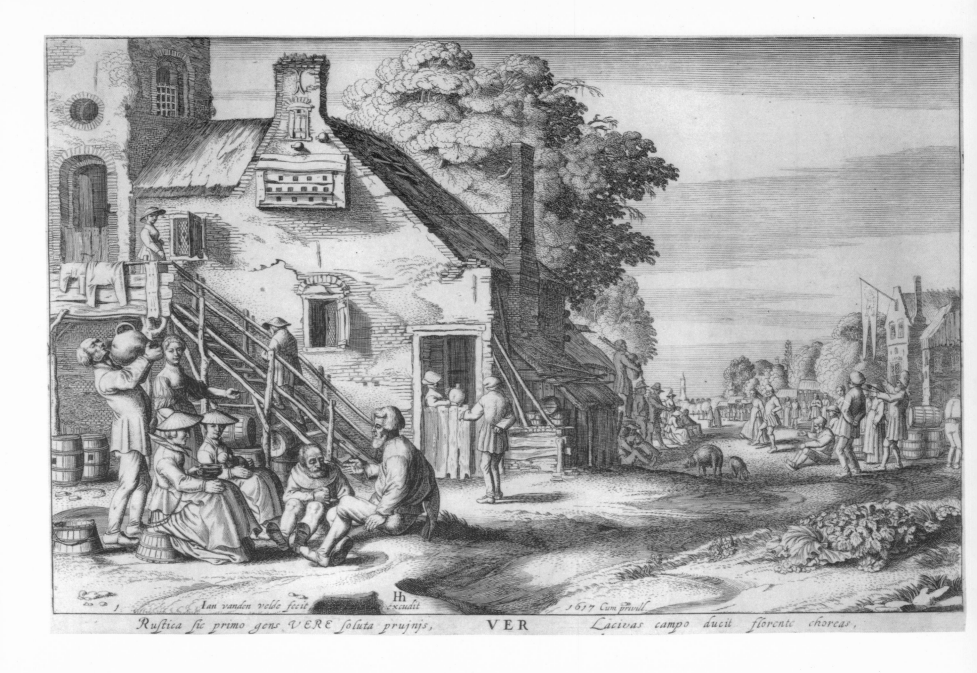

Ian vanden velde fecit Hh excudit 1617 Cum privill.

Rustica sic primo gens VERE soluta prujnjs, VER Lacivas campo ducit florente choreas,

35

These prints are from the *Reisbüchlein*, a series of
twenty-four etchings (P/P 1648–1669) that were
first published in 1636 by Abraham Hogenberg in
Cologne. The complete title explained the pur-
pose of the publication: *Reisbüchlein / von allerlei
Gesichter / und etlichen frembden Trachten für die an-
/ fangende Jügendt sich / darinnen zü üben, / Gradi-
ert, / zü Cöllen dürch Wen= / tzeslaum Hollar vô /
Prag, Anno, 1636 / Abraham Hogenberg / excudit.*[9]

 The sketches for this series were probably done
in 1634 during Hollar's journey through The
Netherlands. Some doubt remains concerning the
order of the etchings within the series. In a later
edition, dated 1645, the pages are numbered; the
prints discussed here are from that edition. Par-
they follows this numbering, as did Michel Abbé
de Marolles, one of the most important collectors
of Hollar's prints. Except for three portraits of
men, the series consists of busts of women who
wear intricate headdresses or head ornaments.
These are not portraits in the exact sense of the
term. They are instead model studies that gave
Hollar the opportunity to depict countless varia-
tions in styles of dress and related accessories.
Through these works, Hollar quickly stood out as
a preeminent "fashion draftsman" and "peintre-
graveur" with a predilection for the detail and feel
of material.[10]

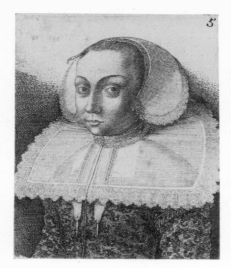

7A
Woman with a Bodkin in her Hair
P/P 1652 2nd state of two
Etching
1636
In design, upper L: WH 1636
Upper R: 5
6.7 x 5.9
7.3 x 6.0

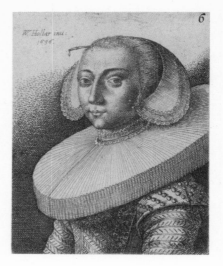

7B
The Same Woman with a Ruff
P/P 1653 2nd state of two
Etching
1636
In design, upper L: W.Hollar inu: / 1636.
Upper R: 6
6.7 x 5.4
7.1 x 5.8

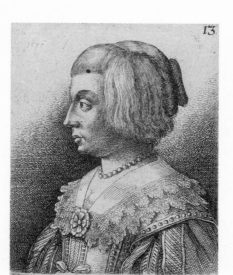

7C
Young Woman with a Lace Collar and Rosette
P/P 1660 2nd state of two
Etching
1635
In design, upper L: 1635
Upper R: 13
6.6 x 5.3
7.2 x 6.4

8A
Bowing Gentleman

P/P 1997 2nd state of two
Paris 1979, no. 163
Etching
In design, lower R: Wentzel Hollar sculp. / Abrah
Hogenberg exc.
13.8 x 7.4
14.0 x 7.8

This print and the one that follows (cat. no. 8B)
form a pair. The gentleman bows gracefully before
the lady in the pendant print. In his hand he
holds a hat with a soft brim and a feather. His
clothing consists of a striped jacket with a white
lace ruff and a scalloped border underneath, a pair
of breeches, and boots with turned-down edges,
which then were worn both indoors and out.

8B
Lady with a Houpette

P/P 1998
Paris 1979, no. 164
Etching
In design, lower R: Wentzel Hollar sculp.
13.6 x 7.4
14.2 x 7.8

The woman, who returns the gentleman's gaze,
wears a flowered dress under a black cloak. Her
long, hooded sleeveless cloak is secured to her
head by a small cap. A long stem with a pompon
tops the ensemble.

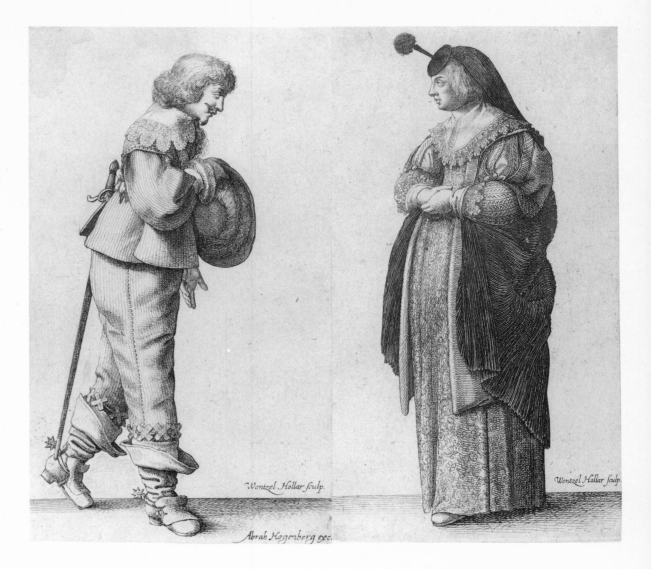

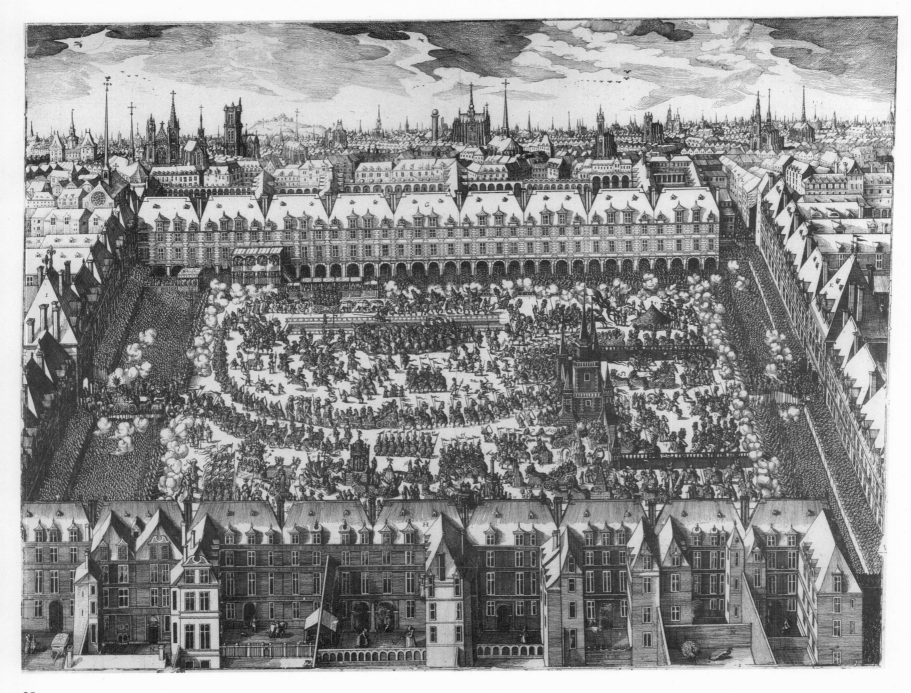

9
Tournament in Paris
by Matthaeus Merian the Elder (1593–1650)
2nd state of two
Hollstein 1954, XXV, p. 113, no. 43
Wüthrich 1972
Rotterdam 1973
Etching
1612
38.0 x 43.7

The supposition that Hollar was trained by Matthaeus Merian or was employed in his workshop is based mainly on the letters of Francis Place (see cat. no. 19). Additional evidence is the different handwriting that appears under the prints of topographic, bird's-eye views by Merian in a publication by Janssonius. One of the handwritings can be identified with that of Hollar. Even so, Merian's influence is clear in the manner of Hollar's works.

In this copy of an engraving by Claude de Chatillon, the subject of the print is the "Inauguration of the royal palace on the Place des Vosges." A costumed procession is depicted, with the pavilions of the king and queen to the right and left. In De Chatillon's print, the upper margin is covered by the text "CAROSEL FAIT A LA PLACE ROYALLE A PARIS MDCXII."

Merian worked in Paris from 1612 to 1614 after training in Zurich. After 1615, Merian lived in Basel, his native city. His itinerant wanderings through German cities ended after his marriage to the daughter of publisher Theodoor de Bry. The two lived first in Heidelberg and then in Basel. After De Bry's death, Merian took over his publishing house in Frankfurt, where Hollar acquired the technical knowledge for rendering perspectives, bird's-eye views, and panoramas.

10
Zuyderzee
P/P 717
Paris 1979, no. 49
Etching
1635
Below: 23. Die Zuyder Zee
5.8 x 9.2
6.1 x 9.4

The subject of this print is a series of twenty-four landscapes and city views, *Amoenissimae / aliquot locorum in Di= / versis Proncijs iacntiu effi= /gies à Wenceslao Hollar Pragensi / delineatae et aere sculptae Coloniae / Agrippinae anno 1635 / Abraham Hogenberg / excudit.* (The loveliest views of places in various provinces by Wenceslaus Hollar of Prague, drawn and cut in Cologne in the year 1635. Abraham Hogenberg published it.) (P/P 695–718).

These prints include views around Prague, Nuremberg, Strasbourg (four), Frankfurt, Coblenz, and Cologne. In The Netherlands, Hollar depicted Delfthaven and the Zuyder Zee, among other locations. Such series were in high demand, as they provided information for a public eager for knowledge about foreign cities and regions. Then as now, everything was of cultural and historical interest to those viewing the prints. Thanks to Hollar's zeal, we can form some idea of the world's condition in 1630. These views, however, did not depict the less attractive side of life, which was quite prevalent in the seventeenth century but which Hollar did not feel called upon to illustrate.

Published in 1635 by Abraham Hogenberg, this series was one of the first publications of Hollar's prints. The etchings are based on drawings that he had done in previous years on his many journeys.

The work of Jan van de Velde II again served as a model for Hollar (see cat. no. 5). Hollar was certainly familiar with the series done by Van de Velde in 1615 that bore the quite similar sound-

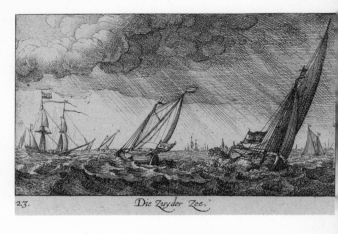

23. Die Zuyder Zee.

ing title *AMOENISSUMAE ALIQUOT REGINCULAE* (Franken/van den Kellen, 217–234).

In 1643, Hollar again turned to using his drawings from the late 1620s and 1630s for the series *AMOENISSIMI ALIQUOT LOCORUM IN DIVERSIS PROVINCIIS IACE= / =TIUM PROSPECTUS etc.* (P/P 719–726).

In both the 1635 series and that from 1643, Hollar used the expression *locus amoenus* (lovely spot). This *topos* served as a principal motif for all drawings from nature from the time of the Roman empire until the sixteenth century. The term, not restricted to pastoral scenes, was also used to describe paradise.[11]

Hollar made two prints of the Zuyder Zee. Thanks to the harbors at Amsterdam, Enkhuizen, Hoorn, and Medemblik, this inland sea played a major role in maritime commerce with the Baltic countries during the seventeenth century. Amsterdam also served as the port for the East India Company.

11

Peter Oliver
by Robert van Voerst (1597–1636)
after Adriaen Hanneman (ca. 1604–1671)[12]
Hollstein 1949, XLI, p. 251 I
Hind 1952, p. 17
Engraving
23.5 x 17.5

When Hollar arrived in England in 1636, the art of engraving was inferior in quality to that practiced on the Continent. Consequently, it was customary to recruit artists from abroad. Many painters and engravers came from The Netherlands, including Cornelis van Dalen (cat. no. 18), Hendrik van der Borcht (cat. no. 85), Robert van Voerst, Lucas Vorsterman (cat. no. 13), Simon and Willem de Passe (cat. nos. 15, 16), and later, Abraham Blooteling (cat. no. 12).

From 1628 on Robert van Voerst lived in London, where at first he studied with Crispijn de Passe and produced portraits of many prominent Englishmen.[13]

Peter Oliver (ca. 1594–1647), whose portrait appears here, was a painter of miniatures, an engraver, and a student of his father Isaac Oliver. He was in service to Charles I to copy his art collection in oil paintings. Charles I took these copies with him during his travels so that he could enjoy his art treasures no matter how far he journeyed. Oliver also painted portraits and was a creditable engraver and etcher.

12

Willem III as a Young Boy
by Abraham Blooteling (1640–1690)

Hollstein 1949, II, p. 197, no. 53
Wurzbach 49
Engraving
In design, bottom: WILIIELMUS III.D.G.
PRINCEPS ARAUSIONUM, / Comitem Nassauiæ,
Catenellebocy, Viandæ, Dietziæ, / Lingæ, Meurzæ,
Buræ, Leerdamj etc. Marchio= / nem Vere ac Fliss-
ingæ, Dominum et / Baronem Bredæ, etc.
Lower L: A. Blotelingh sculpsit
45.0 x 36.4

Abraham Blooteling, a student of Cornelis van
Dalen, resided in England from 1672 to 1678, at
the end of Hollar's life. He created portraits of
the next generation of royalty, in this instance of
the future king of England, William III. This
print was done in Holland, but it is a good exam-
ple of Blooteling's portrait ability when he went
to England.

In comparing this print with the portrait of
James I and Charles I by Willem de Passe (cat. no.
16), it is clear how much the art of portraiture had
changed, not only among English artists but also
among the Dutch artists who journeyed to
England to satisfy the demand for prints. These
prints were more satisfactory in their function of
promoting the individual portrayed and the
painter of the original portrait due to the techni-
cal improvements made by the artists, the many
nuances in light and dark areas, and the attention
paid to the personality of the sitter.[14] Neverthe-
less, these royal portraits remain rather conven-
tional. The only artist to break from these
traditional depictions was Hollar. In his portraits
from the various periods of the life of Charles II,
the childlike and adolescent aspects of the young
man prevail over his royal character.

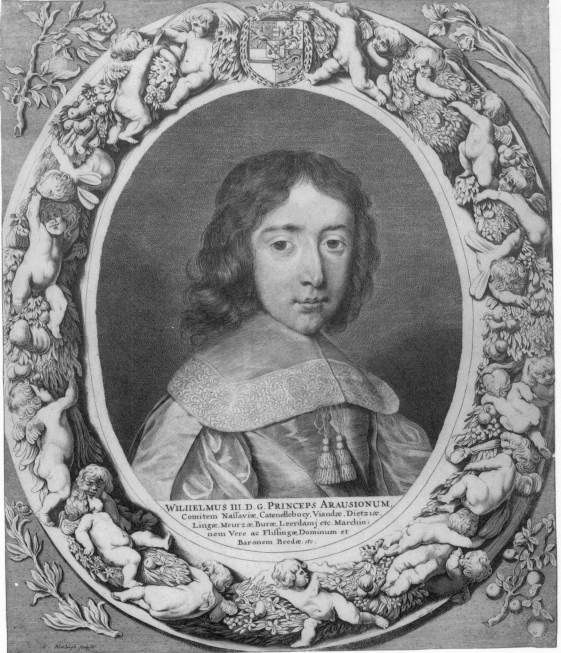

WILIIELMUS III. D. G. PRINCEPS ARAUSIONUM,
Comitem Nassaviæ, Catenellebocy, Viandæ, Dietziæ,
Lingæ, Meurzæ, Buræ, Leerdamj etc. Marchio:
nem Vere ac Flissingæ, Dominum et
Baronem Bredæ. etc.

13
William Herbert, 3rd Earl of Pembroke
by Lucas Vorsterman (1595–1675)
after Daniël Mytens (ca. 1590–before 1648)

Hollstein 1949, XLIV, p. 206, no. 12
Hymans 204
Etching
In oval, top: VNG IE SERVIRAY.
Below: Le tresnoble et puissant Seign. Guillaume,
Comte de Pembrooke Baron Herbert de Cardiff, Seign.
Parr, et / Ross de Caudall Marmion et St Quintin,
Seneschall de la maison du Roy, Guardien de l'estanery.
/ Gouverneur et Capt: pour sa Matc: en la ville, et
Chasteau de Portestmouth, Chevalier du tres: / noble
ordre de la Jarretierre. et du Conseil privé de la Mtc de
la grande Brettaigne: etc:
Lower R: Humill Vorsterma. D. / Cum privilegijs Reg.
41.9 x 30.9

Lucas Vorsterman worked from 1617 to 1619 in
the atelier of Peter Paul Rubens (see cat. no. 56),
who was seeking to broaden public demand for
his paintings through the publication of engrav-
ings. Vosterman thus became the founder of the
graphic school that created prints of Rubens'
work. His most important student was Paulus
Pontius (1603–1658). Vorsterman and Rubens
were in profound disagreement over the fact that
Rubens alone held the rights to his work, includ-
ing engravings done after his paintings. Rubens
also insisted that the engravers work strictly
according to his own drawings. With the self-
awareness of the seventeenth-century artist, Vor-
sterman realized how valuable his prints were.
After breaking with Rubens, he went to England
in 1624, where he worked for Charles I, the Earl
of Arundel, and the Earl of Pembroke, who is
depicted here.[15] William Herbert Pembroke
(1580–1630), lord in waiting and poet, is shown
with all the insignia of his rank.

A few years later, Vorsterman returned to Ant-
werp in 1629, where he devoted himself to work-
ing on Van Dyck's *Iconographia*. Starting in 1638,
he once again made prints for Rubens, specifically

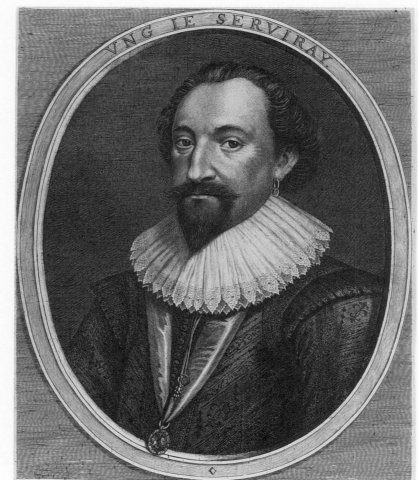

reproductions of his collection of ancient marble
busts.

Daniël Mytens lived in England from 1618 on
and became court painter to Charles I. Before the
arrival of Van Dyck in 1632, he was the favorite
painter of the aristocracy.

14A
Erasmus
by Lucas Vorsterman (1595–1675)
after Hans Holbein the Younger (1497/1498–1543)

1st state of seven
Hollstein 1949, XLIV, p. 154, no. 153
Hymans 159
Engraving
In design, upper L: LV (as monogram)
Below: DESIDERIUS ERASMUS ROT-
TERODAMUS. / Qui Patriæ lumen qui nostri gloria
sech. / THOMÆ HOWARDO, COMITI ARUN-
DELIÆ & SURREIÆ, PRIMO ANGLIÆ COMITI,
DOMINO HOWARDO, MALTRAVERS,
MOWBRAY, SEGRAVE, BREUS, CLUN, &
OSESTRIÆ, COMITI MARESCALLO ANGLIÆ,
NOBILISSIMI PERISCELIDIS SIVE GARTERY
ORDINIS EQUITI, & SERENISSIMO REGI /
CAROLO MAGNÆ, BRITANNIÆ FRANCIÆ &
HIBERNIÆ REGI AB INTIMIS CONCILYS,
artiumgs / omnium liberasium Mecænati maximo,
Sanc Erasmi effigiē amoris ergo humiliter Lucas /
Vorsterman sculptor D.D: Hansus Holbenius
pinxit Cum Privilegijs Reg
21.5 x 15.1

14B
Erasmus
by Lucas Vorsterman (1595–1675)
after Hans Holbein the Younger (1497/1498–1543)

2nd state of seven
Hollstein 1949, XLIII, p. 154, no. 153
Hymans 159
Engraving
Inscription same as 14A, with addition of an *H* in
upper left of design
21.5 x 15.1

Lucas Vorsterman arrived in England in 1624,
apparently at the invitation of Thomas Howard,
Earl of Arundel. While there Vosterman made
many reproductions of paintings from the collec-
tions of Charles I and other noble families.

This portrait of the linguist and humanist
Erasmus (1466?-1536) is a reverse-image copy of a
painting now in the Metropolitan Museum of Art
in New York.[16]

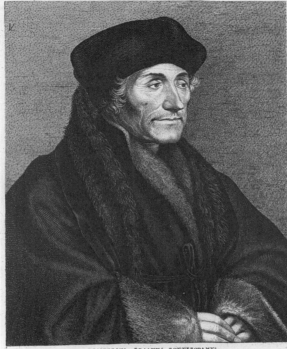

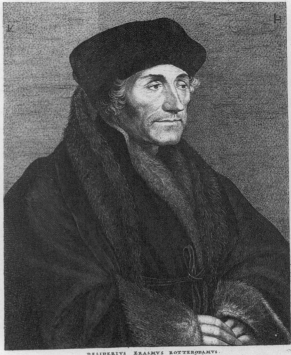

This print contains a commission to Arundel,
who avidly collected the paintings of Hans Hol-
bein the Younger. He had gone to great lengths,
without success, to find the painter's grave, where
he hoped to build a monument that would reflect
his esteem for Holbein.

Lord Lumley, a relative of Arundel, initiated
the earl's Holbein collection. Lumley, who col-
lected portraits of historical figures, acquired Hol-
bein's paintings of Thomas More, Erasmus, and
Christina of Sweden. Of even greater importance
was Lumley's collection of drawings by Holbein,
which Arundel subsequently inherited as a group.

Most of these works are now in the Royal Library
at Windsor.

Holbein went to England for the first time in
1526, staying there until 1528 and gaining accep-
tance through letters of recommendation from
Erasmus, with whom he maintained close ties.
When he returned to England in 1532, Holbein
turned against the opposition party of Thomas
More and became the court portraitist of Henry
VIII. He died in England during a plague epi-
demic in 1543.

Vorsterman and Hollar did not meet in
England. Vorsterman returned to the Continent

in 1630, while Hollar did not arrive in England until 1636. They did, however, use each other's work from time to time. Thus Vorsterman copied two of Hollar's prints: *Mary Magdalene at Prayer* (P/P 180), and *Venus* after Elsheimer (P/P 271). In turn, Hollar made prints after Vorsterman: a portrait of Arundel's mother (P/P 1349), and they worked together on the portrait of the Arundels, the so-called Madagascar portrait (P/P 1353A), after Van Dyck.

15
Thomas Howard, Earl of Arundel
by Simon de Passe (1595–1647)
after Michiel Jansz. van Mierevelt (1567–1641)

Franken, no. 450
Hind 1952, II, 249.5
Hollstein 1949, XVI, p. 155, no. 14
Engraving
1616
In design, upper right: Virtutis / Laus / Actio
In oval: CLARISSUS DOMNUS THOMAS HOWARD COMES A ARUNDELL ET SURREY PRIM. COM:TOTI ANG:
Bottom: The right honourable Lord THOMAS HOWARD / Earle of Arundell and Surrey, Premier Earle of / England Lo: Howard, Fitz Allen, Matroners, Mowbray / Segraut, Bruse and Clun. Knight of the most noble / Order of the Garter, and one of the Lords of his / Maties:most honourable Privy Councell, etc. / Michael Janss: Mir: pinx:.et Simon Passeus sculp:L. Comptō Hollād exc:.
13.9 x 11.1

Simon de Passe, a scion of the famous De Passe family of engravers, was the third son and student of Crispijn de Passe I. His earliest known print is a portrait of Henry, Prince of Wales, dated 1612. From 1616 to 1624, Simon de Passe worked in London for the publisher Compton Holland, for whom he engraved mainly portraits of noble persons. From 1612 to 1622–1623, he engraved on his plates that they were done in London. He must have traveled a few times to Utrecht and Paris, where his brother Crispijn II was working on illustrating the *Manège Royale* of Antoine de Pluvinel. Simon engraved one plate and the portrait of the author for the book. After his English period, Simon de Passe went to Holland until 1631, after which he pursued a successful career in Denmark as the royal engraver for Christiaan IV.

Michiel Jansz. van Mierevelt, the painter of the portrait of Thomas Howard, was a Dutch portrait artist and court painter for the princes of Orange.

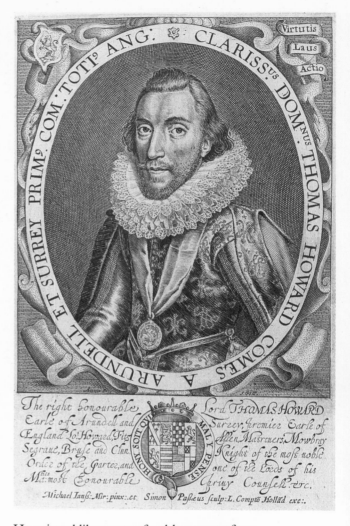

He painted likenesses of noble persons from Delft, The Hague, and, as in this instance, England. In his workshop he kept in stock copies of portraits of popular individuals. Typically, he portrayed his subjects in three-quarter profile without head coverings.

16
James I and Charles I
by Willem de Passe (ca. 1598–1637)

1st state of five
Franken 688
Hind 1952, II, p. 291, no. 10
Hollstein 1949, XVI, p. 203, no. 45
Wurzbach 11
Engraving
1621
Above: JAMES BY THE GRACE OF GOD KING OF GREAT BRITANNIE etc. CHARLES BY Yᶜ GRA: OF GOD PRINCE OF WALES
In design, on sword: FIDEI DEFENSOR
Below: Who viewes not on this reverend aspect
. .
And that through all the world may sound thy name.
Anno Doni / 1621[17]
Lower R: Wilh. Passaeus figu: et sculpsit. / Are to be sould by Thomas Ienner / in Cornhill at the white Beare. / Georg:Fearebeard excudit
24.0 x 19.8
30.0 x 20.6

James I (1566–1625), shown wearing his crown, is seated to the left holding a sword on which is written *FIDEI DEFENSOR* (defender of the faith). He appears with his grandson Charles I (1600–1649), shown at age twenty-one, with a moustache and an adult face, although his figure is that of a boy. The actual models for this double portrait are unknown. According to Willem de Passe, he drew the model for this print himself, *figu*[*ravit*]. It is possible that he used a model from an earlier date and placed an older head on the body of the Prince of Wales, a compositional trick that was often used (see cat. no. 53). Willem de Passe lived in London from 1620 until his death in 1637.

17
Ostriches and Peacocks
by Jan Griffier (1646 or 1657–1718)
after Francis Barlow (1620–1704)

Etching
Lower L: F Barlow delin: / I Griffier fec.
Bottom: key to names of the birds
Lower R: P Tempest ex:
21.9 x 30.0

George Vertue, in volume I of his *Notebooks* (p. 51), writes that Jan Griffier was seventy-two years old when he died, which should place the year of his birth at 1646.

Before he began studying with the landscape painter Roeland Roghman (ca. 1620–1682), Griffier trained as a carpenter, tile painter, and floral painter. In the early years of his painting career, he received advice from and came under the influence of Adriaan van de Velde (1636–1672) and Jacob van Ruysdael (1628/1629–1682). After the Great Fire of London in 1666, Griffier went to London, where he not only painted and etched but also made mezzotints after paintings by the new generation of important English painters, such as Sir Peter Lely, Sir Godfrey Kneller, and Francis Barlow. His manner of etching is quite similar to that of Robert Gaywood and Francis Place. Even though all of them etched after Barlow's model, which naturally provided stylistic similarities, they all shared Hollar's freeness of line, clarity of tone, and imitation of a free drafting style.

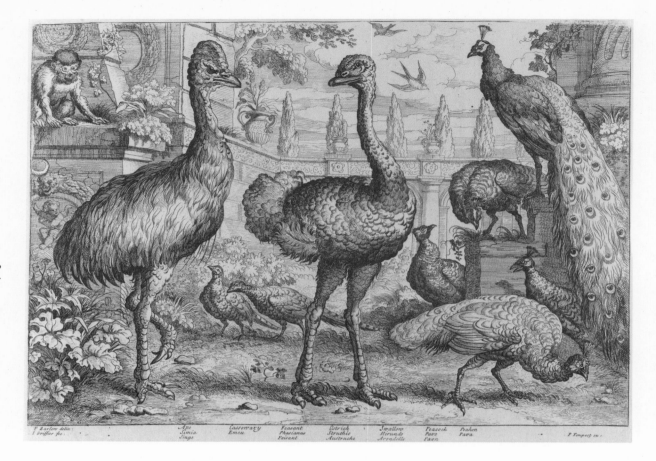

18
Algernon Percy
by Cornelis van Dalen (1602–1665)

Hollstein 1949, 148
Hind 1952, III 254.5
Engraving
1636
In oval: PERCEY. COM: NORTHUMBERLAND.
HONORATISS: D. ALGERNON
Bottom: The right Honourable, and most noble,
ALGERNON PERCY, / Earle of Northumberland,
Lord Poynings, Fitz-payne & Brian, knight of the /
most noble order of the Garter, Admirall & Generall of
his Maiesties Fleet for this: / Expedition A° 1636
Lower L: Corn. Van Dalen sculpsit
Lower R: Sould by Tho: Ienner at the Exc.
21.9 x 16.1

This portrait dates from 1636, the year in which
Algernon Percy (1602–1668) was sent to Scotland
by Charles I. Four years later, in connection with
Percy's second expedition to Scotland, Hollar did
an equestrian portrait of this Earl of Northumber-
land, along with Oliver Cromwell and the Duke
of York (P/P 1474). Both prints were published
by Thomas Jenner.

Cornelis van Dalen lived in England from 1633
to 1638. He was the first of a series of foreign
engravers who made prints of Arundel's collec-
tion. The earl's practice of attracting better
trained professionals from abroad was quite sim-
ple to achieve, as there were no guilds in London
to oppose the action. Arundel had become famil-
iar with Hendrik Goudt's prints after paintings by
Adam Elsheimer while the earl was in Rome (cat.
nos. 61, 62). The fine manner in which Goudt
reproduced a painting in an etching inspired
Arundel to commission an engraver to copy his
own collection.

Arundel took Cornelis van Dalen along on his
journey to Vienna, with the artist serving as the
"reporter" of the mission. While looking for
paintings by Dürer in Nuremberg or while travel-
ing through Cologne, Arundel came into contact
with Hollar and his work.[18]

The only time Arundel referred to Hollar was
in a letter dated May 27, 1636, written from
Nuremberg, to his agent in Italy. "I have one
Hollarse wth me whoe drawes & eches printes in
strong water quickly and wth a pretty spirite."[19]
The more talented Hollar soon replaced Van
Dalen.

19

Dedication to Ricardo Domino Maitland in
Multae et Diversae Avium
by Francis Place (1647–1728)
after Francis Barlow (1620–1704)

P/P 2144–2157[20]
Etching
1658
Title, in design: Illustrissimo Heroi / Richardo Domino Maitland / Caroli Comitis de Lauderdale / Filio natu maximo, / Picturæ omniumque Bonarum Artium Cultori Egregio, / Amplissimo suo Mecænati, / Has Avium Tabulas celeberrimâ Francisci Barlow manu quam elegantissime delineatas / Grati Animi Pignus. / D.D.D. / Humill^mus et addictiss^mus Servus / P: Tempest
Lower L: Fra. Barlow delin.
Bottom: Fra. Place fecit
Lower R: P. Tempest excud.
21.3 x 29.9

During his second period in England, Hollar worked with younger English artists with whom he maintained personal as well as artistic relations. In 1654, he etched an eagle after a model by Francis Barlow. Four years later this print was included in Barlow's *Diversis avium species* (P/P 2144–2158), the series of bird studies for which this commission was intended. Barlow's drawings and paintings of birds stirred Hollar's interest in the subject, as witnessed by his many later works featuring birds.

During this time Hollar also worked with English engravers who were engaged in reproducing a series of paintings on the hunt after models by Barlow, called *Severall Wayes of Hunting, Hawking and Fishing* (cat. nos. 128–132). In contrast to what has been often thought, neither Barlow nor Place was an actual student of Hollar. Both of them underscored this fact in their own words, as Barlow did in his introduction to the fables of Aesop in 1666, just one year after Hollar published his illustrations of the same fables. In his work, Barlow writes that he never strove for particular accuracy, as he was not a professional etcher.

20
Chickens
by Francis Place (1647–1728)
after Francis Barlow (1620–1704)

Etching
Lower L: F. Barlow delin.
Bottom: key to names of the birds
Lower R: F. Place Fecit. P. Tempest ex.
21.3 x 29.9

Francis Barlow's subjects were made into prints
by Francis Place, a true "virtuoso" who, dissat-
isfied with studying law, returned to his estate,
collected art, and made many prints. Place com-
pleted etchings after Parmigianino, among others,
and copied various bird studies by Hollar, with
whom he shared a predilection for drawing but-
terflies and insects. He made a significant contri-
bution to Hollar's biography when, in 1716,
thirty-nine years after Hollar's death, Place wrote
a letter containing all kinds of information to
George Vertue, Hollar's first biographer.[21] Place
is considered one of the four reliable contempo-
rary sources for Hollar's biography.[22]

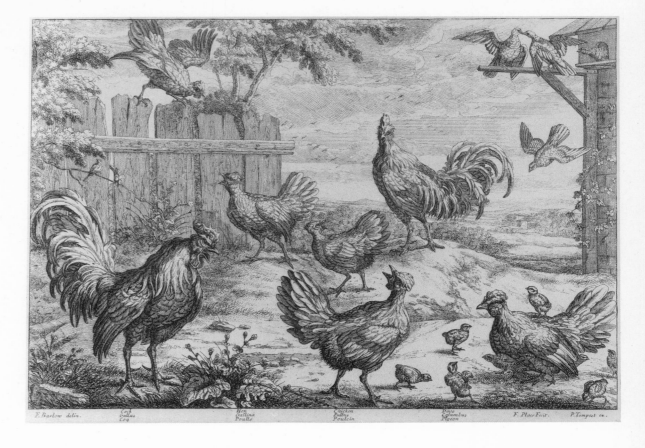

21
Rabbits
by Robert Gaywood (act. 1650–1711)
after Francis Barlow (1620–1704)
Etching
Lower L: Fra: Barlow delin:
Lower R: P. Tempest ex:
In design, on rabbit hutch: F. Barlow / inuen. / R.
Gaywood / fecit
20.5 x 32.7

This print, which deceptively resembles a print by
Hollar, illustrates the great difficulty that is inher-
ent in making attributions in general, and for
making them for artists who worked in the same
circle and were each other's students and/or
friends in particular.

 Most of the work of Robert Gaywood consisted
of portraits and copies of images by Hollar, with
whom he worked from 1672 to 1677 on a project
of illustrating Francis Sandford's *Genealogical His-
tory of the Kings of England*. For this series Hollar
did twenty-three full-page plates, and Gaywood
produced several prints that could pass for works
by Hollar. Many prints traditionally attributed to
Hollar, according to Pennington, are in fact by
Gaywood, such as the title page for *Diversae
Avium Species* (P/P 2124) from 1658.[23]

23
William Dobson
by Josiah English (1630–1718)

Etching
Below: Vere Effigies Guilielmi Dobson Armiger / et pictor Regia Majestatis Anglia. / in aquaforti f: 't / Soud by Thomas Rowlett neare Temple Barr
22.4 x 37.2

Introduced to Charles I by Anthony van Dyck, William Dobson (1610–1646) stayed at Oxford from 1642 until his death in 1646, where he did portraits of the king's children and royal household. He was a student of Frans Cleyn, whom Hollar used as a model for many mythological prints (see cat. no. 116).

Josiah English, the engraver of this self-portrait by Dobson, was a prosperous man and an amateur print artist who worked in mezzotint. English echoed Hollar's style, though this portrait is somewhat romantic and robust, as though the engraver drew his model directly onto the plate. English did most of his prints after models by his friend and teacher Frans Cleyn. He supplied one of the prints for John Ogilby's 1651 publication of Aesop's fables, the lion's share of which Hollar etched. Cleyn, as well as English himself, provided many subjects for Josiah English's carpet-weaving factory in Mortlake.

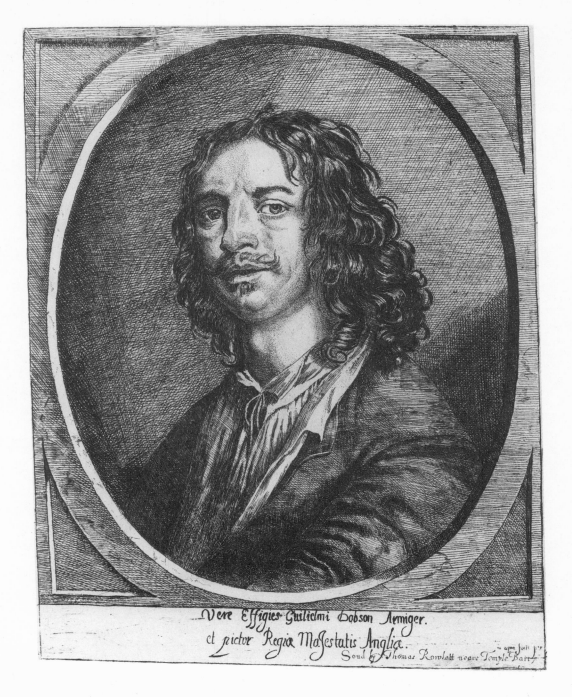

Vere Effigies Guilielmi Dobson Armiger.
et pictor Regia Majestatis Angliæ.
Soud by Thomas Rowlett neare Temple Barr

The Seasons
P/P 614–619

In this set of four costume prints, women wear clothing that symbolizes each of the four seasons. This series was apparently so popular that its publisher, Peter Stent, had copies made in 1644, the year of its first publication.

Hollar used the same models as those for his earlier series of women in full-length views (P/P 606–609). Even the accessories, from veils and head coverings to muffs, are found in all his costume prints.

Such personifications of the seasons were made with little change from late antiquity into the eighteenth century. In the frescoes and mosaics of Pompeii, spring is represented as a young woman with flowers; summer as a woman with a sickle and an ear of grain; autumn as a woman with grapes; and winter as a woman heavily clad against the cold. In later paintings the personifications were complemented by background activities proper to the season. The seasons were depicted as either men or women. In the Renaissance, a return was made to the ancient tradition of pagan gods representing the seasons: Flora or Venus for spring, Ceres for summer, Bacchus for autumn, and Boreas or Vulcan for winter. In the plastic arts the human lifespan was on occasion tied to the four seasons. Thus spring was likened to youth, summer to early adulthood, autumn to the more mature years, and winter to old age.

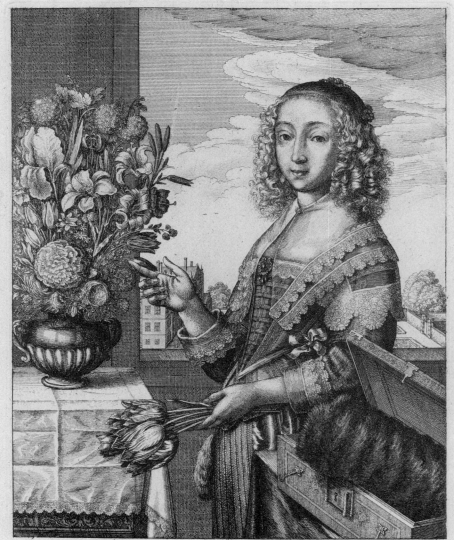

VER

SPRING

24A
Spring

P/P 610 4th state of four
Etching
1641
Below, in two columns, Latin on L and English on R:
SPRING / Ffurs fare you well, the winter is quite gone /
and beauty's quarter now is coming on / When nature
striveth most to shew her pride / our beauty's being the
cheefe we must not hide
Lower L: W:Hollar inventor et fecit Londini, A 1641
24.1 x 17.8
26.8 x 19.7

Spring is shown as a woman with loose-hanging
curls. She wears a low-necked dress, over which a
lace collar is draped. In her left hand she holds a
bunch of tulips, and with her right hand she
points to a bouquet of spring flowers in a vase.
The fur muff, which Hollar often incorporated
into his prints, is in a chest to be stored away
before summer. Its presence refers to the line
"Furs fare you well." A country estate and garden
are visible through the window.

24B
Summer

P/P 611 2nd state of two
Etching
1641
In design, bottom: W. Hollar inv:1641
Below, in two columns, Latin on L and English on R:
SUMMER / In Sumer when wee walke to take the
ayre, / wee thus are vayl'd to keepe our faces faire / And
lest our beautie shoold be soyl'd with sweate / wee with
our ayrie fannes depell the heate
24.1 x 17.3
27.0 x 19.8

Summer is depicted as a woman with a fan in her
right hand and gloves in her left. A veil draped
over her face protects her skin from the sun. The
poem speaks of Zephyr and the purpose of the
veil. A wide river is visible through the window.

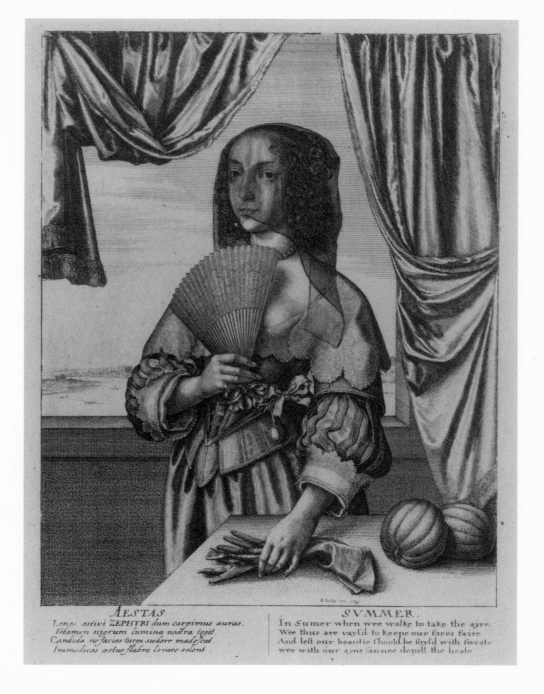

AESTAS
Lenes æstivi ZEPHYRI dum carpimus auras.
Velamen nigrum lumina nostra tegit.
Candida ne facies turpi sudore madescat.
Immodicos æstus flabra levare solent.

SVMMER.
In Sumer when wee walke to take the ayre.
Wee thus are vayl'd to keepe our faces faire
And lest our beautie shoold be soyl'd with sweate
wee with our ayrie fannes depell the heate

24C
Autumn

P/P 612 2nd state of two
Etching
1641
In design, lower R: W.Hollar inv: / 1641
Below, in two columns, Latin on L and English on R:
AUTUMNE / Our ioy and sorrow now come both
together / Autumne brings freute but Autumne brings
cold weather / here hast the first the last you'll feele no
doubt / except attir'd like mee you kepe it out.
25.0 x 17.8
27.0 x 19.8

Visual references to autumn are the dish of fruit
and the woman's head covering. In the poem
autumn is hailed as "our joy and sorrow now
come both together. . . ." Evidently Hollar did
not work extensively with the background. Just as
in *Winter*, the background is filled mainly with
crosshatched lines.

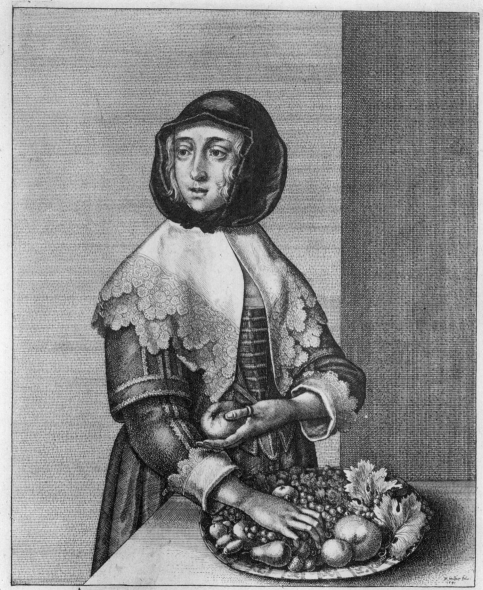

AVTVMNVS
Convenère simul iam noſtra et gaudia luctus,
AVTVMNVS fruges, frigora et riide parit
Has primò guſtos poſthac senſurus et illa,
Ni bene munitus veſte, vel igne cales.

AVTVMNE.
Our ioy and ſorrow now come both together (weather
Autumne brings freute, but Autumne brings cold
here taſt the firſt, the laſt you'll feele no doubt
except attir'd like mee you kepe it out.

24D
Winter
P/P 613 2nd state of two
Etching
1641
In design, lower L: W.Hollar inv.1641
Below, in two columns, Latin on L and English on R:
WINTER / Thus against winter wee our felues doe
arme / and thinke you then the cold can doe us harme /
but though it be to hard for this attire / yet wee'll
orecome it not with sword but fire.
24.5 x 17.4
27.0 x 20.1

The muff worn by the woman is one of the two
muffs that Hollar owned. Time and again this
muff of two different types of fur is seen: as an
accessory, and as a kind of still life, such as the
small one of a fur collar and mask on the win-
dowsill. Hollar's specialty was depicting fur. He is
said to have been the first artist to promote fur
and lace as independent subjects (see cat. nos. 68–
70). In the poem it states that we must protect
ourselves against the winter and the cold, not
with the sword, but with fire.

57

25

The Wedding at Cana
by William Faithorne (1616–1691)

Fagan 72.3
Etching
1653
Below: Et die tertia nuptiæ factæ sunt in Cana Galilææ :
et erat mater Jesu ibi. &t. / And yᶜ third day there was a
marriage in Cana of Galilee, & yᶜ mother of Jesus was
there.
Lower L: Pag. 213.
Center: Jo : 2:3
Lower R: Witt: Faithorne Sculp:
27.4 x 30.0
293 x 310

William Faithorne, the first English engraver to
achieve the level of skill of other European artists,
was mainly a portraitist. Here he was chosen to
produce three illustrations for a pietistic text by
Jeremias Taylor. For the biblical subjects
Faithorne chose models derived from sixteenth-
century art. The wedding feast of Cana is tradi-
tionally shown with a long, foreshortened table
and classical architecture. The group in the right
foreground appears in almost every sixteenth-
century painting and print that shows a meal in
progress, as does the person who offers jugs of
wine or water.

Faithorne had studied with the court painter
Robert Peake (1592?–1667) and the engraver
John Payne (act. ca. 1600–1640). Peake had a
print publishing house the published Faithorne's
early prints. Another of Peake's students was
George Glover (cat. no. 22). Many portraits of
nobility that are attributed to Faithorne are, in
terms of the somewhat coarser line, stylistically
more like the work of Glover. Faithorne and
Robert Peake were good friends of Hollar, with
whom they took the side of the royalists in the
vain effort to defend Basing House (1645) during
the Civil War. After his imprisonment, Faithorne
did portraits of several major figures from both
parties. Banished to Paris, Faithorne befriended
the print collector Michel Abbé de Marolles and

the artist Robert Manteuil, one of the most signif-
icant French portrait artists of the seventeenth
century. From him, Faithorne learned the art of
pastel drawing. In 1650, Faithorne returned to
London and set himself up as an engraver, pub-
lisher, and print dealer "Att ye signe of ye shipp
within Temple Barr." Twelve years later he wrote
a treatise on *The Art of graveing and etching* (1662).
This small book is little more than a translation of
Abraham Bosse's *Traité desmanieres de graver en
taille douce* (Paris, 1645). Even the illustrations
were copies of Bosse's etchings. In England,
books on technique were written not by practi-
tioners of art but by virtuosi and "Ingenious Gen-
tlement." Faithorne's book was not only the first
complete and illustrated treatise on the technique
of engraving and etching but also a sign that
England was ready for such technical
understanding.

An important contemporary of Faithorne was
the diarist Samuel Pepys, who on several occa-
sions mentions his visits to and admiration of
Faithorne. On January 3, 1662, he wrote, "And
after dinner to Faithornes en there bought some
pictures of him."[24] Over four years later, on
November 7, 1666, Pepys wrote after an outing
with one of his women friends:

But took coach and called at Faythornes to buy some prints
for my wife to draw by this winter, and there did see mylady
Castlemaynes picture done by him from Lilly's in red chalk
and the colours, by which he hath cut it in copper to be
printed. The picture in chalke is the finest thing I ever saw in
my life I think, and did desire to buy it, but he says he must
keep it a while to correct his Copper-plate by, and when that is
done, he will sell it to me.[25]

This fragment is important for understanding sev-
eral of the functions of prints: they served as a
model for an amateur draftsman and as the repro-
duction of a painting. Faithorne had made a chalk
drawing instead of a line drawing prior to the
print. Also, "côteries" were formed where people
could meet to look at, discuss, and sell art. It is
not reported whether Pepys managed to acquire

the drawing, although he did write on the follow-
ing December 1, 1666, "But by coach home in
the evening, calling at Faithornes and bying there
three of my lady Castlemaynes heads, printed this
day which indeed is, as to the head I think a very
fine picture and like her."[26]

Et die tertia nuptiæ factæ sunt in Cana Galilææ : et erat mater Jesu ibi . &c.
And y̆ third day there was a marriage in Cana of Galilee, & y̆ mother of Jesus was there.

Pag. 213. Jo: 2 : 1. Will: Faithorne sculp:

26

The Arrest of Christ
by William Faithorne (1616–1691)
Engraving
1653
Lower L: 1653
In design, lower R: WFaithorne scul:
Below: Qui autem tradidit eum, dedit illis signum,
dicens, Quemcunq osculatus fucro, ipse est, tenete
cum Et confestion accedens Iesum, / dixit Auc Pabbi.
Matth. 26 / Now he that betrayed him, had given them
a token, saying, whomsoever I shall kisse, that is he, lay
hold on him / Place this fig: in Sect: 15. P 461.
26.1 x 20.2
28.3 x 31.0

The three prints by William Faithorne shown and
described here are the subject of *The great Exem-*
plar of Sanctity and Holy life according to the Christian
Institution by Jeremias Taylor.[27] In his work, and
in keeping with the taste of his time, Faithorne
chose an archaic model from a sixteenth-century
Dutch engraver. One possibility is Cornelis Cort
(1533–1578), who based his engraving on the
subject by Girolamo Muziano in 1568.[28]

27
The Ascension of Christ
by William Faithorne (1616–1691)
Fagan p. 73 1st state of four
Etching
1653
Below: Et cum hec dixisset, videntil illis elevatus est : &
nubes suscepit cum ab oculis eorum. / And when he
had spoken these things, while they beheld he was
taken up, & a cloud received him out of their sight. /
Pag. 553. / Act:1–9. / W: Faithorne sculp:
26.4 x 20.4
27.4 x 31.0

This print has more in common stylistically with
Hollar than the previous two (cat. nos. 25, 26),
particularly in the foreground. As Hollar did in so
many of his landscapes, the edges of a sloping field
are shaded with crosshatching. The overwhelming
event of the ascension and the awe of the
bystanders are shown in a manner reminiscent of
the works of late Renaissance masters, such as *The
Transfiguration* by Raphael and *The Coronation of
Mary* by Dürer.

Et cum hæc dixisset, videntib' illis elevatus est : & nubes suscepit eum ab oculis eorum.
And when he had spoken these things, while they beheld he was taken up, & a cloud received him out of their sight.
Pag: 553. Act: 1. 9. W: Faithorne sculp:

28
Wenceslaus Hollar

P/P 1420 1st state of six
Etching
1647
In design, upper R: Ætatis 40. 1647
14.0 x 10.1

This self-portrait, done at the age of forty, is
framed in an oval with lobe-shaped ornamenta-
tion and scroll work. In this self-portrait, Hollar
places greater emphasis on his mother's coat of
arms, which is in the field of an escutcheon, than
on that of his father. His mother's family had had
a coat of arms for generations, while his father's
was more recent. After his father was knighted by
Rudolph II, he could add "of Prachna" after his
name. Prachna, a castle near Hrazdovice, is
depicted in the coat of arms (see cat. no. 51).
Pennington views the fact that a Roman Catholic
emperor awarded this favor to the Hollar family as
a reason to assume that Hollar came from a Cath-
olic family. This contradicts most biographers,
who have good reasons to assume that Hollar
came from a Protestant home. In the second issue
of this self-portrait, Hollar substituted the family
coat of arms for that of his father. The copper
plate was passed from country to country. The
publisher of the fourth edition was Dutch, while
the sixth edition, dated 1739, was published by a
Frenchman.

Two self-portraits of Hollar are known for cer-
tain: P/P 1419 in *Images de Divers Hommes d'Esprit
Sublime* (cat. no. 51), and this one. Following
Vertue, Pennington suggests a third possibility,
Man with a Pointed Beard (P/P 1649), which does
bear a striking resemblance to portraits of Hol-
lar.[29] Moreover, both Barlow and Gaywood cop-
ied the print. John Aubrey and Francis Place
described some of Hollar's idiosyncracies. Aubrey
noted, "He was a very friendly goodnatured man
as could be, but shiftlesse as to the world, and
dyed not rich." Also, "He was very shortsighted

. . . and did work so curiously that the curiosity of
his work is not to be judged without a
magnifying-glass. When he took his landscapes,
he, then had a glasse to help his sight."[30]

29
Portrait of Edward Benlowes
by Francis Barlow (1620–1704)
Le Blanc, 115
Etching
1652
28.3 x 18.3

This portrait of the author Edward Benlowes
(1603?–1676) is striking for the use of the
baroque cartouche. Scrollwork, acanthus leaves,
and escutcheons in the lower corners are pulled
out of shape, and the loose manner of etching
lends a somewhat frivolous aspect to this portrait
of the religious author. This work was intended
for the title page of *Theophilia or Love's Sacrifice, a
Divine Poem,* in which the author, who had con-
verted to Protestantism, expressed his mystical
feelings.

Hollar also had connections to Benlowes. He
designed an ornamental border for Benlowes'
poem "Sacred Contentment" (P/P 2568).

30

The Holy Family
after Pierino del Vaga (1501–1547)

P/P 134
Etching
1642
In design, upper L: Perino del Vago inu: / Wenceslaus
Hollar Bohem, fecit Londini 1642 / Ex Collectione
Arundeliana / Cum Privilegio Regis
Below: VIRO PRESTANTISS:ᵐᵒ DNO: HIERO-
NYMO LENNIERO, etc. OMNIUM BO: / naurm
Artium et Elegantiarum Fautori et admiratori summo,
utq earum amantissimo, ita sibi / devinctissimo, grati-
tudinis ergo. D:D:D / Wenceslaus Hollar, Bohemus,
etc.
Lower R: H. Van der Borcht excudit.
21.0 x 15.9
21.5 x 16.5

In 1655, one year after the death of Aletheia,
Countess of Arundel, an inventory of her posses-
sions was drawn up in Amsterdam. Over the pre-
ceding years she occasionally had to sell works of
art from the collection of her late husband. The
original inventory has been lost, but a copy of it,
published in 1911, was not arranged in any par-
ticular order and appeared in Italian. Mary Her-
vey later arranged the inventory by artist.[31]

The following works by Pierino del Vaga were
specified in the 1655 inventory list of the Arundel
collection: *Madonna and Child*; *John and St. Ann*;
Dancing Cupids; two cartoons with arabesques and
a girl; *Acis and Galatea* (chiaroscuro); and five
watercolor cartoons with Jupiter.

The only print known by Hollar after Pierino
del Vaga was this *Holy Family*, published in Ant-
werp in 1644, the year that Hollar and his col-
league and friend Hendrik van der Borcht fled
from England to The Netherlands.

Pierino del Vaga (Pietro Buonaccorsi) was a stu-
dent of Ghirlandaio in Florence. In Rome he
joined the circle around Raphael. He was quite
prolific, particularly in the field of decorations.

31
Four Classical Figures
after Andrea Mantegna (1431–1506)
P/P 465
Etching
1638
Below: Andrea Mantegnio inu: W:Hollar,:fecit 1638.
Secundum Originale quod conservatur in Ædibus
Arundelianis Londini,
25.8 x 18.5
28.4 x 20.3

This print shows a story from antiquity, in which
a bearded, naked man humbly puts a sheep's head
on an offering table. Another naked man, holding
a spear and a shield, looks on. The two other fig-
ures may be Mars and Minerva, who holds in
front of her a shield with the image of Medusa's
head.

Andrea Mantegna, on whose work this print
was based, was one of the most influential
painters of fifteenth-century Italy. He harbored a
predilection for reproducing and accentuating
perspective and depicting figures in difficult, fore-
shortened positions. His art, with its definite
graphic character, belied his preference for Roman
art, strong traces of which are found in his paint-
ings and prints. Much of his work has been lost.
Best preserved are the frescoes in the Palazzo
Ducale in Mantua.

Arundel greatly admired Mantegna, particularly
the way he conveyed the power and glory of the
Gonzaga family in the Camera degli Sposi in the
Palazzo Ducale. Considering himself no less wor-
thy than one of the most famous families in Ital-
ian history, the earl commissioned Anthony van
Dyck to paint a family portrait of Arundel, his
wife Lady Aletheia Talbot, and their grand-
children based on the portrait of the Gonzaga
family by Mantegna. The project was never real-
ized, however, because Van Dyck died pre-
maturely. Philips Fruytier provided a stiff painting
that did not radiate with expressive power.

Of sixty prints that Hollar produced in the

Andrea Mantegnio inu: W. Hollar, fecit. 1638. Secundum Originale quod conservatur in Ædibus Arundelianis Londini.

period from 1637 to 1641, only four are marked with the words "in Ædibus Arundelianis" (in the house of Arundel) (cat. nos. 31, 32, 42, and 81). He was particularly busy with copying the collection in drawings. Hollar did at least fifty-nine drawings, for which he had been contracted. This is clear from the fact that later, during his time in Antwerp, Hollar documented his prints after these drawings with the words "Ex Collectione Arundeliana." In 1646 and 1647, when part of the collection was in Antwerp, he reproduced fourteen paintings and twelve drawings from it.

In the 1655 inventory list of Arundel's collection, two works by Mantegna are mentioned: *Apollo in his Chariot of the Sun God* and *St. Augustine*. Two etchings that Hollar did after Mantegna, *The Sacrifice* and a design for a chalice (cat. no. 42), are not mentioned.

32
Seleucis and his Son
after Giulio Romano (1499?–1546)
P/P 527
Etching
1637
In design, under throne: Iulio Romano in: / WHollar, fecit, 1637
Below, L: Exoculandus erat. severa lege SELEVCI, / Qui commisiβet, crimen adultery / Vnicus est Patri delatus fisius, huius / Qui plane arguitur, criminis eβe reum.
ILLUSTRISSIMO et EXCELLENTISSIMO DOMINO, DNO: / Summo Angliæ Marescallo, & Nobilissimi Ordinis Gartery Equiti, & / Clementissimo, Hanc tabulam a Iulio Romano olim delineatam, nunc vero / insculptam, Wenceslaus Hollar, Bohem,: humillime dedicat
Below, R: Fisius ambobus ne privaretur ocellis, / En Pater indulgens, eruit ipse suum / Iustitia exemplum adsectus simul atgs paterni. / Quo pascas oculos, quodg irniteris habe, / Henr: Pechamus
THOMÆ HOWARD, COMITI ARUNDELLIÆ, ET SURRIÆ, & / Artis Picturæ amatori, collectori, ac promotori maximo, Dno suo / in Ædibus Arundelianis Londini conferuatam, et fecundu originale hic / consecratq. Londini. Anno Domini, MDC: XXXVII,
28.0 x 37.1
28.5 x 37.7

Seleucis and his Son is not mentioned as a drawing or painting in the 1655 inventory. The following six works, however, are included in a section under Giulio Romano: *Hylas Pulled by Three Water Nymphs*, *St. Catherine*, *The Resurrection of Christ*, *Mars and Venus*, *Christ at the Scourging Post*, and *Madonna*. For this print, one of the first that Hollar did for Arundel, he probably used a drawing in the Arundel collection as a model. The original is a fresco in the Palazzo del Té in Mantua. One special feature of the etching is the reference to Hollar himself, who places his name in the same line as that of Giulio Romano, both of whose names appear on the dais on which Seleucis is sitting. The print also shows that Arundel considered himself as the restorer of the values of the Renaissance court. In the inscription he is mentioned as the greatest admirer, collector, and patron of the arts. The "message" of the image—Seleucis as ruler and father—is expressed in a poem in Latin by Henry Peacham. Seleucis (358–280 B.C.) was a ruler in Asia Minor whose son was found guilty of adultery. Punishment for this crime was the loss of both eyes. Although Seleucis had the power to repeal the sentence, he allowed one of his son's eyes to be removed to show that parental love should not pervert the application of justice. The story underscores the wisdom of the satrap, and many a ruler took heed of this tale, as did Arundel.

This print is unique in its execution, size, and inscription, and was probably meant to be the first and the last print in a publication undertaken concerning the Arundel inscriptions.

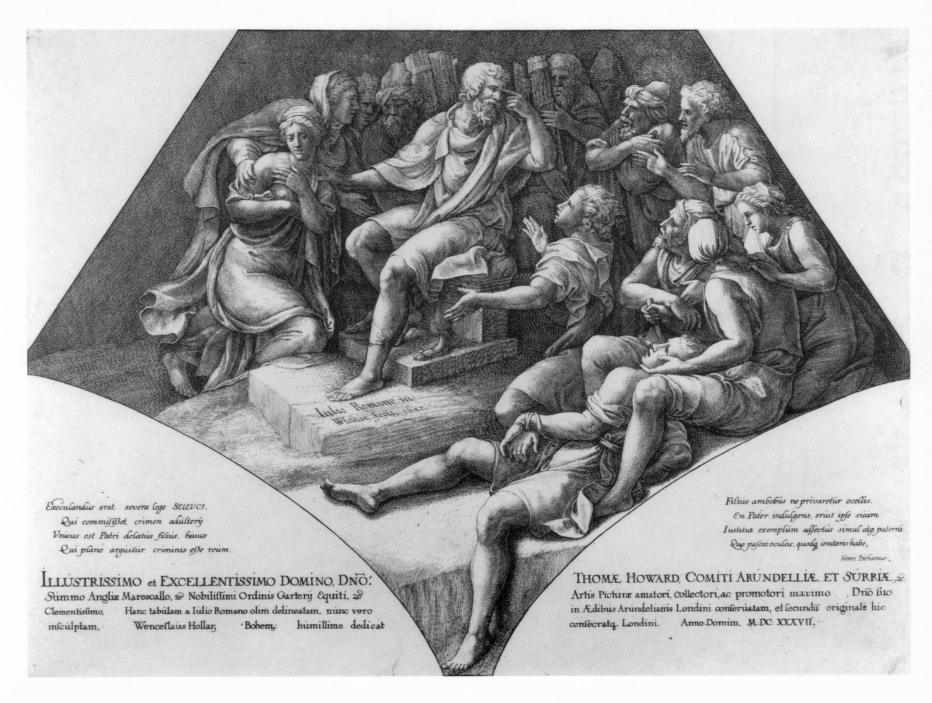

Iulio Romano in.
W.Hollar fecit 1637

Exoculandus erat. severa lege SELEVCI.
 Qui commisißet. crimen adulterij
Vnicus est Patri delatus filius. huius
 Qui plané arguitur. criminis eße reum.

Filius ambobus ne privaretur ocellis.
 En Pater indulgens, eruit ipse suum
Iustitia exemplum adfectus simul atq paternu
 Quo pascas oculos, quodq imiteris habe,

Henr: Pechamus.

ILLUSTRISSIMO et EXCELLENTISSIMO DOMINO, DÑO:
Summo Angliæ Marescallo, ꝟ Nobilissimi Ordinis Garterij Equiti, ꝟ
Clementissimo, Hanc tabulam a Iulio Romano olim delineatam, nunc vero
insculptam, Wenceslaus Hollar, Bohem: humillime dedicat

THOMÆ HOWARD, COMITI ARUNDELLIÆ, ET SURRIÆ, &c
Artis Picturæ amatori, collectori, ac promotori maximo , Dñõ suo
in Ædibus Arundelianis Londini conseruatam, et secundũ originale hic
consecratq. Londini. Anno Domini, M.DC.XXXVII,

67

33

Spring

P/P 614 2nd state of three

Etching

1644

On window frame: W. Hollar fecit

Below: SPRING

The Spring like to a Virgin fully growne / Stands heere,
or like an Early Rose newblowne / Shee's Natures Dar-
ling, and doth make the Earth / Give to the smiling
flowers a happy birth,

Beneath: London, Printed & Sold by Peter Stentt, at
the Crowne in Giltspurr-street, Betweene Newgate &
Pye Corner, A° 1644.

Lower R: 1

16.1 x 12.2

A formal garden is visible through the window. A
basket of roses placed on the windowsill symbol-
izes spring. The woman has a white feather in her
hair and is wearing a dress in the style of the court
of Charles I's wife Henrietta Maria. The dress fea-
tures the characteristic collar laid over the low-
necked dress.

SPRING

The Spring like to a Virgin fully growne | Shee's Natures Darling, and doth make the Earth

Stands heere, or like an Early Rose newblowne | Giue to the smiling flowers a happy birth,

London, Printed & sold by Peter Stentt, at the Crowne in Giltspurr-street, Betweene Newgate & PyeCorner, A° 1644. 1

34

Summer

P/P 615 2nd state of three
Etching
1644
Below: SUMMER
Phebus doth now grow hott, and with bright / By
Courting Summer doth prolong the dayes rayes / Like
Loves plump hills her naked brests lye bare, / Her Fann
protects her from Sunburning ayre
Lower R: 2
16.2 x 12.4

A woman holding a fan stands in front of a window that looks out over a park. Her hair is styled in the fashion of the period.

SVMMER

Phebus doth now grow hott, and with bright | Like Loues plump hills her naked brests lye bare
By Courting Summer doth prolong the dayes | Her Fann protects her from Sunburning ayre

2

35
Autumn
P/P 616 2nd state of two
Etching
Below: AUTUMNE
Autumn doth like a pittying Widdow looke / Vayled in
black to see her fruite downe shoake / And mournes to
behold the faynting Sunn / Forsake her when the
Spring and Sumer's done
Lower R: 3
16.3 x 12.1

Standing before a window, a woman puts on her
gloves. She wears a kind of hood or small cap that
fastens under the chin.

AVTVMNE
Autum doth like a pittying Widdow looke | And mournes to behold the faynting Sunn
Vayled in black to see her fruite downe shoake | Forsake her when the Spring and Sumer's done
3

36
Winter
P/P 617
Etching
1644
Below: WINTER
Cold as the feete of Rocks so Winter stands, / With
Masked face and Muff upon her hands, / Admit the
coverd in warme habitt goe, / Though black without
her skin is white as snowe
Lower R: 4
17.1 x 12.4

A young woman wearing a hood stands facing
left. Her mask protects her face from the raw win-
ter wind. Wearing such masks was originally a Flo-
rentine fashion that was introduced by Catherine
de' Medici. Hollar still attracts many art lovers
with this kind of print. His manner of reproduc-
ing fur and black velvet is inimitable.

This series of half-figures in various seasons was
very successful, and copies of it were published by
Peter Stent in 1644. A series of copies by Pere-
grine Lovell was done three years later, in 1647.
They were printed with and without ornamental
borders.

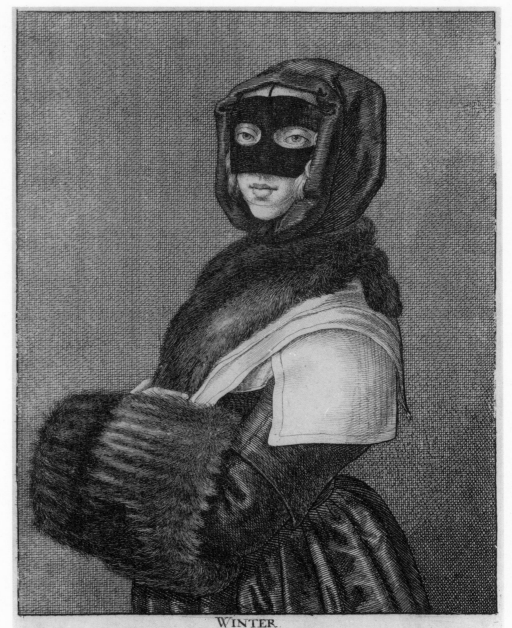

WINTER
Cold as the Feete of Rocks so Winter stands, | Admit she coue'rd in warme habitt goe.
With Masked face and Muff vpon her hands, | Though black without her skin is white as snowe
4

RICHMOND

37

Richmond, copy by H. himself

P/P 1058
Etching
1638
In design, C: RICHMOND
Lower R: W. Hollar fecit 1638
10.9 x 33.2
15.4 x 34.1

This etching of "Richmond" is probably printed from a second plate of the same subject by Hollar. The differences between this version and the so-called authentic one are the absence of a period after RICHMOND, the absence of a comma after Hollar, and the image on the ship's flag becomes a capital letter *G*.

A boat has docked on the shore opposite this palace with its many domed towers. The figures coming ashore are Charles I and his son, the future king James II, Henrietta Maria with Princess Mary, the future princess of Orange, and servants. The palace was built on the ruins of Sheen Manor, and rebuilt and expanded under Henry VIII and Elizabeth I, who died there in 1603. After Charles I was deposed and beheaded, the palace stood empty and was finally razed around 1720. Hollar's preparatory drawing of the central section of the print is in the British Museum.[32]

38

Thomas, Earl of Arundel

P/P 1351 6th state of six, with Peter Stent's address[33]
Etching
1639
In oval: VIRTUTIS LAUS ACTIO
Below: ILLUSTRISSIMUS & EXCELLENTISSIMUS
DOMINUS, THOMAS HOWARDUS, / Howar-
dorum primus, comes Arundeliæ, et Surriæ primus
Comes, & Comes Marescallus Angliæ; Baro Howard,
Mowbray, Segrave Brewes de Gower, Fitz-Alan, Clun,
Oswaldestre Maltravers & Graystock / Iusticiarius'
omnium Forestarum Regis vltra Tentam: locum tenens
Regis in Provincijs de Norfolcia, / Sussexia, Surria,
Northumbria, Cumberlandia, & Westmerlandia,
Nobilissimi Ordinis Gartery Eques: Serenis: / simi
potentissimiq Principis, Caroli, Magnæ Brittaniæ,
Franciæ & Hiberniæ Regis, Fidei defensoris, &c. in
Ang: / lia Scotia, et Hibernia a secretioribus Concilijs,
& ejusdem Regis Supremus & Generalis Militæ Dux,
&c:
Beneath: Hanc Excellentiæ suæ Effigiem, ab Antº:van
Dyck Equiᶜ:Aurº:ad vivum depictam, Wenceslaus Hol-
lar, Bohem, eiusdem Comitis Coelator Aquaforti æri
insculpit Aº 1639, Londini / CVM PRIVILº:
SACRÆ:REGæ:MAIᵗⁱˢ Sould by Peter Stent
26.7 x 18.8
27.1 x 19.1

Arundel probably brought Anthony van Dyck to
England in 1620. Thanks to his extensive range of
acquaintances in The Netherlands, the earl had
long remained current with activities in artistic cir-
cles there. Van Dyck spent just one year in
England, during which time he painted the first
portrait of Arundel and an important historical
piece, *The Continence of Scipio*. In 1622, Van Dyck
met the earl and countess again in Venice, and in
1632, the artist moved permanently to England.
Hollar's print is a detail of the painting that Van
Dyck did in 1635 of Arundel and his grandson
Thomas (the portrait is still at Arundel Castle).
Terribly pleased with the double portrait, Arundel
informed William Petty, his agent in Venice, that
he was forwarding the painting to have a marble
bas-relief done of it by the sculptor François
Dieussart.

Born in 1585, Arundel died in Padua, in exile from the English Civil War, in 1646. Shortly before Thomas' birth, his father was imprisoned in the Tower of London, where he died ten years later, in 1595. Upon James I's accession to the throne in 1603, Arundel's family returned to royal favor, and through the court, Thomas came into contact with Gilbert, 7th Earl of Shrewsbury. Arundel learned much from this avid collector, and in 1606 he married the earl's daughter Aletheia. In the first decade of the seventeenth century, Arundel became an authority in the field of painting, and important figures, such as architect Inigo Jones (1573–1652), considered it an honor to travel with him. The Earl and Countess Arundel received various diplomatic commissions to travel to the Continent. Thomas took advantage of these opportunities to journey to Italy from time to time. Meanwhile, he tried to win the favor of the king in every manner possible. He officially abjured Catholicism, but he had to entrust influence in the political arena to Lord Buckingham, the favorite of Charles I. Arundel's chance to win royal favor came with Buckingham's death in 1628. The political situation completely changed, and around 1630 he finally became a highly esteemed favorite of the king. He was sent on various missions, including the one to Vienna in 1636 that proved crucial to his position as a patron of the arts. Arundel met Hollar during that journey, which was to ensure the succession to the Palatinate of the son of Charles I's sister, Elisabeth of Bohemia. Although these missions were political failures, Arundel's reputation grew. During the turbulent years leading up to the Civil War, he was entrusted with the mission of accompanying to France the mother-in-law of Charles I, Maria de' Medici. Arundel understood that the king's power was finished, and soon he and his wife moved to the Continent, taking with them a large number of his art treasures. After his marriage fell apart, Aletheia stayed in The Nether-

lands, and Arundel himself lived miserably for four years in Padua, where he died in 1646.

In Antwerp, Hollar did another version of this same portrait (P/P 1353, see cat. no. 81). This portrait is not set in an oval, and the hands are visible.

39

Henrietta Maria

after Anthony van Dyck (1599–1641)

P/P 1537 1st state of two

Etching

1641

Lower R: Ant: van dyck pinxit, W. Hollar fecit, / 1641

15.5 x 11.6

15.9 x 11.9

Between 1632 and 1640, Henrietta Maria posed
for Anthony van Dyck at least twenty-five times.
With portraits of important individuals, copies
were made immediately in the forms of prints,
paintings, and drawings. Five variations of this
painting are known to have been made by Van
Dyck himself.[34] Hollar's portrait is said to be a
reverse-image copy of a portrait of Henrietta
Maria by Johannes Meyssen.[35] It is certain that
no engraver portrayed the unpopular queen so
attractively. It appears that in all cases Hollar lost
himself in the desire to "beautify," as though he
deliberately did not want to see the unpleasant
side of people and events. This small portrait
remained unfinished, even in the second edition,
where the number "13" was added in the lower
right-hand corner.

40
Sir Philip Herbert, Earl of Pembroke
after Anthony van Dyck (1599–1641)
P/P 1481 2nd state of two
Etching
1642
In oval: V N' IE SERVIRAY
Below: THE RIGHT HONOURABLE SIR PHILIPP
HERBERT, Knight, / Earle of Pembroke & Montgom-
ery, Baron Herbert of Cardiffe & Sherland, Lord / Parr
& Rosse of Kendall, Lord Fytz-hugh, Marmyon &
Saint Quyntin, Lord Lieu / tenant of Wyltes, Hamp-
shire & the Ile of Wight, Glamorgan, Monmouth,
Breck / nock, Carnarvon & Merioneth, Chancellor of
the University of Oxford, Knight / of the most noble
order of the Garter & one of his Mai:ᵗⁱᵉˢ most hono:ᵇˡᶜ
privy Councell etc.
Beneath: London printed and sould by Peter Stent at
the Crowne in Gilt Spur Street / betwixt new Gate and
pie Corner
Lower L: Sʳ. Antoni van dyk pinxit. W. Hollar fecit
26.9 x 18.7
27.1 x 19.1

The British Museum collection has a pen drawing
with wash that Hollar did in preparation for this
print.³⁶ No painting by Van Dyck is known as a
direct model for this print.

The 4th Earl of Pembroke succeeded his
brother William Herbert to the title (see cat. no.
13). Although he was a favorite of James I and
served as chancellor of Oxford University, Philip
Herbert was not nearly so upright and popular as
his brother. People turned against him because he
yielded to the demand for parliamentary reforms.
In Oxford a statue of him stands in the Bodleian
Library, and Pembroke College bears his name.

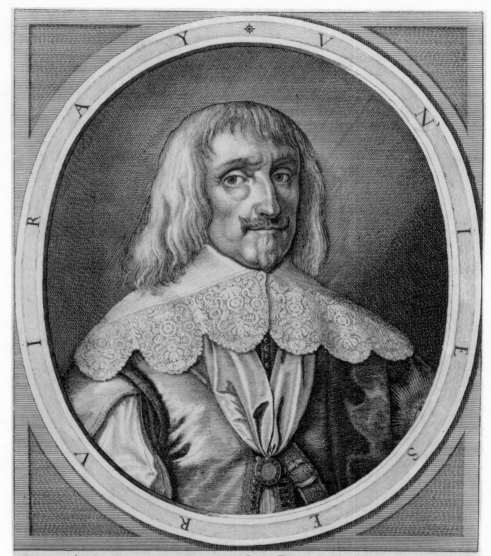

THE RIGHT HONOVRABLE SIR PHILLIP HERBERT Knight
Earle of Pembroke & Montgomery, Baron Herbert of Cardiffe & Sherland, Lord
Parr & Rosse of Kendall, Lord Fytz-hugh, Marmyon & Saint Qvyntin, Lord Lieu
tenant of Wyltes. Hampshire & the Ile of Wight, Glamorgan, Monmouth, Breck
nock, Carnarvon & Merioneth, Chancellor of the Vniversity of Oxford, Knight
of the most noble order of the Garter & one of his Maiᵗⁱᵉ most honoᵇˡᵉ privy Councellᵉ
London printed and sould by Peter Stent at the Crowne in Gilt Spur street
betwixt new Gate and pie Corner
Sʳ Antoni van dyk pinxit. W. Hollar fecit

41
Charles II as the Prince of Wales

P/P 1436 2nd state of two
Etching
1641
In oval: 1641
Below: Charles by the grace of God / Prince of Wales,
Duke of Corn / well, York and Albany borne May 29 /
1630
9.8 x 7.4 (oval)
12.2 x 7.7

This print looks like a sketch due to the oval being
done by hand and the absence of a background
and signature. Hollar is said to have etched this
small portrait using as a model one of the many
portraits of the prince that were in circulation.

This second state was used in the publication
*The True effigies of our most illustrious soveraigne lord,
king Charles, queene mary, with the rest of the royall
progenie* (1641). Hollar did three additional prints
for this publication: *Queen Henrietta Maria* (P/P
1416), *Charles I* (P/P 1433), and *Mary Princess of
Orange* (P/P 1467).

During the Civil War, this small print appeared
in pamphlets that challenged the royal status of
Charles II.

42
A Chalice
after Andrea Mantegna (1431–1506)

P/P 2643
Amsterdam 1988, no. 605
Etching
1640
Below: Tabulam hanc olim ab ANDREA MANTENIO
cum penna delineatam, et nunc / Londini in Ædibus
Arundelianis conservatam, Wenceslaus Hollar, Bohem,
aqua forti æri insculpsit, 1640
46.0 x 24.0
46.4 x 24.2

After the death of his wife and heir in 1654, much
of Arundel's collection was sold by her son Lord
Stafford. Even though Lady Aletheia had been
forced to sell objects from the collection, it still
contained more than 2,000 drawings, many of
which were devoted to architecture and the
applied arts, such as table ornaments by Giulio
Romano and studies for ornaments by Hans Hol-
bein. Arundel loved architecture, sculpture, and
the applied arts. He opened his collection to
architects and other artists so that they could learn
and become inspired by it.

In this print after Mantegna's drawing for a
chalice, Hollar attempted with great dedication to
express the complexity of such an object.[37] The
life of Christ is shown in the band of the chalice.
Its base was designed according to Arabic/
Moorish pattern. Halfway up the stem, the apos-
tles appear in niches and are surmounted by
cupids. The drawing is now in the British
Museum (inv. no. 1893.7.31.20).

Tabulam hanc olim ab ANDREA MANTENIO cum penna delineatam, et nunc
Londini in Ædibus Arundelianis conservatam, Wenceslaus Hollar, Bohem, aqua forti æri insculpsit

43
Greenwich
P/P 977 4th state of four
Hind 1922, no. 20
Paris 1979, no. 104
Etching
1637
In design, top: GRÆNWICH
In cartouche: Ad ripas Grenovica his THAMESIS /
Alluit Angligenum Regalie fecta Monarche / Que situe
que forma decuq. virentia septa / CJoncelebrant totum
longe latio per orbem / Behould, by Prospect with
what art . . . how they ly.
Beneath: W Hollar fecit
Lower L: London Printed and Sould by Peter Stent at
the Crowne in Giltspur street betwixt new Gate and pie
Corner.
15.4 x 83.1
15.4 x 84.4

This masterfully handled view of Greenwich consists of two plates printed next to each other. Hollar reproduced the meandering river with its ships, the distant towers of London, and the low line of hills in the distance not only with great craftsmanship but also somewhat dreamily. As one of his first major works in England, this prestigious print was intended to impress those who had given him the commission. The print is also interesting because of its text. The first state had a long dedication from Arundel to Queen Henrietta Maria, but that text was soon replaced by a few meaningless lines by the poet Henry

Peacham.[38] Few prints of the first edition are known. Hollar and his publisher were apparently afraid that the unpopularity of the court would hamper sales of the print.

The house on the hill to the left is Duke Humphrey's Tower, built in the time of Henry VIII on the site of an old tower. The structure was rebuilt in 1675 and used as an observatory by John Flamsteed, the first royal astronomer. It is still in use as an observatory. At the center stands Queens House, begun in the time of James I and, according to some, partially completed by Inigo Jones in 1635 for Henrietta Maria. This is Hollar's earliest dated view of London.

44
Dover

In his 1853 publication, Gustav Parthey placed these three etchings of Dover in a series of sixteen English views (P/P 921–936). These small prints, all in the same format, feature views of Jersey, Dover, Plymouth, and Calais. It is unclear when these etchings were done. The various suggested dates differ by as much as ten years. The etching of Dover is dated 1642, which does not coincide with Hollar's departure from England, when he probably journeyed to Antwerp through these islands. Two prints of Elisabeth Castle, Jersey (P/P 923 and P/P 924) are dated 1650 and 1651. The Channel Islands were in royalist hands at that time, and many people stopped there on their travels to The Netherlands.

The original publication date is also unknown, but after Hollar's return to England in 1652, the prints were published as a group under the title "Divers Vieuws / after the Life By / W. Holler / P. Tempest exc:." Initially, it was believed that Hollar had been part of the retinue of Charles II, which had lived on the islands from September 17, 1649, to February 13, 1650. Since Hollar had left England in 1644, it is more likely that, given his habit of working at all times and places, he had done these drawings on his journey to Antwerp and had made prints of them once back in England.

44A
Dover Cliff

P/P 926
Etching
In design: The Clyff of Dover from Sea
5.7 x 13.2
6.0 x 13.5

The chalk cliffs jut out into the sea. Six merchant ships lie at anchor, and a two-master sails to the left.

44B
Dover Cliff

P/P 928
Etching
In design: The Clyff of Dover
Lower R: W Hollar fecit
5.8 x 13.2
6.3 x 13.6

People look out from the cliff from an improbably high standpoint. To suggest distance, the foreground includes sloping, hatched lines that range from darker to lighter. The ships along the coast are in the same position as those in cat. no. 44A.

44C
Dover

P/P 929 1st state of two
Etching
1642
In design: Dover
Lower L: W Hollar fecit 1642
5.8 x 13.2
6.1 x 13.5

In this etching Hollar used every motif possible to convey tension in the landscape. In the left foreground a fantastically shaped boulder stands as a side scene. Two small figures point to the next level, where promenaders look out over the sea and the town rooftops. The whole scene is etched in rather dark shades of gray, yet the castle in the background stands in full sunlight.

The Clyff of Dover from Sea

The Clyff of Dover

Dover

The Winter habit
of ane English Gentlewoman.

45
English Lady in a Winter Costume
P/P 1999
Etching
1644
Lower L, in design: Hollarfecit 1644
Below: The Winter habit / of ane English
Gentlewoman.
13.6 x 6.1
14.2 x 6.8

While this print is not part of a series of seasons or costumes, all the accessories that Hollar used repeatedly in images of winter are here: the muff, feather fan, mask, cape, and stole. Hollar did a series of seasons with women shown full-length (P/P 606–609), for which this may be a preliminary exercise. It is interesting to see how efficiently Hollar worked with the few "props" he owned.

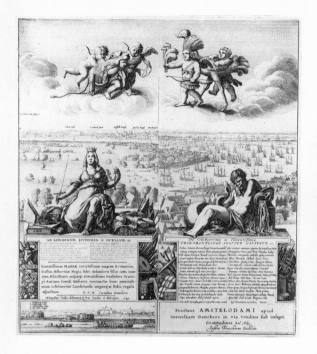

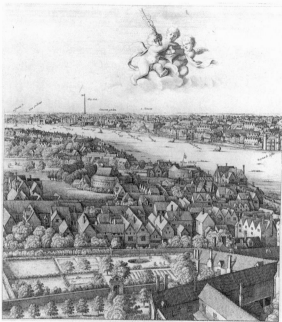

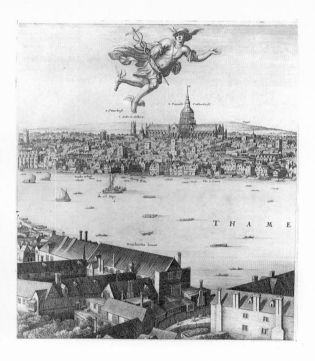

46
The Long View of London

This large aerial view of London, done in 1647, consists of six plates, each measuring 46.2 x 39.2 cm. One of the plates contains the two end views, so that after cutting, the panorama should consist of seven scenes. For the sake of clarity, the numbers 1 through 7 are used in describing the sheets, which were printed separately. A cartouche bearing the title "LONDON" appears in the middle of print 4. Latin verses appear on print 1, under which is a dedication to Princess Mary of Orange, the sister of Charles II and the mother of William III, that is signed by the publisher, "Cornelius Danckers." A female figure with a crown and a sword, surrounded by symbols of trade, represents the "Nympha Brittanica," and the ensemble is completed with Hollar's signature— "Wenceslaus Hollar delineavit, et fecit Londini et

Antverpiae, 1647''—which means "Wenceslaus Hollar drew (this) and did it in London and Antwerp, 1647.'' It is interesting to note that the preliminary drawings of the prints were probably done in London, and most of the etchings were produced in Antwerp, where Hollar had fled following his patron Arundel and his collection.

In addition to his own observations from or in the vicinity of St. "Mary Overy," Hollar used an etched view of London by Jansz. Visscher dated 1616. Experts do not consider either etcher reliable, although both do seem to have given a fair representation of how the city looked before the Great Fire of 1666. This view of London by Hollar runs from the west, through Whitehall and Westminster Abbey, to the east past St. Catherine's. A large area with fields and gardens is visible to the west of Winchester House. On the left initial print, Hollar placed at the bottom a small

image of Tothill Fields (see also cat. no. 118), which clearly lies to the west of the edge of this panorama.

As can be seen from the print, London before 1666 consisted mainly of Gothic buildings, with the exception of Banqueting Hall at Whitehall by Inigo Jones and the classical additions to St. Paul's. Between Westminster and Blackfriars, along the north bank of the Thames, were the delightful houses of the upper nobility, as well as the royal palace of Whitehall (see also cat. no. 49). The most important of these houses are included in this print. From west to east, names are provided for Suffolk House (later called Northumberland House), and then York House, which later became the property of George Villiers, Duke of Buckingham. He had a new building erected there, of which now only a water gate remains at the end of Buckingham Street. The

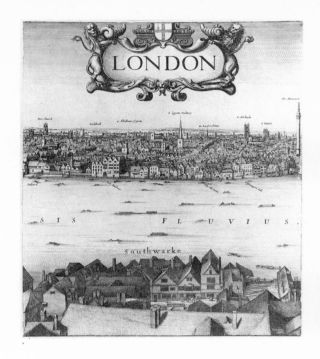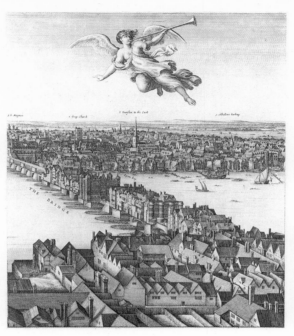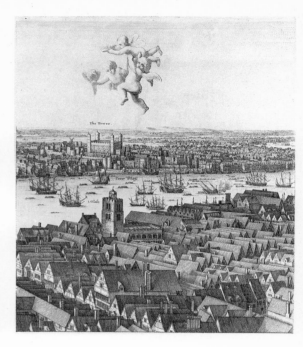

next large structure is Durham House, once the residence of Sir Walter Raleigh, and Arundel House, where Hollar lived as a member of Lord Arundel's household. Then come Essex House and Baynard's Castle (built in 1428 by Humphrey, Duke of Gloucester). The "New" or Royal Exchange, a popular shopping district from the Restoration until the end of the reign of Queen Anne, was built in 1608–1609 on a section of land attached to Durham House (see also cat. no. 114). On the print it is marked "E: Salisbury House," probably through an oversight.

The Globe Theater shown on the print is not the famous theater associated with William Shakespeare, although it does date from that era. Immediately nearby is another sort of theater, the "Beer baything house," where the atrocious sport of "bear baiting" was undoubtedly held. The fishers' boats and the "eel ships" on plate 3,

opposite Winchester House, can still be seen under London Bridge. They are moored in the Thames as a symbol of the established right of Dutch fishermen to sell eel at Billingsgate.

The old St. Paul's Cathedral is shown with its cupola in plate 3. The top of the tower was struck by lightning and destroyed by fire in 1561. The construction of the temporary roof seems to have been quite unreliable (see cat. no. 113). The handsomely decorated houses in the middle of London Bridge in plate 5 form Nonsuch House. In the last plate are thirty-four Latin verses by Edward Benlowes (see cat. no. 29), with the address of the publisher, Danckers, below: "Prostant Amstelodami apud Cornelium Danckers in via Vitulina sub insigni Gratitudines An 1647" (In Amsterdam, at Cornelis Danckers' on Mortar Street at the sign of the "Gratitudines").

Hollar performed an enormous service for subsequent generations with this masterpiece. Without this panorama and the detailed prints that Hollar made of many buildings in London, we would have little visual evidence of what London looked like in the turbulent times of Charles I, Cromwell, and Charles II, when England experienced revolutions from monarchy to republic and finally back to monarchy. The panorama as it appears here is a second edition from 1661 by Justus Danckerts, the son of Cornelius Danckers. Hollar updated some of the plates: in plate 2 he included the maypole; in plate 3 the tower of St. Paul's is replaced by a dome; and in plate 4 the monument was added. In plate 7 the year "1647" is replaced with "1661." The publisher added his address under the year.

83

46/1

London. The long view: The left end of the panorama

P/P 1014(a)

Etching

1647

In design, C: names of buildings, including "white-hall, Scotland Yard, suffolk house, yorke house"

In design, on book: LEX

In design, on pillar: AD LONDINUM EPITOMEN & OCELLUM (followed by sixteen lines of Latin text)

Serenißimæ MARIÆ invictißimæ magnæ Britanniæ, / Galliæ, Hiberniæ Regis, fidei defensoris filiæ natu max = / imæ, felicißimis auspicijs Potentißimo Guilielmo Princi = / pi Auriaco, Comiti Naßavio coniunctæ hunc amoenißi = / mum celeberrimi Londinensis emporij ac fedes regalis / aspectum. D.C.Q. Cornelius Danckers.

Below: Wenceslaus Hollar delineavit et fecit Londini et Antverpiæ, 1647

In view, below: 1. Parliament house / 2. Westminster Hal / 3. Westminster Abby / 4. the Cloke house

and

46/7

London. The long view: The right end of the panorama

P/P 1014(g)

Etching

1647

In design, on pillar: De Celeberrima & Florentissima / TRINOBANTIADOS AUGUSTÆ CIVITATE (followed by thirty-four lines of Latin text)

Below: Prostant AMSTELODAMI apud / Cornelium Danckers in via vitulina sub insigni / Gratitudines An? 1661 / Justus Danckerts Excudit.

46.2 x 39.2

47.3 x 39.4

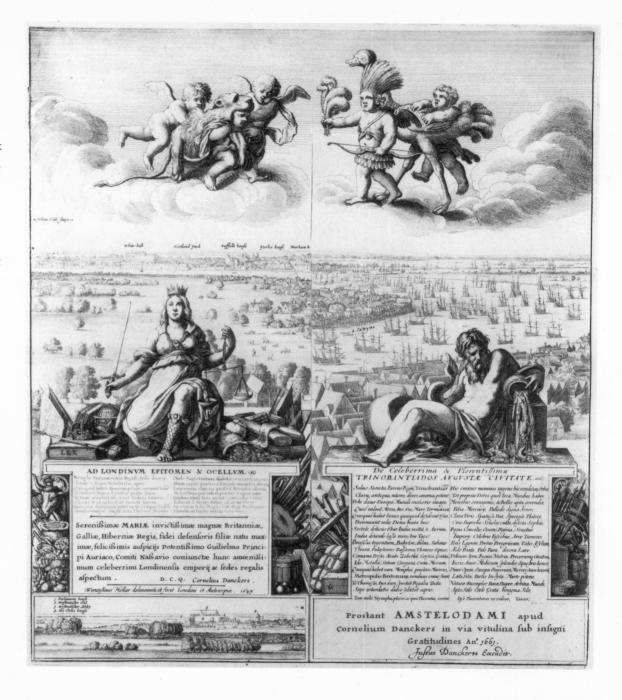

46/2
London. The long view: View of the west bank from "Salsburry h." just west of the Savoy to Baynard's Castle.
P/P 1014(b)
Etching
1647
46.2 x 39.2
47.3 x 39.4

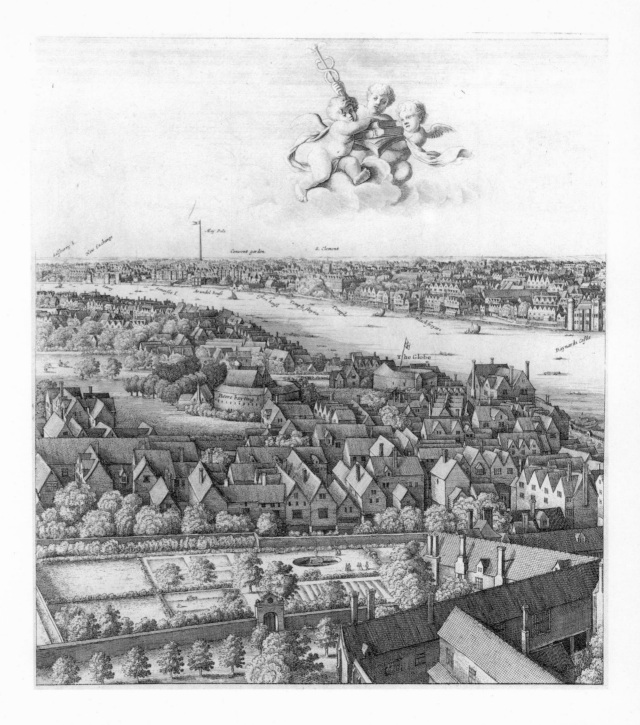

46/3

London. The long view: View of the city from Baynard's Castle eastward to Stilliards.

P/P 1014(c)

Etching

1647

46.2 x 39.2

47.3 x 39.4

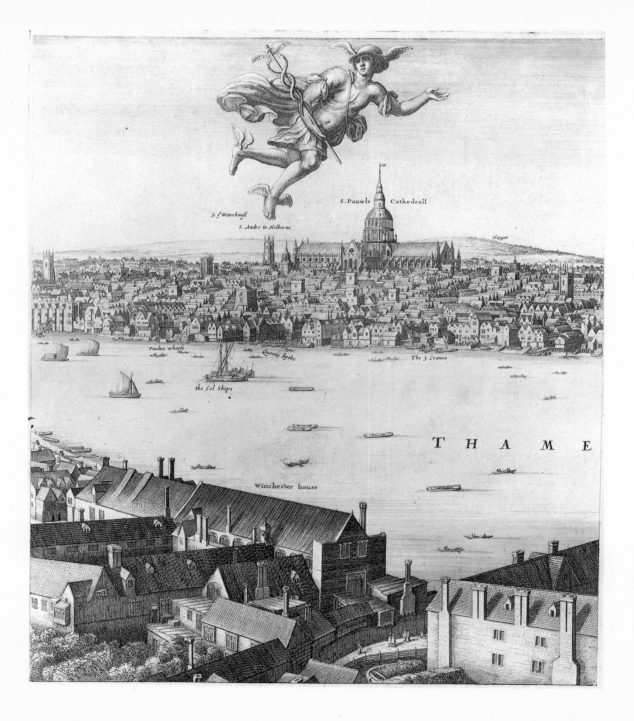

46/4

London. The long view: View of the city from "Boo Church" eastward to "S. Petris."

P/P 1014(d)

Etching

1647

46.2 x 39.2

47.3 x 39.4

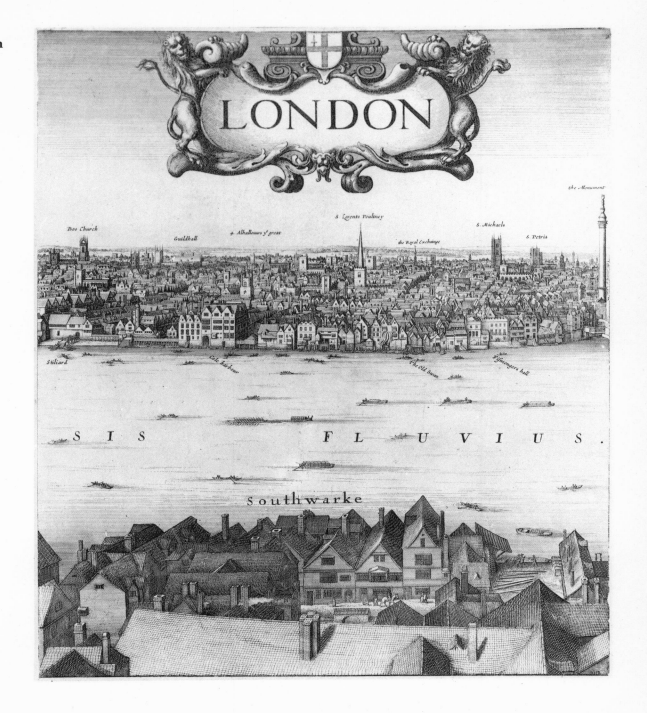

46/5

**London. The long view: View of London
Bridge and of the city to the east.**
P/P 1014(e)
Etching
1647
46.2 x 39.2
47.3 x 39.4

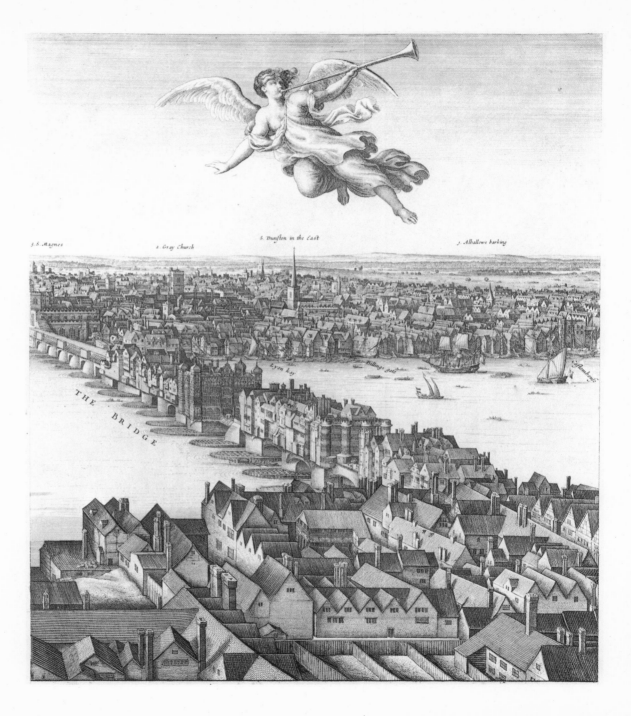

46/6
London. The long view: View of the Tower and the city to the east with part of Wapping on the right.
P/P 1014(f)
Etching
1647
46.2 x 39.2
47.3 x 39.4

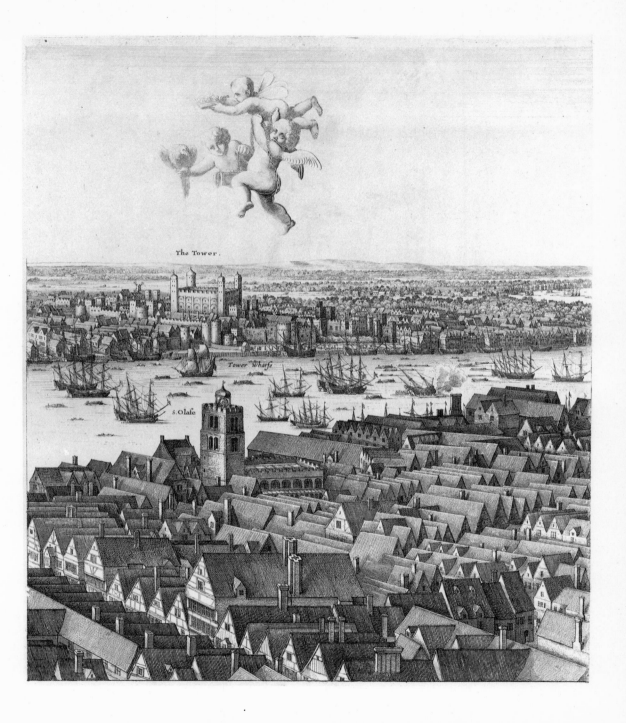

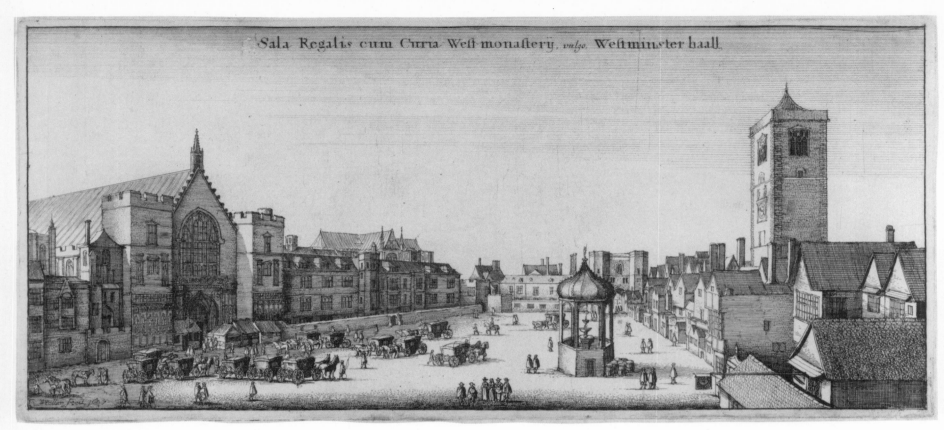

Sala Regalis cum Curia West-monastery, vulgo, Westminster haall.

47

Westminster Hall
P/P 1040 1st state of four
Hind 1922, no. 90
Etching
1647
In design, top: Sala Regalis cum Curia West monastery,
vulgo, Westminster haall
Lower L: WHollar fecit 1647
14.4 x 32.4
15.0 x 33.1

Viewed from the east, Westminster Hall stands to
the left of the New Palace Yard. The clock tower
is to the right, and the palace gate appears at the end
of the square. The gate led out into King Street.

 Behind the houses to the left stand the towers of
Westminster Abbey, with St. Margaret's West-
minster in front of it. Hollar is buried there.[39]
After excavations in 1973, it now seems that the
fountain, which was the only source of open
water now known, was eight-sided, not six-sided,
and stood much closer to Westminster Hall. Dur-
ing great festivals, such as coronations, wine
flowed from all the spouts. Westminster Hall is
the oldest part of the palace that still stands. It
was built at the end of the eleventh century by
William the Red, son of William the Conqueror.
After the thirteenth century, the important tribu-
nals of the Royal Council and the Court of Justice
were held there.

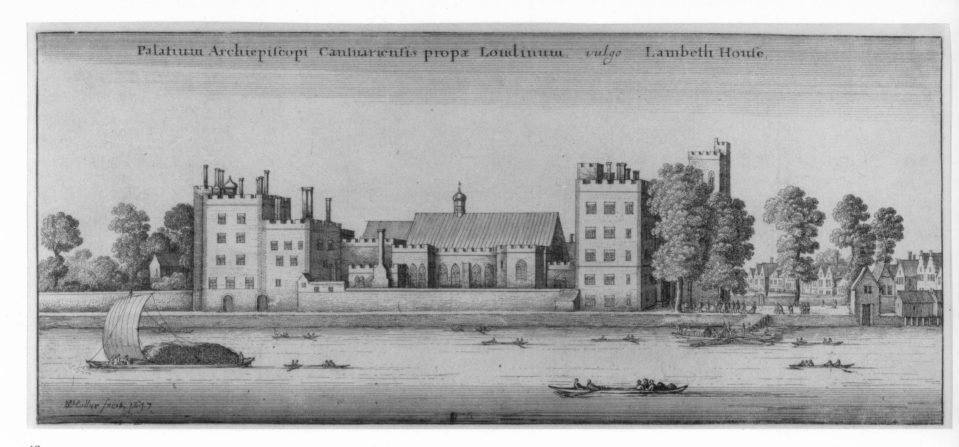

Palatium Archiepiscopi Cantuariensis propæ Londinum, vulgo Lambeth House.

48

Lambeth Palace from the River
P/P 1038 1st state of three
Hind 1922, no. 107
Paris 1979, no. 109
Etching
1647
In design, top: Palatium Archiepiscopi Cantuariensis
propræ Londinum, vulgo Lambeth House
Lower L: WHollar fecit, 1647
14.2 x 32.2
15.0 x 32.9

Built early in the thirteenth century on the south
bank of the Thames, Lambeth Palace was the
London residence of the archbishops of Canter-
bury. Since 1435, Lollard's Tower has stood to
the left, with the gardens next to those that were
laid out in the thirteenth century throughout the
marshy area. The garden provided fruit and vege-
tables to the residents of the palace and the sur-
rounding area. At the center stands the Great
Hall, and to the right, Morton's Tower, which
dates from the 1490s. At the dock to the right,
Bishop Laud and his entourage are going
ashore.[40]

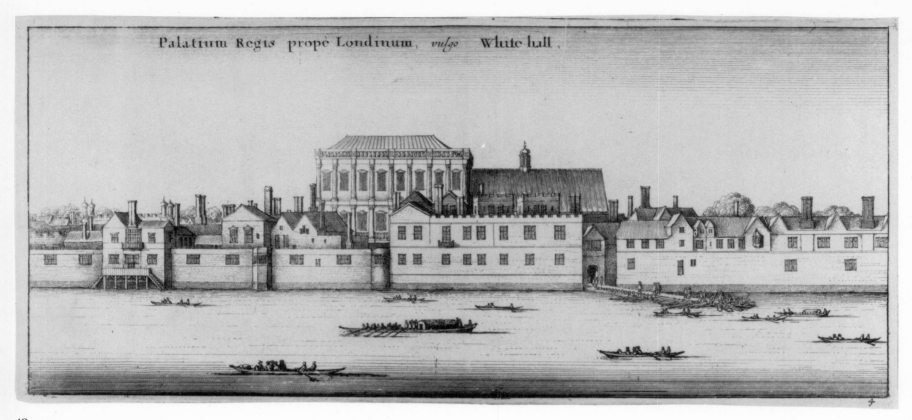

Palatium Regis prope Londinum, *vulgo* White-hall.

49

Whitehall from the River

P/P 1039 2nd state of three
Hind 1922, no. 85
Paris 1979, no. 110
Etching
In design, top: Palatium Regis prope Londinum, vulgo Whitehall
Lower R: 4
14.5 x 32.7
15.2 x 33.2

Whitehall, originally called York House, at one time was the residence of Cardinal Wolsey. After Wolsey fell into disfavor, Henry VIII made it, rather than Westminster Palace, the royal residence in 1530. James I commissioned Inigo Jones to embellish it, but the only structure built was the festival hall (1625). After a fire in 1698, only the Banqueting House, with its ceiling paintings by Rubens that glorify James I, was preserved.

Whitehall was the most important palace for the kings of England from Henry VIII to William III. The Palladian-style Banqueting House dominated the rest of the buildings. This print is number four in a series of four views of London (see also cat. nos. 47, 48). The central portion of a drawing by Hollar in the British Museum corresponds largely to this print.[41]

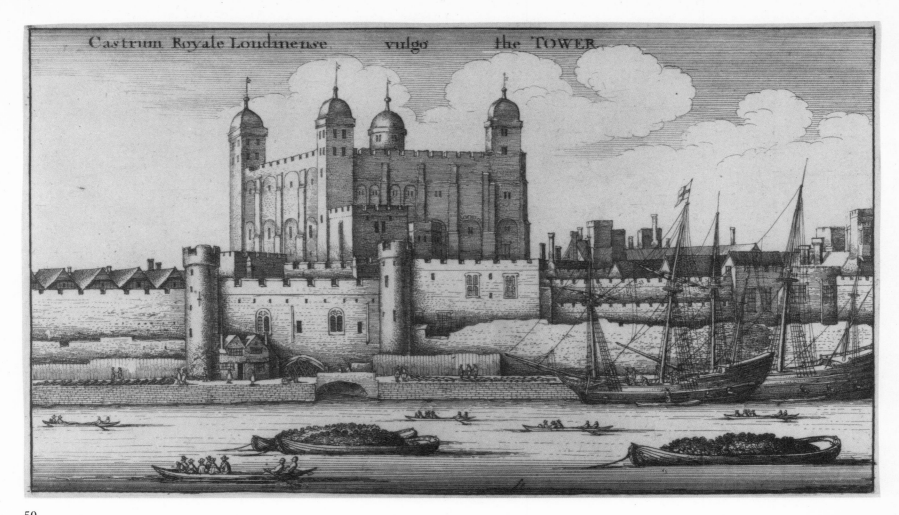

50

Tower of London

P/P 908 1st state of two
Hind 1922, no. 22
Paris 1979, no. 93
Sprinzels 1938, no. 340
Etching
In design, top: Castrum Royale Londinense vulgo the
TOWER
14.2 x 25.2

The Tower, the former royal residence and the state prison, is shown from the Thames, with the White Tower at the center. The oldest section was built in 1078 on orders of William the Conqueror. In the foreground stands Thomas Tower, and the section ends with Traitors Gate. A lightly colored drawing by Hollar with the Tower as its subject is in the British Museum collection. In that drawing, the Tower is seen from a more distant perspective.[42]

51
Wenceslaus Hollar
after Johannes Meyssens (1612–1670)
P/P 1419 1st state of four
Etching
15.2 x 11.4

This is the first state of a portrait intended for
Images de Divers Hommes d'Esprit Sublime, con-
ceived and published by Johannes Meyssens. That
series of prints, featuring portraits of important
artists and academics, was, in fact, a continuation
of Van Dyck's *Iconographia* (see cat. no. 52). Hol-
lar sits before a window that looks out over
Prague. The Cathedral of St. Vitus, a Gothic
cathedral built in the fourteenth century on the
Hradcany, is readily identifiable.[43] In addition to
the tools of a printmaker, Hollar displays a copper
plate with an image of St. Catherine after a paint-
ing by Raphael from the Arundel collection.

Hollar's family coat of arms appears in the
upper left corner. The fourth state of this portrait
was used in subsequent editions as an example in
Het Gulden Cabinet vande edele vrij Schilderkonst
(Antwerp, 1661) by Cornelis de Bie. A long
poem brimming with superlatives about Hollar's
talents appeared in that edition. The author
expands not only on Hollar's relationship with
the muses but also on envy, which stirs the spirits
of others. The story reinforces that Hollar had not
become rich from his work and that he was the
object of *jalouzie de metier*. It also seems that his
fame as an etcher was firmly established during
that period. This series of portraits and texts was
later published in England in 1694 and again in
1739 as *True effigies of the most eminent painters in
Europe*.[44]

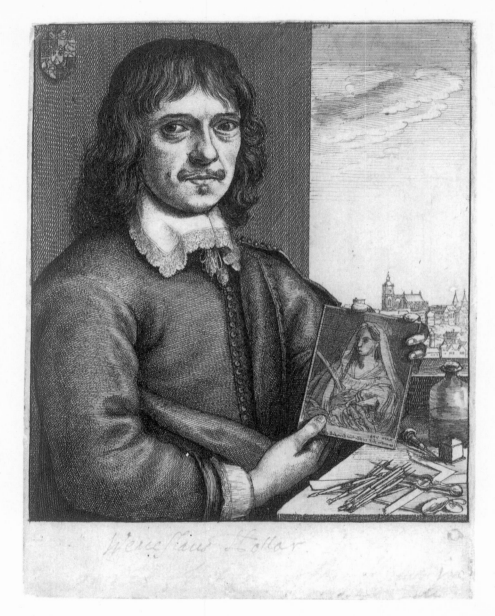

52
Charles II
after Anthony van Dyck (1599–1641)

P/P 1442 4th state of seven
M.-H. 1956, no. 131 IV
Etching
1649
Below: CAROLUS II D.G.: MAGNÆ BRITTANIÆ
FRA.ciæ ET HIBERNIÆ REX etc. natus Aº 1630. /
Hanc Maiestatis suæ Effigiem ab Antonio van Dycke
Equite sic prius depictam, Humillimus Cliens Wen-
ceslaus Hollar, Boh: / Aquaforti æri insculpsit Anno
1649.
Beneath: Ant van Dycke pinxit Io Meyssens excudit.
W: Hollar fecit
22.4 x 17.8
25.1 x 18.7

Hollar produced portraits of Charles II on nine
occasions, from Charles' youth until he became
king. Charles is seen here at age nineteen, stand-
ing in front of a window that looks out over
St. James's Park and Banqueting Hall. Ironically,
Charles spent the greater part of his youth in Hol-
land. On February 16, 1649, seventeen days after
his father's execution, Charles was proclaimed
"Roy Charles Second" in Jersey, and in Scotland
he was proclaimed king on the day of his father's
beheading.

In the second state of the print, Hollar is
announced as the etcher and publisher. In Ant-
werp during this period, Hollar probably wanted
to express his royal affinities through this portrait
and its humble dedication. In the fourth edition,
the print became part of Van Dyck's *Iconographia*
as published by Johannes Meyssens. This indi-
cates that not all the portraits in the *Iconographia*
were initially intended to be used in it. Moreover,
Anthony van Dyck was no admirer of Hollar. He
found that Hollar scarcely did justice to his
portraits.

Iconographia is the title under which approxi-
mately two hundred portraits in prints after paint-
ings by Van Dyck are known. Most of these
works are engravings published in all kinds of edi-

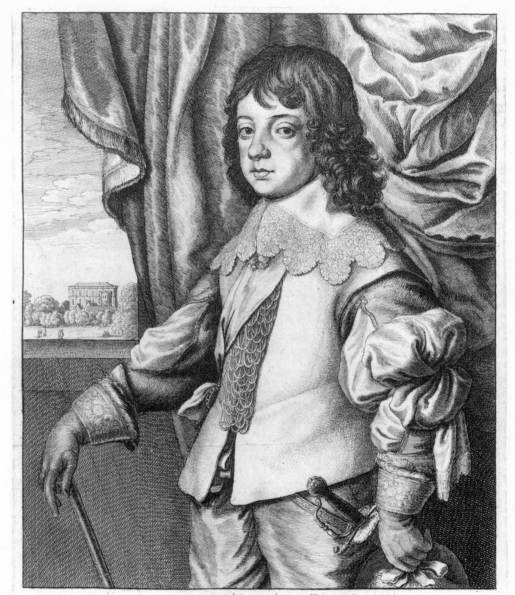

CAROLVS II. D.G: MAGNÆ BRITANNIÆ FRÃ.ciæ et HIBERNIÆ REX etc. natus Æ.1630.

Hanc Maiestatis suæ Effigiem ab Antonio van Dycke Equite sic prius depictam, Humillimus Cliens Wenceslaus Hollar Boh:
v Aqua forti æri insculpsit Anno 1649.

Ant van Dycke pinxit. Io. Meyssens excudit. W: Hollar fecit

tions by various artists. It began with a series of eighteen portraits by Van Dyck in the late 1620s and early 1630s. During the same years he produced another eighty portraits of his contemporaries, at the urging of the publisher Martinus van de Ende (act. 1630–1654). These portraits of artists, monarchs, army commanders, and important scholars and statesmen were published by Van de Ende between 1636 and 1641 (the first eighteen etchings were not included). A few years later, the copper plates and prints came into the possession of the Antwerp publisher Gillis Hendricx (registered in the Antwerp guild from 1643/1644 to 1677). He added to the *Iconographia* fifteen of the eighteen early etchings by Van Dyck, commissioned additional portraits, and in 1645/1646 published a second edition with one hundred prints. Portraits were added regularly in the seventeenth and eighteenth centuries. Finally, in 1851, the Louvre purchased the copper plates, where they remain today.

53
Charles II
after Johannes van Hoecke (1611–1651)
P/P 1440
Etching
1650
Below: CAROLUS SECUNDUS / D.G. MAGNÆ BRITANNIÆ, / FRANCIÆ, ET HIBERNIÆ REX etc.
Lower L: I van Hoecke pinxit W. Hollar fecit, 1650
19.4 x 13.4

The Flemish painter Johannes van Hoecke studied with his father Kaspar as well as with Peter Paul Rubens. He designed the festive decorations for the glorious entry of Crown Prince Ferdinand of Austria into Antwerp in 1635. Although he produced numerous portraits and historical works, Van Hoecke has largely been forgotten over time.

Hollar made this print nearly identical to his portrait of Charles II (P/P 1439). In this larger format copy, Charles has a light moustache. Latin text appears on both sides of the crowned royal coat of arms that is placed inside a garter. The face was completed by another hand, and the burin lines are quite different from the etching lines in the rest of the print.

This portrait is an almost precisely enlarged detail of the standing portrait of Charles II after Cornelis Schut (cat. no. 55).

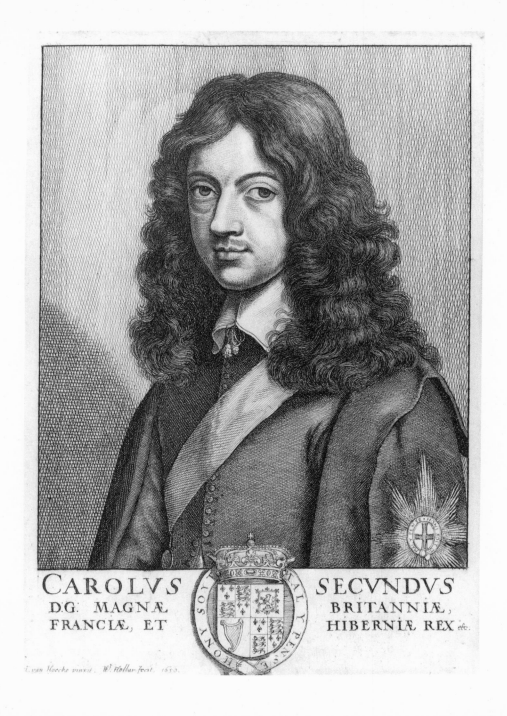

CAROLVS SECVNDVS

D.G. MAGNÆ BRITANNIÆ,
FRANCIÆ, ET HIBERNIÆ REX etc.

I. van Hoecke pinxit. W. Hollar fecit. 1650.

97

54
Charles II
after Abraham van Diepenbeecke (1596–1675)

P/P 1444 3rd state of four
Etching
1650
In design, in the lozenge: REDIVIVO PHœNICI / LUCIFERO NEBULAS FUGANTI, / SOLI TENEBRAS PENITUS ABOLENTI / CAROLO II. D.G. MAGNÆ BRITANNIÆ, FRANCIÆ ET HIBERNIÆ REGI
Tartareæ fugiunt volucres; fugit atra caligo, / Et metus, atque horror sole oriente fugit: / Sic et CAROLIDÆ redijs depulsa recedat, / Inque suam fugiat gens inimica stygem / Te nascente comes Phabo stella aurea fulsit, / Et luce insolita splenduit aucta dies: / Tu geminam flammæ vim prestes (CAROLE) saenos / Vre kostes, populum lumine restituas.
In design, lower L: Abr. a Diepenbecke deli: WHollar fec.
44.8 x 33.3

Numerous symbols refer to the divine power of the prince Charles II. To the left an army is being routed. A goddess with a thunderbolt is chasing after a harpy. The changes after the first edition were not made by Hollar. Subsequent engravers, perhaps Faithorne or Paulus Pontius (1603–1658), brought the portrait up to date by adding a youthful moustache. Also, the figures of the prince and the goddess were completed. Apparently Hollar wanted to portray the king from his second homeland during the difficult years of 1649–1650. The model for this print, a colored drawing by Abraham van Diepenbeecke, is in the Ashmolean Museum at Oxford, England. Van Diepenbeecke worked as a painter, particularly on glass, in Antwerp. He was commissioned by the printer Plantijn to do several etchings after paintings by Rubens, whose style he imitated, particularly in his biblical and historical works.

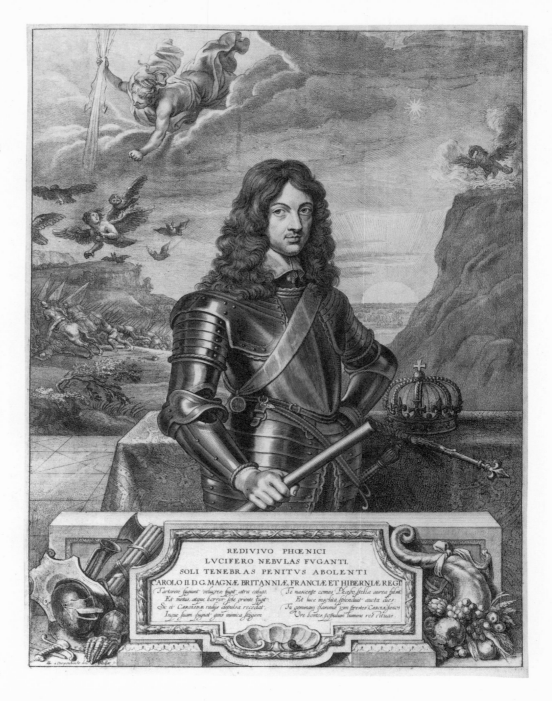

55

Charles II

after Cornelis Schut (1597–1655)

P/P 1445 1st state of three
Etching
1650
In design, lower L: Cornelius Shut inu: W: Hollar
fecit, 1650
Below: CAROLO SECUNDO DEI GRATIA
MAGNÆ BRITTANIÆ FRANCIÆ, ET HIBERNIÆ
REGI. / Quod proculcatam Regiæ Maiestatis digni-
tatem, et abominandæ feruituti mancipatam Patriam:
in vindicationis, et vendicationis spem erexerit. Regiæ
suæ Maiestati Se æternum Vouens Anglia Lachrijma-
bunda exhibet. (followed by three Latin quatrains in
three columns)
50.3 x 37.4

Once again Hollar's royalist proclivities are evi-
dent as he repeatedly depicted Charles II in his
capacity as king. In the texts of these prints, Hol-
lar ascribes to Charles all the honor due a mon-
arch. An allegorical setting devised by Cornelis
Schut further embellishes the portrait of the
twenty-year-old monarch. Charles, standing on a
pedestal and wearing full armor, is being crowned
by Jupiter, who rides an eagle. To the right, Mi-
nerva defends the monarch from the dragon,
which fails to frighten the "Majestas." In the
foreground, the patroness of London is portrayed
with a shield bearing the cross of St. George. Var-
ious small angels busily hold allegorical attributes.
The king's face was engraved with a burin.

Cornelis Schut was a Flemish painter and etcher
who worked in Antwerp. He painted primarily
altarpieces, initially in the style of Rubens, but
gradually his style became more personal. He was
famous for his lively compositions and his fresh
use of color.

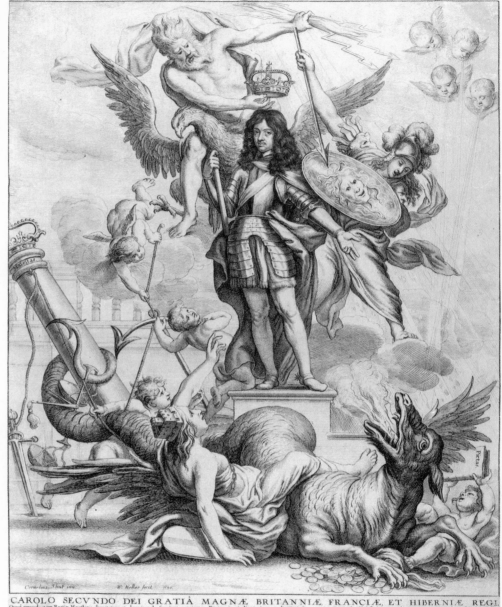

56
Self-Portrait of Peter Paul Rubens
after Peter Paul Rubens (1577–1640)
P/P 1498 2nd state of two
Etching
In design, lower L: WHollar fecit
In design, lower R: F. van den / Wijngarde ex:
Below: Excellentis: Dns. D: PETRUS PAULUS
RUBENIUS, pictorum Apelles / decus huius seculi,
Orbis miraculum, Aulam Hispanicam, Gallicam,
Anglicam, Belgicam, penicillo / suo illustravit. Quem
gladio donavit Philippus Quartus Hispaniarum Rex, et
statuit sibi a Secretis in Sanc= / tiore suo Consilio
Bruxellensi, et ad Regem Angliæ Legatum Extraordi-
narium misit.
24.4 x 18.4
25.0 x 19.0

Some authors call the arrival of Peter Paul Rubens
in England in 1629 the most important event in
the field of English art.[45] As an envoy of his
patroness, the archduchess Isabella, governess of
the Spanish Netherlands, Rubens' commission
was to negotiate a possible peace between Spain
and England. During his stay Rubens was com-
missioned to do paintings of Banqueting Hall in
Whitehall. He also painted a portrait of Lord
Arundel (Isabella Stewart Gardner Museum, Bos-
ton). In a letter dated August 8, 1629, Rubens
wrote to Peter Dupay that he had learned a great
deal from English culture, particularly from the
incredible quantities of exceptional classical paint-
ings and inscriptions (texts): "I shall not mention
the marmoria Arundeliana, where I was over-
whelmed. I must acknowledge that I have never
seen anything in the world that is so special in the
area of Antiquity."[46] Rubens also described the
Earl of Arundel as "one of the four evangelists of
our art."[47]

 This joyous portrait of Rubens is set in an egg-
shaped cartouche, with grotesques that date back
to antiquity. Palettes appear on both sides of the
portrait at shoulder height.

 In Antwerp, Frans van den Wijngaerde pub-
lished seventeen prints by Hollar, mainly portraits.

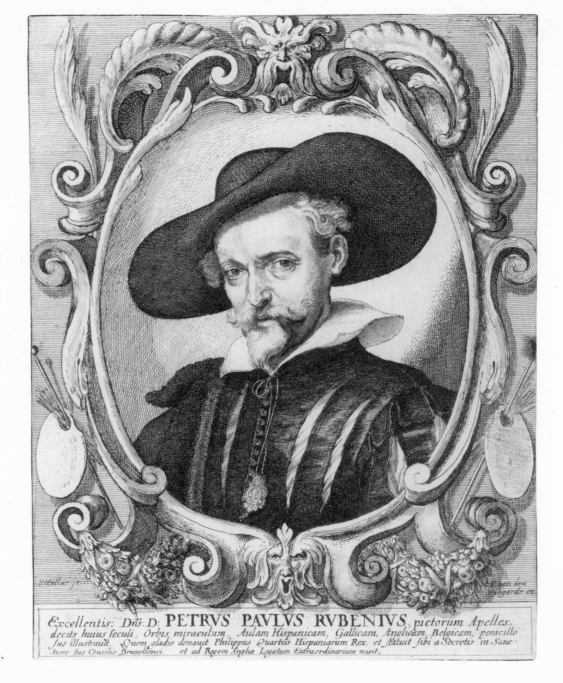

100

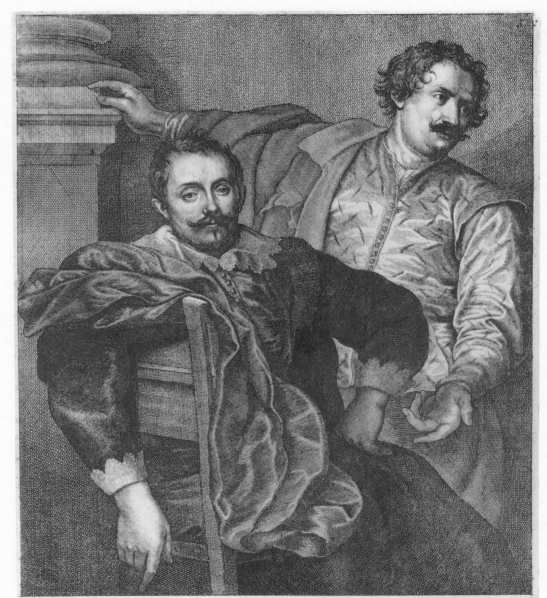

57
Lucas and Cornelius de Wael
after Anthony van Dyck (1599–1641)

P/P 1517 4th state of five
M.-H. 1991, no. 136
Etching and engraving
Below: LUCAS ET CORNELIUS DE WAEL ANTU:
FFr. GERMANI IOis FF: QUI PICTORIAM AR- /
TEM HÆREDITARIO IVRE CONSECUTI HIC
RURALIUM ILLE OMNIGENUM PRÆCIPUE-
QUE / CONFLICTUUM REPRESENTATOR
Beneath: Ant. van Dyck Eques pinxit, W:Hollar fecit,
1646 I: Meysens exc
29.1 x 22.3
29.9 x 22.9

In this work, his first double portrait, Van Dyck
experimented with placing two individuals of
equal importance in close proximity to each
other. The painting is in two contrasting colors,
following Raphael's double portrait of himself
with his fencing master (now in the Louvre,
Paris). The portrait of the De Wael brothers was
probably painted in 1623 in Genoa and is now
housed in the Pinacotheca Capitolina in Rome.

Cornelis (1592–1667) and Lucas (1591–1661)
de Wael came from Antwerp and established
themselves as painters in Genoa. Hollar's print
was probably done after an oil sketch by Van
Dyck that is now in Kassel, Germany.

Hollar did only one print after a painting by
Lucas de Wael: a view of Antwerp (P/P 823).

58
Anatomy
after Leonardo da Vinci (1452–1519)

Making reproductions of sketches was uncommon in Hollar's time. He was one of the first to receive a commission to do so. The function of the sketch as the *prima idea* slowly began to be perceived as the most important expression of the artistic spirit. Arundel was a passionate collector of drawings. Through his interest in the medium and his desire to collect initial sketches and drawings by the great masters, he proved himself to be a "modern" collector. Thanks to the attentiveness of his agents in Italy and Spain, a great many drawings by Leonardo came into the possession of the English royal house through Arundel's efforts.

Leonardo was exceptionally productive as an author and draftsman. More work by him has been preserved than by any other important artist. In the 1655 inventory of the belongings of Arundel's widow, five works by Leonardo were described: Leda, a beheaded John the Baptist, St. Catherine, a portrait of a man with a flower, and a set of horses.[48] The presence of drawings by Leonardo in the Arundel collection is evident from copies done of them after 1627.[49]

Around 1510, Leonardo was implementing his plan to describe the human anatomy on paper, replete with studies of muscles and the skeleton. He had become interested in anatomy twenty years earlier. In Milan, he dissected corpses and grouped drawings of them into a portfolio of 779 works, all for his friend Marcantonio della Torre, a professor of anatomy at Padua.

These etchings after anatomy studies by Leonardo were not done as a series. Their dates vary from 1645 to 1660. The three etchings exhibited here were all done during Hollar's period in Antwerp. The publisher is unknown.

58A
Anatomy
after Leonardo da Vinci
P/P 1768
Etching
1645
In design, lower L: Leonar:
da Vinci inu: / W Hollar fecit 1645
7.4 x 5.0
9.3 x 5.4

58B
Anatomy
after Leonardo da Vinci
P/P 1771[50]
Etching
1651
In design, top: Leonardo
da Vinci / inv.
W. Hollar fecit / 1651 /
Ex Collectione Arund:
12.4 x 6.4
12.5 x 6.5

58C
Anatomy
after Leonardo da Vinci
P/P 1772
Etching
1645
In design, upper L: Leonardo
da Vinci inu. / W. Hollar
fecit / 1645
11.6 x 6.8
11.7 x 7.3

59
Lady with Curled Hair
after Albrecht Dürer (1471–1528)

P/P 1535 2nd state of two
Etching
1646
In design, upper R: 1497 / AD (as monogram)
Below: Quid Virgo Sparsis prætendit compta capillis: /
Et Christum querens consequi sola putat; / Soli Deo
Seruire cupit, seseque beatam / Reddere, nam Crucis
gaudia sola beant
Beneath: Albertus Durer pinxit WHollar fecit, ex
Collectione Arundeliana Aº 1646
24.5 x 17.6

Arundel was a great admirer of Albrecht Dürer.[51]
During his stay in Nuremberg in 1636, Arundel
the diplomat received a gift from the bishop of
Würzburg: a Madonna by Dürer. From the city
magnates, he received a self-portrait by Dürer and
a portrait by Dürer the Elder. Arundel gave these
last two portraits to Charles I. He could not bear,
however, to part with the Madonna. From Frank-
furt he wrote to William Petty on December 5.

Though I wrote unto you since I came hither, yet I
cannot upon the Posts going, but salute you again and
say I wish you saw the Picture of the Madonna of Al-
brecht Durer which the Bishop of Witzberg gave me
last week as I passed by that way. And though it were
painted at first upon an uneven board and is varnishes,
yet it is more worth than all the toys I have gotten in
Germany, and for such I esteem it, having ever carried
it in my own Coach since I had it. And how then do
you think I should value things of Leonardo, Correggio
and such like. . . .[52]

A woman from the Fürlegger family is portrayed,
and the family coat of arms is shown at the upper
right. The painting is now in the Städelsche
Kunstinstitut in Frankfurt am Main.

Quid Virgo Sparsis prætendit compta capillis.
Et Christum querens consequi sola putat?

Soli Deo Seruire cupit, seseque beatam
Reddere, nam Crucis gaudia sola beant

Albertus Duren pinxit WHollar fecit, ex Collectione Arundeliana. Aº 1646

60
Wedding Feast
after Pieter Bruegel (ca. 1525–1569)
P/P 597
Etching
1650
Below: Non has condit Hymen mensas, non pronuba
Iuno, / Nec struit has coreas musa, charisue thorum, /
Non sponsalia nunc, sed Bacchanalia dantur, / Ne
renuas Sponso cornua Bacche tua, / O.T.
Beneath: P. Brueghel inu: W: Hollar fecit, A°
1650 A:A: Bierling excud:
25.7 x 37.1

A "Fiesta de Contadini" by Pieter Bruegel was
listed in the 1655 inventory of Arundel's paint-
ings. Whoever compiled the list did not specify
which Bruegel was meant, although he did name
a full six pieces showing farmers celebrating or
dancing. Jan Bruegel the Elder did these
drawings/paintings using motifs derived from his
father, Pieter Bruegel. The drawing on which this
print is based is in the British Museum.[53] At that
time farmers were used to personify everything
that was coarse and unpleasant, although their
lackluster reputation was based on centuries of
struggle against their poor existence.

The text under the print speaks of the farmers'
lack of moderation in the consumption of alco-
holic beverages.

Non has condit Hymen menſas, non pronuba Iuno,
Nec ſtruit has coreas muſa, chariſue thorum,

Non ſponſalia nunc, ſed Bacchanalia dantur,
Ne renuas Sponſo Cornua Bacche tua, O.T.

P. Brueghel inu. W. Hollar fecit, A.º 1650, A.A. Bierling excud.

105

61
Tobias and the Angel
after Hendrik Goudt (1582–1648)
after Adam Elsheimer (1574/1578–1620)

P/P 75 1st state of three
Hollstein 1949, VIII, p. 151, no. 1
Paris 1979, no. 9
Etching
Below: Incolumis Raphaele viam monstrate Tobias /
Per varios casus, itqueritque domum / Tu quoque si
sequeris quo custos Angelus anteit / Securus coeli regna
Paterna subis
Lower L: AElsheimer / pinxit
Lower R: W. Hollar / fecit
12.5 x 18.0

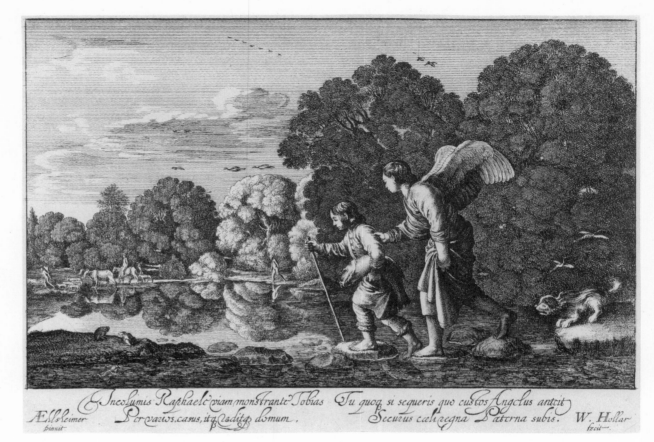

As told in the apocryphal book of *Tobias*, the story
of Tobias takes place in Niniveh at the time of the
Jewish exile in Assyria in the eighth century B.C.

Tobit, the father of Tobias, performed the ritual
burial of the Jewish victims of the Assyrian king,
although that was forbidden. Having been
blinded by the droppings of a starling, Tobit sent
his son Tobias to Media to bring him money
which he was owed. The archangel Raphael, in
human form, is Tobias' traveling companion.
While on his journey, Tobias went swimming in
the Tigris river and encountered a great fish.
Tobias caught the fish, kept its heart, liver, and
gall, and used the gall to cure his father's
blindness.

The painting by Adam Elsheimer, painted on
copper in 1607–1608, is now in the Historisches
Museum, Frankfurt. (For Elsheimer's biography
see cat. no. 111.) The etching by Hendrik Goudt
is probably one of the prints that Arundel
obtained from the artist in Rome. Lord Arundel
was taken with the idea that a painting could be
translated into a print. Indeed, his acquaintance-
ship with Goudt's work acted as an immediate
incentive for the earl to take an engraver into his
service.

Jonkheer Hendrik Goudt was an amateur
etcher, whose entire oeuvre consists of seven etch-
ings, all after Elsheimer, with whom he became

acquainted while he was in Rome (1608–1610).
The quality of Goudt's etchings was so high that
Elsheimer's work became known abroad through
them. In Holland, Jan van de Velde II certainly
was influenced by Elsheimer. The etching shown
here is a reverse copy after Goudt's etching. Hol-
lar even copied the handwriting of his model.

62
Ceres and Stellio
after Hendrik Goudt (1582–1648)
after Adam Elsheimer (1574/1578–1620)

P/P 273
Hollstein 1949, VIII, p. 155, no. 5
Paris 1979, no. 12
Etching
1646
Below: Dum frugum genitrix tadas accendit in Ætna, /
Et toto natam quærit in Orbe suam, / Victa siti con-
specsit anum Limphamque rogavit. / Oranti Limpham
Rustica dulce dedit, / Dum bibit acceptum risit puer
improbus illam / Nec satis hoc auidam dixerat ille Deam
/ Ridentem Liquida fertur sparsisse polenta, / fugisset,
sed iam stellio factus erat
Lower L: AElsheimer pinxit
Lower R: W Hollar fecit, aqua forti / 1646
30.0 x 23.0

As in the preceding entry (cat. no. 61), this is a
reverse copy after an etching by Hendrik Goudt
dated 1610. The story is taken from Ovid's *Meta-
morphoses*, book V, verses 446–461.

Ceres is looking for her daughter Proserpina,
who was abducted by Pluto, the god of the
underworld. On her search, Ceres becomes terri-
bly thirsty and asks an old woman for a drink.
While she drinks voraciously, a small boy laughs at
her and also calls the old woman a skinflint. In
punishment, he is changed into a lizard.

This small painting, done on copper, was sold
from the estate of Rubens to Philip IV of Spain in
1645. It is now in the Prado in Madrid.

Dum frugum genitrix, tædas accendit in Ætna,
Et toto natam quærit in Orbe suam.
Victa siti conspecsit anum, Limphamque rogavit.
Oranti Limpham Rustica dulce dedit.

Dum bibit acceptum, risit puer improbus illam.
Nec satis hoc, auidam dixerat ille Deam.
Ridentem Liquida fertur sparsisse polenta
fugisset, sed iam stellio factus erat.

Elsheimer pinxit.

W Hollar fecit, aqua forti
1646

63
Esther before Ahasverus
after Paolo Veronese (ca. 1528–1588)
P/P 77 2nd state of two
Berlin 1984, no. 123
Etching
After 1652
Lower L: Paulo Verones Inventor
C: 10 Alta 15 Lata
Lower R: W Hollar fecit
40.4 x 46.2
41.2 x 47.1

As told in the Old Testament book of Esther, in
the fifth century B.C. Ahasverus (Xerxes) of Persia
had become enamored of Esther, unaware that
she was a Jew. His prime minister Haman had
persuaded the king to kill all the Jews in Persia.
Esther's uncle Mordechai begged her to come to
her people's aid. Wearing beautiful clothes, she
went to the king uninvited, which could have
cost her life. At this moment, the king on his
throne holds his scepter in Esther's direction as a
sign that he will receive her. Her courage was
rewarded. The Jewish people were spared, and
Haman was hanged on the gallows that he himself
had erected for Mordechai. This wonderful rescue
of the Jewish people is still celebrated every year at
Purim.

This print is an enlarged detail of P/P 76, in
which the painting is shown in its frame and as an
object in a collection. *Esther before Ahasverus* by
Veronese is now in the Uffizi in Florence, but
clearly in the seventeenth century it was in the
collection of Archduke Leopold Wilhelm, the
second son of Emperor Ferdinand II of Austria.
David Teniers the Younger included the painting
in his canvas *Archduke Leopold Wilhelm in his
Painting Gallery in Brussels*. Arundel had met
Leopold in Vienna during his journey to Prague
in 1636, and perhaps then he had the occasion to
see the painting by Veronese.

64
Doubting Thomas
after Francesco Salviati (1510–1563)

P/P 112
Etching
1646
In design, below: Fra^{co} Salviati inu: W: Hollar fecit,
1646 Antverpiæ, ex Collectione Arundeliana
44.8 x 40.6
45.3 x 40.8

This painting by Francesco Salviati, which,
according to Hollar, once belonged to Arundel,
shows Christ with a standard among his disciples.
Thomas kneels before him and points to the
wound in Christ's side. Thomas was absent the
first time Christ appeared to the disciples after his
resurrection. When he was told of the miracle, he
did not believe it. At Christ's second appearance,
he told Thomas to place his finger into the
wound. Thomas, too, was then convinced that
Christ had risen (John 20:19–29). This theme
remained popular because it fulfilled the purpose
of religious art, i.e., the confirmation of Christian
doctrine.

Francesco Salviati, a painter and set decorator,
was a student of Andrea del Sarto, among others.
After 1530, Salviati worked in Rome in the service
of Cardinal Salviati, whose name he adopted. In
Rome he was influenced by Michelangelo and
Pierino del Vaga. His frescoes in the Palazzo Far-
nese in Rome exhibit his mannerist style.

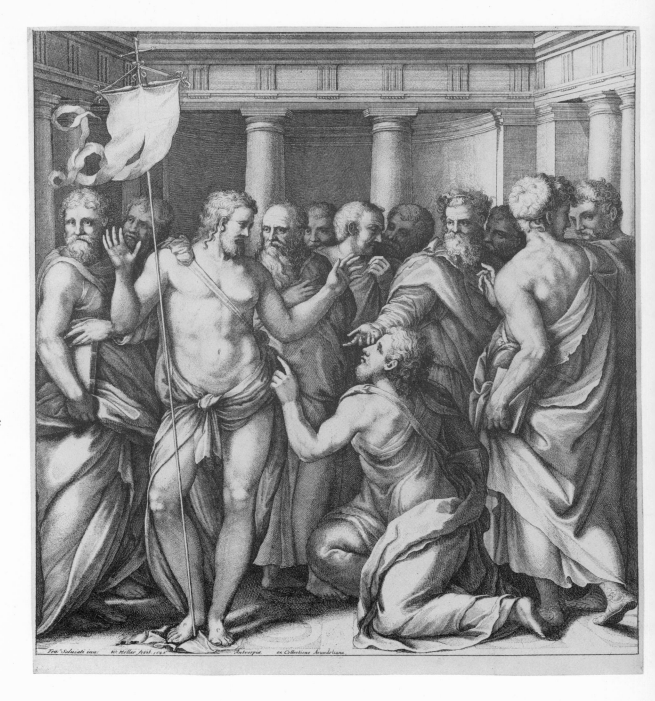

65
The Infant Hercules Asleep
after Parmigianino (1503–1540)

P/P 275 2nd state of four
Etching
In design, lower L: F. Parmegiano inu:
In design, lower R: WHollar, fecit
Below: Cum Privil:ᵃ Sac:ʳᵃᵉ Reg:ᵃᵉ Mai:ᵗⁱˢ
14.7 x 13.8

Though his oeuvre is quite varied, it is striking
that Hollar did few prints of subjects from classi-
cal mythology (P/P 267–285). Nine of them are
after paintings by Adam Elsheimer, six after Giulio
Romano, one after Pieter van Avont, and one
after Parmigianino. The others are all after his
own invention. During the 1650s, Hollar created
forty-three illustrations after designs by Frans
Cleyn (see cat. no. 116) for John Ogilby's transla-
tion of Virgil.

Although the source for the tale of Hercules
lies in the Gilgamesh epic of ancient Sumerian leg-
end, his role as Heracles in Greek mythology is
better known. He was worshipped as a protector
of men and towns, and his cult was widespread.
For the Romans, too, Hercules played an impor-
tant role. According to the myth, he was the son
of the mortal Alcmene and Jupiter, and after his
death he was made a god by Jupiter.

Hercules was seldom shown sleeping. Hollar's
print, based on Parmigianino's model, is a varia-
tion on a sleeping cupid, etched in the dry point
technique (fig. 5). In this common motif, Amor
or Cupid sleeps under a tree. This is how he
appears in images of the farewell of Venus and
Adonis, indicating that men always have their
thoughts elsewhere, and not with their beloved.

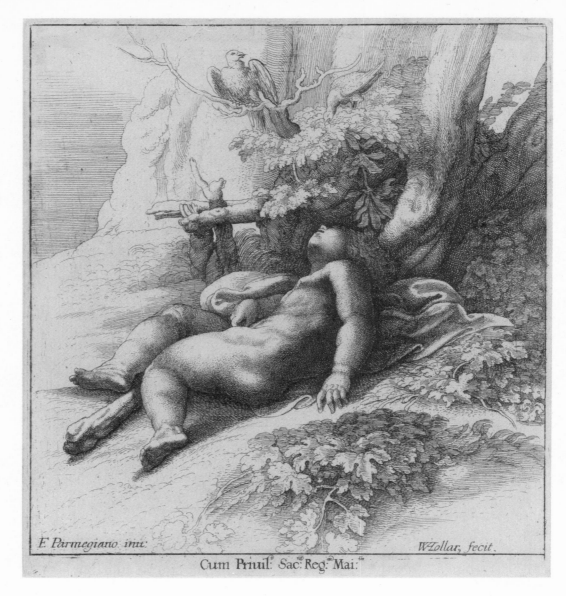

F. Parmegiano inu: WHollar, fecit.

Cum Priuil: Sac: Reg: Mai:

66
Woman's Head

P/P 1910
Etching
1642
Between borderlines, top: W: Hollar fec: 1642
9.7 x 9.1

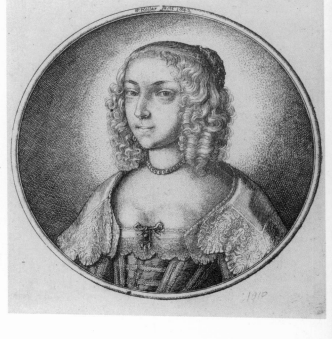

Hollar produced a series of thirty-six heads of women, framed in circles and unnumbered (P/P 1909–1944). Just as with the figures from the series *Aula Veneris* (cat. nos. 93, 94), these plates concentrate more on fashions than on portraiture. In this and the following three prints (cat. no. 67), Hollar's interest lies primarily in the various hairstyles. The heads are etched against a blank background within a circular frame. A shadowed area that is always darker on the right appears behind the shoulders in each print. All four of the heads face to the left. One theory maintains that Hollar did these medallion portraits before he began the *Aula* series. Later he reduced the size and used them with the costume prints.

A string of pearls holds part of each woman's hair in a bun. On the sides, her hair hangs in curls to her shoulders. She wears an intricate lace collar with a double-scalloped edge. In a copy of the print in the British Museum in London, a penciled note that was added later identifies this woman as the Duchess of Lennox. This is not very convincing, especially when this face is compared with the duchess' portrait after Van Dyck (see cat. no. 92).

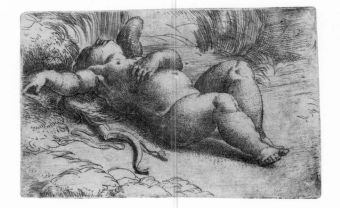

Figure 5
Sleeping Cupid
by or after Parmigianino (1503–1540)
Bartsch, no. 11
Etching
7.2 x 11.1
Museum Boymans-van Beuningen, Rotterdam

111

67A
Woman's Head
P/P 1912 1st state of four
Etching
1646
Lower L: WHollar fec: / 1646
10.3 x 9.6
10.9 x 10.1

The woman's dark hair is parted in the middle, and long, tight curls fall on either side of her face and end in a bow at the bottom. She has a knot on the back of her head. Her lace shoulder covering is held together by a jewel similar to that worn by the woman in the previous etching (cat. no. 66). In its third edition, this etching was assigned the serial number ''15.''

67B
Woman's Head
P/P 1915
Etching
1646
Lower L: WHollar fecit
10.4 x 9.5
11.1 x 10.2

This woman wears her thick, dark hair short on the top and perhaps in a small knot at the back of her head. She looks quite noble in her double lace collar, which stands out from her shoulders like a pair of wings.

67C
Woman's Head
P/P 1918
Etching
1645
Upper L: W.Hollar fecit / 1645
10.2 x 9.6
10.7 x 10.2

This young girl somehow looks quite different
from her mundane predecessor (cat. no. 67B).
Her blonde hair is probably pinned up in the
back. In front, short locks fall over her forehead,
and her wavy hair frames her face.

68
Muffs
P/P 1947 2nd state of two
Etching
1645
In design, lower L: W. Hollar fecit 1645
7.2 x 11.2
8.2 x 11.5

With great dedication, Hollar did nine prints of
muffs and other pieces of fur. In these original
compositions Hollar shows his masterful etching
technique and his great artistry. It is astonishing
how creative he could be with a few pieces of fur
and accessories that he owned. The same muffs,
fur caps, lace collars, and gloves are seen repeat-
edly in his portraits of women and costume
pieces. Here, the muff, made of two kinds of fur,
was also used with the figures of women repre-
senting winter (see cat. nos. 24D, 36, 45), as is
also the case with the fur stole or shawl.

69
Muffs
P/P 1951
Etching
1647
In design, bottom C: WHollar fecit Aqua forti 1647.
Lower R: Antverpiæ
10.9 x 20.3
12.5 x 21.7

This still life is composed of pieces of fur, lace col-
lars, a pair of gloves, a mask, and two kinds of
fans. Hollar was the first to show these items as a
still life in and of themselves. He arranged the
accessories carefully to achieve a balanced compo-
sition. The artist's only known drawing of a muff
is of the one seen here with the brocade band.
That elaborate drawing is on gray paper with
black wash, heightened in white (British
Museum, London).[54]

70
Muffs
P/P 1952 1st state of two
Etching
1645/1646
In design, lower L: W.Hollar fecit 1645 / et 1646
7.7 x 12.7
8.0 x 12.0

The muff that appears most often in Hollar's
work is shown from five different angles, creating
an unusual visual effect. Since his main focus was
on the fur, Hollar sketched in the arms of the five
women. The second muff at the top is worn dif-
ferently, with the dark half towards the wearer's
elbow.

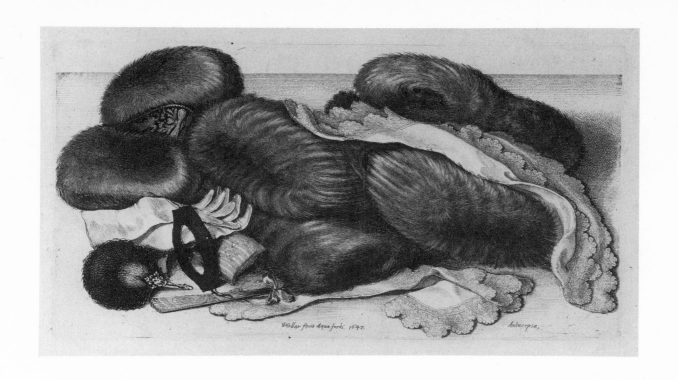

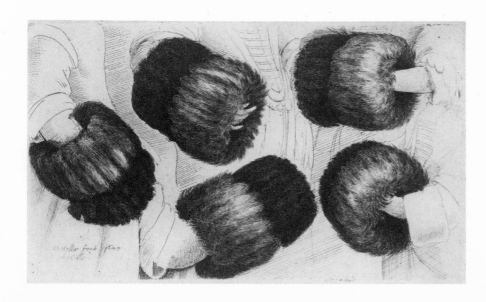

71–73
Hounds
after Pieter van Avont (1599–1652)

This title page introduces a series of twelve plates (P/P 2041–2052) with hounds and hunting trophies after designs by Pieter van Avont. Neither the exact sequence nor the precise content of this series is known. For example, P/P 2042 is after a design by Frances Barlow and probably does not belong with the series. P/P 2043 also differs significantly in its dimensions. P/P 2052 differs from the other prints because it shows nine sheep standing tranquilly side by side and has little to do with hunting. Out of a yearning for order and for a convenient arrangement, print dealers and later writers of catalogues, such as George Vertue and Gustav Parthey, thought in terms of a series as much as possible. To avoid further confusion, subsequent authors have used their predecessors' classification system while adding their own commentaries.

The hounds as they appear in these prints figured in many seventeenth-century paintings. Thus, these prints form a catalogue of the types of hounds an artist could choose to include in paintings. This "series" was published several times. In the third edition, this title page bears a dedication to Theodoor Pauw as a devotee of the arts. In the sixth edition, the dedication to Theodoor Pauw was replaced with the text "Livre de plusieurs Animaux / a dessiner / par Hollar," which indicates that one of the prints' purposes was as a model for those who wanted to draw.

71
Title page
after Pieter van Avont
P/P 2041 2nd state of six
Etching
1646
In design, lower L: WHollar fecit 1646
13.6 x 20.4
14.4 x 21.1

This title page consists of a stag's skin supported by bundles of spears. Hounds stand or lie to either side. A shotgun and attributes of the hunt lie on the ground. In this second edition, the skin bears a coat of arms held by lions.

72
Six Hounds
after Pieter van Avont
P/P 2046 1st state of two[55]
Etching
1647
In design, lower R: WHollar fecit, 1647
13.8 x 20.5

Five hounds lie on the ground, while a sixth starts to stand. The dogs are drawn in various positions, with most of them licking themselves clean.

117

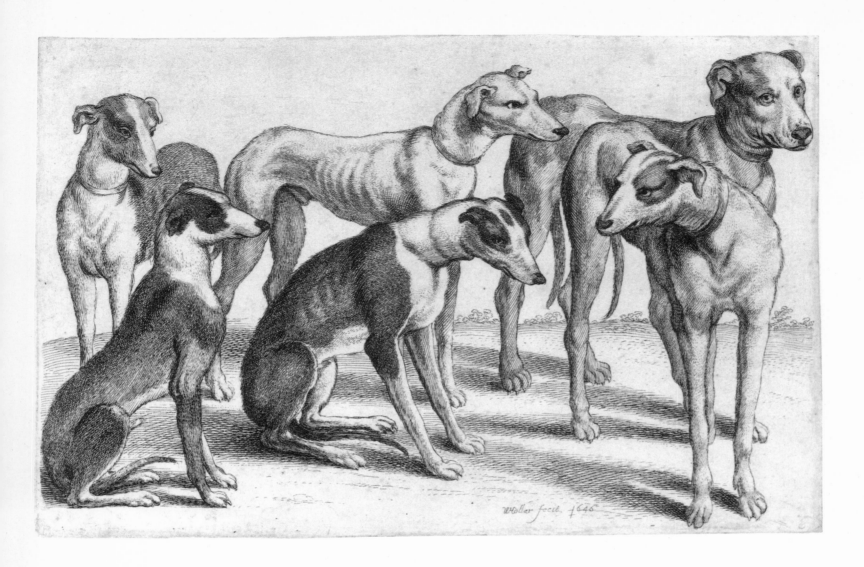

73

Six Hounds

after Pieter van Avont

P/P 2047 1st state of two[56]

Etching

1646

In design, bottom C: WHollar fecit, 1646

13.5 x 20.7

Five greyhounds and one unidentifiable dog are shown standing or sitting. Hollar also added a sort of landscape to this print. At the horizon shrubs are sketched in between the dogs' legs.

74
Variae Figurae

P/P 2671 1st state of five
Etching
1645
In design, upper R: VARIE FIGURÆ ET PRO= / bæ,
Artem picturæ incipiendæ / Ivuentuti utiles, a Wen-
ceslao / Hollar Bohemo, aqua forti æri in= / sculptæ,
Antverpiæ A:º 1645.
In design, lower L: W. Hollar fecit
7.8 x 11.6

This title page was probably created for the first
edition of the so-called caricatures (cat. nos. 98,
99) or for the series of anatomical prints after
Leonardo (cat. no. 58). The title itself has the
same tenor as that of Hollar's *Reisbüchlein* (see cat.
no. 7). In the text, Hollar states that these prints
are intended as practice material for beginning
artists. The female figure, a personification of the
art of drawing or engraving, holds two copper
plates featuring engravings of anatomy and heads.
The plate, which rests on the ground, bears a sig-
nificant likeness to the figure in cat. no. 58B.

75–76
Butterflies and Insects

The series of butterflies and insects are a high
point in Hollar's work. The perfected depiction
of the subject makes these butterflies, caterpillars,
moths, and other creatures look incredibly real.
The insects appear to be pinned to a background,
but in reality Hollar did these butterflies not from
actual specimens but after colored drawings that
were part of the Arundel collection. Hollar
acknowledged this fact on the title page. The
artist of the initial drawings is unknown. Found
in the list of Hollar's graphic works that were sold
by the collector John Towneley in 1818 is the title
*A Volume containing an extraordinary and unique col-
lection of Birds, Beasts, Fish and Insects inimitably per-
formed by the hand of Hollar. . . .* Many artists
specialized in this field, creating drawings and
prints of all possible subjects of scientific interest.
Thomas Moufet (Moffet), for instance, published
a volume on butterflies and insects entitled *Insec-
torum sive minimorum animalium theatrum* (Lon-
don, 1634).

Many books of this kind were published in
Holland in the early seventeenth century. Several
similarities are found between Hollar's butterflies
and those from the publication by Nicolaas Jansz.
Visscher, dated 1630 and entitled *Diversæ insec-
torum volatilium icones advivum . . . depictæ per . . .
D. I. Hoefnagel.*

Joris Hoefnagel (1542–1600), an important
miniaturist, traveled throughout Europe as an
artist and dealer. He undoubtedly created art
while he was in England in 1569. The publishers
Braun and Hogenberg commissioned him to pro-
duce topographical drawings for their atlases, and
Hoefnagel was a friend of the famed geographer
Abraham Ortelius. Hoefnagel met with his great-
est success in his miniatures of animals.

Most of the butterflies and insects from this
series appear again in a subsequent series by Hol-
lar, *Diversæ insectorum figuræ* (P/P 2178–2183),

which was published in Antwerp. In those plates,
the butterflies are larger and are arranged
differently.

75A
Title page for a series of insects
P/P 2146 1st state of two
Paris 1979, no. 178
Etching
1646
In cartouche: Muscarum Scarabe = / orum, Vermium-
que Varie Figure & / Formæ omnes primo ad vivum
colo = / ribus depictæ & ex Collectione Arun = / delian
a Wenceslao Hollar aqua forti æri / insculptæ
Antverpiæ, Anno, 1646
At bottom of cartouche: WHollar fecit. 1646.
7.9 x 11.9

A cartouche with grotesque curls is surrounded
by a variety of butterflies and dragonflies.

75B
Six Insects

P/P 2165 1st state of three
Etching
Ca. 1646
In design, upper L: W. Hollar fecit ex Collectione
Arundeliana
8.1 x 11.9

Two grasshoppers appear at the bottom. Above
them are three butterflies and a winged insect
with long, curved antennae, all depicted with
outspread wings.

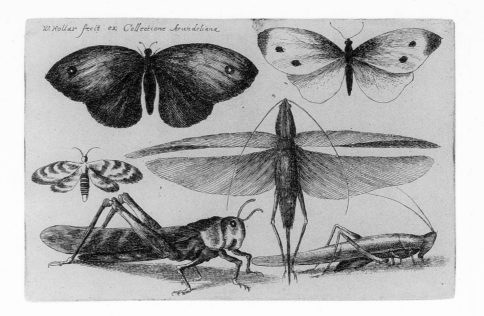

75C
Four Caterpillars and a Snail

P/P 2167 1st state of three
Etching
1646
In design, lower R: WHollar fecit, ex Collectione
Arun- / deliana, A° 1646
8.0 x 11.7

A fat, light-colored caterpillar appears at the top,
above two others: a hairy one, rolled into a ball, is
to the right, and another one is stretched out at
the lower left. A brightly spotted caterpillar is
between them, and beneath that moves a snail to
the left. In its next issue, the print was numbered
"9," and in the third, "12."

75D

Dragonflies and a Bumblebee

P/P 2169 1st state of three
Etching
1646
In design, upper L: WHollar fecit ex Collectione /
Arundeliana 1646
8.1 x 11.7

In the upper left corner is a bumblebee, and in
the lower right corner is a dragonfly with light-
colored wings. Two more dragonflies with out-
spread wings are in between them. A small but-
terfly with closed wings occupies the lower left
corner. In the next two issues the print is num-
bered "11" and "10," respectively.

75E

A Moth and Three Butterflies

P/P 2166 1st state of three
Etching
1646
In design, upper L: W.Hollar fecit 1646
In design, upper R: ex Collectione Arundeliana
8.0 x 11.7

A large moth with outspread wings fills nearly the
whole plate. Two butterflies and a sort of winged
beetle are shown on a much smaller scale. In the
second state, this print has the number "3," and
in the third, "5."

75F

A Moth, Three Butterflies, and Two Beetles

P/P 2168 1st state of three
Etching
Ca. 1646
8.0 x 11.8

The print is neither signed nor dated. A gigantic
moth, wings outspread, occupies most of the
print. Immediately below it appears a reasonably
large butterfly with beautifully drawn wings. Two
smaller butterflies with folded wings are shown on
each side. Halfway up, two beetles are sche-
matically drawn.

This print was assigned the number "5" in the
second edition, but it was replaced with a "3" in
the third edition.

75G

Three Butterflies and a Wasp

P/P 2170 1st state of three
Etching
Ca. 1646
In design, lower L: WHollar fecit ex Collectione
Arundeliana,
8.2 x 11.8

The *pièce de résistance* on this page is the butterfly
with unusually large wings that end in the shape
of a swallow's tail. Flanking this are two smaller
butterflies with closed wings; a huge wasp sits
between them.

In both later issues this print is numbered "7,"
but the placement of the number on the page dif-
fers in each.

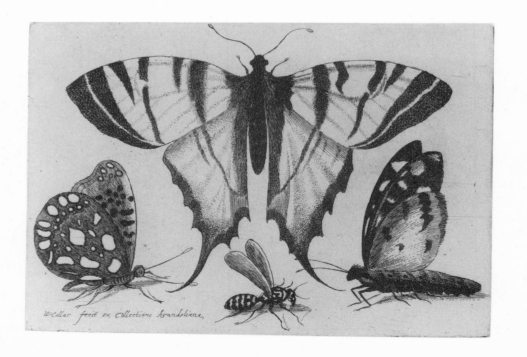

76A

Two Moths and Six Insects

P/P 2171 1st state of three
Etching
1646
In design, upper L: WHollar fecit ex Collectione /
Arundeliana 1646.
8.2 x 11.8

Two moths are shown on an enlarged scale, one
above the other. Although their wings differ in
pattern, this may be the same moth, viewed once
from above and then from below. The print is
otherwise filled with two bugs, one bluebottle,
one beetle, and two small butterflies.

 In the second and third editions this print is
numbered "4."

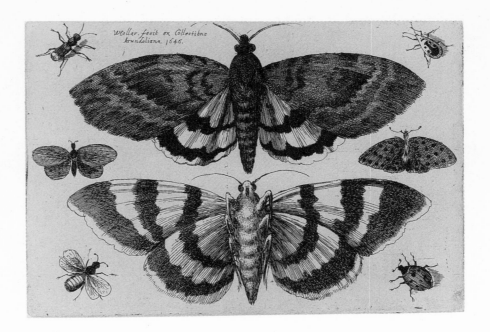

76B

Four Butterflies, a Moth, and Three Insects

P/P 2185
Etching
1646
In design, bottom C: Hollar fecit 1646
7.9 x 11.9

Although Parthey and Pennington describe this
print as having five butterflies, the insect with the
outspread wings at the upper left looks more like
a moth. In terms of style and composition, this
print belongs to the series P/P 2164–2175,
described above. However, it does not appear in a
bound album of the prints from the time of
publication.

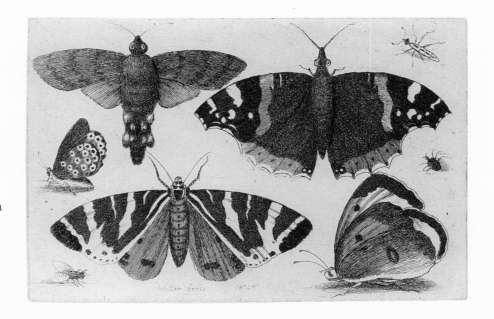

76C

Three Moths, Two Butterflies, and a Bumblebee

P/P 2172 1st state of three
Etching
1646
In design, top C: WHollar fecit, ex Collectione /
Arundeliana 1646
8.1 x 11.9

Three moths and a butterfly with open wings
occupy the center of the page. On the right is a
small butterfly with folded wings, and in the
upper left corner is a bumblebee. In the second
issue this print was numbered "8"; in the third
issue it was replaced with a "9."

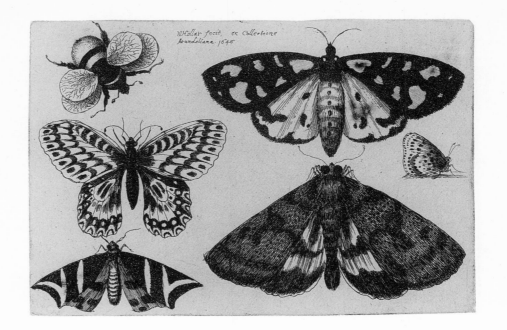

76D

Five Butterflies

P/P 2175 1st state of three
Etching
In design, upper L: WHollar fecit ex Collectione
Arundeliana / 1646
8.0 x 11.8

At the top, a swallow-tailed butterfly is beau-
tifully rendered with open wings. Beneath are two
more butterflies with open wings juxtaposed
against two smaller ones whose wings are closed.
The print was numbered "1" in the second edi-
tion, and in the third edition it was altered to a
"6."

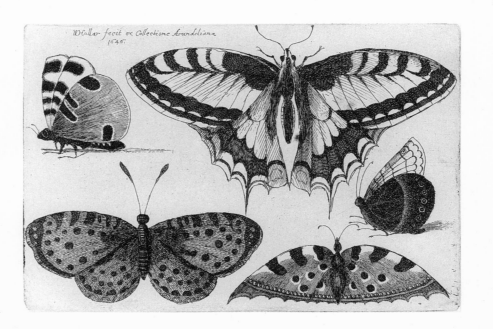

77
A Dead Mole

P/P 2106
Etching
1646
In design, lower L: W: Hollar fecit, 1646.
7.2 x 14.1

From 1645 to 1647, Hollar focused on his unique etchings of fur and pelts. In nearly all his costume prints, Hollar exhibits his remarkable gift for conveying the tactile quality of materials and the texture of fur. In addition to using exceptionally fine lines, he achieved subtle nuances in tone by treating one part of the plate with etching water.

 A mole can symbolize literal or figurative "blindness." It also stands for gullibility. In Hollar's case, however, the matter was mainly a question of portraying the animal's pelt.

78
A Poodle
after Adriaen Jacobsz. Matham (1600–1660)

P/P 2097
Etching
1649
In design, lower L: A:Maetham delin:
In design, lower R: WHollar fecit, 1649.
7.7 x 12.0
8.0 x 12.3

Over the years, this little dog has been identified as one of any number of breeds. Most authors consider it a poodle. Some see it as a King Charles Spaniel, and others call it a "Shock Dog," but it most resembles a Maltese. In its play of tones, this print is exactly the opposite of the previous one (cat. no. 77). Here, Hollar placed the white animal against a darker background, and even so he managed to make the pelt "caressable."

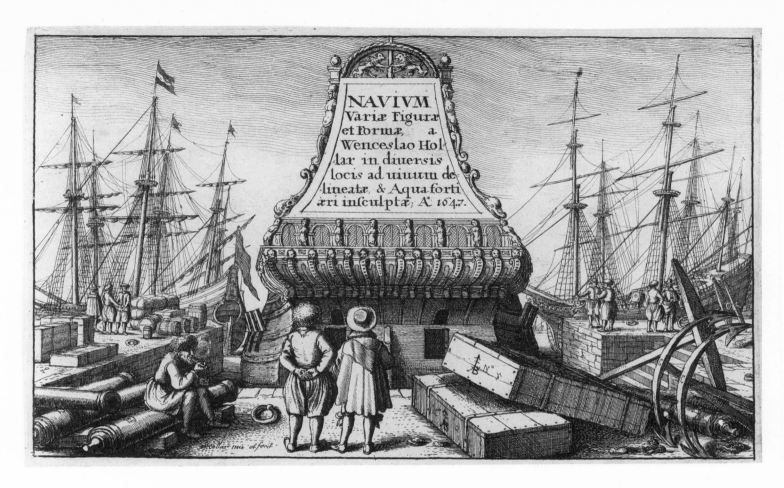

79A
Title page for a series of ships
P/P 1261 1st state of five
Paris 1979, no. 122
Paris 1989, no. 108
Etching
1647
In cartouche: NAVIUM / Variæ Figuræ / et Formæ, a
/ Wenceslao Hol= / =lar in diversis / locis ad vivum
de= / =lineatæ, & Aqua forti / æri insculptæ, Aᵒ
1647.
In design, lower L: WHollar inu et fecit
14.8 x 23.8
14.9 x 24.1

In 1647, Hollar completed a series of twelve ships
in Antwerp. The title is written on the stern of a
merchant ship that lies at anchor in the harbor.
Seamen and merchants stand together below,
calmly talking. As he did so often, Hollar referred
to earlier drawings, in this case from the time he
spent in Holland in 1634. A drawing, dated
1634, is known for cat. no. 80B (fig. 6). Judging
from the flags, the text on the plates, and the
prints' collective title, this series contains primar-
ily Dutch ships that Hollar drew "from life."

After the first publication, four other editions
were produced by Dutch publishers.[57]

In design, top: Naves Mercatoriæ Hollandicæ per Indias Occidentales

Wollar fecit, 1647

79B
Dutch West Indiaman
P/P 1262 1st state of two
Paris 1989, no. 109
Etching
1647
In design, top: Naves Mercatoriæ Hollandicæ per
Indias Occidentales
In design, lower L: WHollar fecit, 1647
14.0 x 23.0

Having the lion of Holland decorate the prow was the most common motif in ship ornamentation. Here Hollar created a "close-up" of a ram prow and an elevated bowsprit. In the middle ground is a ship whose masts are not yet rigged, but sailors are hard at work putting everything into readiness. The harbor front is seen in the background between the two ships.

From the late seventeenth century on, Dutch seamen sought out the best navigation routes to the east and west alike. The United East India Company [VOC, Verenigde Oost-Indische Compagnie] was founded in 1602 to protect this trade monopoly and other interests. After the utility of such an agreement among merchants became clear, the Chartered Dutch West India Company [WIC, Geoctrouyeerde West-Indische Compagnie] was founded in 1621.

128

In design, top: Navis Mercatoria Hollandica, per Indias Orientales

In design, upper L: Naves Bellicæ

80A

Dutch East Indiaman

P/P 1263 1st state of two
Paris 1989, no. 110
Etching
In design, top: Navis Mercatoria Hollandica, per Indias
Orientales
In design, upper L: Naves Bellicæ
In design, lower L: WHollar fecit 1647
14.0 x 23.0
14.6 x 23.6

A three-masted ship with two rows of cannons is being piloted by an eight-oar boat. To the left, two boats, each with three masts, lie at anchor, and the hazy outline of a city appears on the horizon.

The Dutch East India Company had a trade monopoly, primarily in spices, as far as the Cape of Good Hope. Ships usually traveled in convoys, and the enormous ships were accompanied by smaller ones that were able to call at shallower harbors along the way. These ships and their crews were always well armed to protect themselves from pirates. The most heavily equipped ships could be used in battle during maritime wars.

80B

Fitting of a Hull

P/P 1264 1st state of two
Etching
1647
In design, lower L: WHollar fecit 1647
13.8 x 23.2
14.5 x 24.0

Two preliminary drawings for this etching of the construction of a ship's hull are known: one in Prague at the Narodni Galerie (fig. 6), and one formerly in the Springell collection.[58] This is one of Hollar's most appealing works. It offers exactly what his public sought: a studious etching with plenty of details and an air of geniality and industry. Two ship owners sailing in a sort of sloop oversee the workmen's activities. In the foreground, a still life of anchors and wood blocks is etched with much more mobile lines than the ship under construction. This sort of still life shows Hollar as a true "peintre-graveur."

In the distance another ship is visible, as are some unmistakably Dutch facades.

130

Figure 6
Warship
Pen with black, red, white, and blue ink
Sprinzels 1938, no. 84
28.1 x 20.8
Narodni Galerie, Prague (Inv. K. 31210)

131

Thomas Howard, Earl of Arundel
after Anthony van Dyck (1599–1641)

P/P 1353 1st state of three
M.-H. 1956, no. 129
Etching
1646
Below: ILLUSTRIS:us & EXCELLENT:mus D:mus
DOMINUS THOMAS HOWARD, COMES ARUN-
DELIÆ & SURRIÆ / primus comes & summus
Marescallus Angliæ, etc nobilissimi ordinis Gartery
Eques, Serenissimi po= / tentissimique Principis
Caroli; Magnæ Britanniæ Franciæ & Hiberniæ Regis,
Fidei defensoris, etc. in Anglia, Sco= / tia, et Hibernia
a Secretioribus Consilijs, et ejusdem Regis Aº 1639
Contra Scotos Supremus & Generalis Militiæ Dux,
Lower L: Ant: van Dyck Eques pinxit
C: WHollar fecit 1646
Lower R: I: Meyssens exc: Antverpiæ
26.3 x 19.2
26.7 x 19.9

This version of the portrait of Thomas Howard,
Earl of Arundel (see also cat. no. 38) was included
in Van Dyck's *Iconographia*. His likeness was taken
by Hollar or by Van Dyck himself from the
double portrait of Arundel and his grandson in
Arundel Castle. As in P/P 1351, he wears armor.
In one hand he holds a staff, and the other rests
on a helmet. The text below the portrait men-
tions the honorable commission that Arundel
received from Charles I to lead the fight against
the Scots as commander of the English army dur-
ing the first "Bishops' War ." Arundel saw this as
the reward in his effort to win the king's trust. He
had himself portrayed as a sovereign, somewhat
prematurely, however, since the whole expedition
was called off. The text also reports Arundel's
important post of honor, that of Earl Marshall. In
that capacity Arundel was in charge of all ceremo-
nies at court. He was a "Primus inter Pares" of
the nobility.

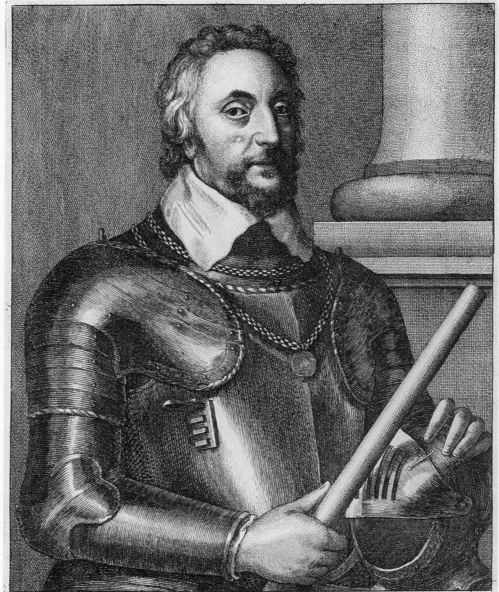

ILLVSTRIS:us & EXCELLENT:mus D: DOMINVS THOMAS HOWARD, COMES ARVNDELIÆ & SVRRIÆ
primus Comes & summus Marescallus Angliæ, etc nobilissimi ordinis Garterij Eques, Serenissimi po-
tentissimiq, Principis Caroli; Magnæ Britanniæ Franciæ & Hiberniæ Regis, Fidei defensoris, etc in Anglia, Sco-
tia, et Hibernia a Secretioribus Consilijs, et ejusdem Regis Aj 1639. Contra Scotos Supremus & Generalis Militiæ Dux,

Ant: van Dyck Eques pinxit. Whollar fecit. 1646. I: Meyssens exc: Antverpiæ.

82
Aletheia, Countess of Arundel
after Anthony van Dyck (1599–1641)

P/P 1354 1st state of four
M.-H. 1956, no. 130
Paris 1979, no. 184a
Etching
1646
Below: ILLUSTRISSIMA ET EXCELLENTISSIMA
DOMINA; DNA: ALATHEA TALBOT, etc.: /
Comitissa Arundelliæ & Surriæ, etc: et prima
Comitissa Angliæ
Lower L: Ant: van Dyck Eques pinxit
C: WHollar fecit, 1646 Antverpiæ
Lower R: Ioh: Meyssens excudit
26.7 x 19.8
26.9 x 21.1

Lady Aletheia Talbot, Countess of Arundel (ca.
1586–1654) married Thomas Howard, Earl of
Arundel and Surry, in 1606. She was the daughter
of the Earl of Shrewsbury and inherited a consid-
erable estate at his death in 1616. Thanks to this
inheritance, Arundel was in a position to assemble
a stunning art collection. She did not accompany
Arundel when he went to Padua in 1642 for his
health. She preferred to stay in The Netherlands,
where she had journeyed after her flight from
England. She lived alternately in Alkmaar and
Amersfoort, and probably also in Amsterdam,
where she died in 1654. It was there, too, that
the inventory of her possessions was done in 1655.

In this print, which was used in the *Icono-*
graphia, she is shown as the future ruler of Mad-
agascar. Van Dyck painted the couple anticipating
Arundel's appointment as governor of that island.
The painting, with the sobriquet "The Mad-
agascar Portrait," appears in the 1655 inventory.
Various versions of this painting exist, including
one that is still in Arundel Castle. Although
Arundel himself was very interested in distant
countries and exotic peoples, and even in folk art,
Aletheia wanted to avoid "banishment" to such a
primitive island. In the portrait by Van Dyck, the
countess is shown with all kinds of symbols of

ILLVSTRISSIMA ET EXCELLENTISSIMA DOMINA; DÑA: ALATHEA TALBOT, etc:
Comitissa Arundelliæ & Surriæ, etc: et prima Comitissa Angliæ.
Ant: van Dyck Eques pinxit WHollar fecit, 1646 Antverpia Ioh: Meyssens excudit

maritime travel. Hollar replaced them with a
string of beads.

Hollar also made a print after the whole paint-
ing (P/P 1353A), in which Arundel nonchalantly
uses a small pointer to indicate Madagascar's loca-
tion on the globe.

83

Allegory on the Death of the Earl of Arundel
after Cornelis Schut (1597–1655)

P/P 466 2nd state of three
Paris 1979, no. 13
Etching
Ca. 1646
In design, on shield: CONCORIDA / CUM
CANDORE
Below: ILLUSTRISSIMÆ ET EXELLENTISSIMÆ
HEROINÆ ALETHEIÆ MARTIÆ / Talbotorum
gentis Salopiæ Comitis heredi uxori unicæ, et unicæ
dilectæ, peregrinationum omniumque fortunarum
fidæ et / indefessæ Comiti THOMÆ HOWARDI Ill,^mi
et Ex,^mi Arundelliæ, Surriæ, et Norfolciæ Comitis,
Angliæ Comitum Supremi, / unicique illius Regni
Marescalli Nobilissimæ gentis Howardæ principis,
Baronis Howardi Mowbray etc. Nobilissimique aureæ
Peris= / celidis Sodalitii Equitis, Doctorum hominum
fautoris, bonarumque artium instauratoris, hunc artis
Pictoriæ cordiali eius amore cui Spes / omnis incum-
bebat, deiectæ, luctum, ac Mæcenatis sui a mortis,
temporisque oblivione, famâ, artiumque Geniis defen-
dentibus æternas vin= / dicias obseruantiæ et grati-
tudinis ergo in viuam, memoriæ et pietatis in
defunctum. LMD.D.
Lower L: Cornelius Schut Inventor
C: Wenceslaus Hollar fecit.
Lower R: Henricus vander Borcht junior
43.2 x 32.0

Just before Arundel left England for the final time
in 1642, he had a last will and testament drawn
up. One section was devoted to his wishes con-
cerning his own burial.

I desire that the place of my interment may be Arundel with-
out any funeral Pomp. That my Tombe be my own Figure (of
white marble or brass designed by Signr Francesco Fanelli) sit-
ting and looking upwards (according to the last clause of the

Epitaph) leaning upon a Lion holding a Escutcheon upon
which the Epitaph to be engraven, and at the feet the Mar-
shall's Staff with a Cornet or the like.[59]

In fact, none of that was done after the earl
died in Padua. Cornelis Schut must have been
acquainted with the wishes expressed in the will,
as the earl's tomb is shown in accordance with the
above description. The allegory that Schut, and
perhaps Hollar and Hendrik van der Borcht
together, devised is full of references to death as
well as to Arundel's abiding interest in the plastic
arts. Fame blows a trumpet while nearly falling
out of her chariot. Holding out an hourglass,
winged Father Time pulls Arundel by his ermine
coat with the aid of a skeleton. In the foreground
is a personification of the art of painting. At the
center a small cupid holds Holbein's *Solomon and
the Queen of Sheba*. To the left stand two portraits
by Holbein, the larger of which shows Arundel's
grandfather Thomas Howard, Duke of Norfolk.
In the left foreground is a print after Raphael
showing *The Assumption of Mary*. Around it are
figurines, coins, and a book. To the right are
ancient marble busts. All this suggests the depth
and variety of Arundel's collection.

The inscription is a tribute to the earl, although
it is dedicated to his widow Aletheia.

ILLVSTRISSIMÆ ET EXELLENTISSIMÆ HEROINÆ ALETHEIÆ MARTIÆ.

Talbotorum gentis, Salopiæ Comitis heredi, uxori vnicæ, et vnicæ dilectæ, peregrinationum, omniumq̃, fortunarum fidæ et
indefessæ Comiti THOMÆ HOWARDI Jll.ᵐⁱ et Ex.ᵐⁱ Arundelliæ, Surriæ, et Norfolciæ Comitis, Angliæ Comitum Supremi,
vnicuq̃, illius Regni Marescalli, Nobilissimæ gentis Howardeæ principis, Baronis Howardi Mowbray etc. Nobilissimiq̃, aureæ Peris
celidis Sodalitii Equitis, Doctorum hominum fautoris, bonarumq̃, artium instauratoris, hunc artis Pictoriæ cordali eius amore, cui Spes
omnis incumbebat, deiecte, luctum, ac Mæcenatis sui à mortis, temporisq̃ oblivione, famâ, artiumque Geniis defendentibus æternas vin-
dicias, obseruantiæ et gratitudinis ergo in viuam, memoriæ et pietatis in defunctum. L.M.D.D. Henricus vander Borcht junior.

Cornelius Schut Inventor. Wenceslaus Hollar fecit.

135

84

The Peace of Münster

P/P 561 1st state of two
Paris 1979, no. 14
Etching
1648
In design, bottom C: Eygentlycke Afbeeldinghe / ende
Maniere van de publicatie van den Peys, / tusschen syne
Mayesteyt den Coninck van Spagnien, ende de /
Heeren Staeten Generael van de Vereenichde
Nederlanden op eene / Heerlycke Stellagie voor het
Stadthuys van Antverpen, ter Pre= / sentie van de
Heeren Schouteth, Amptman, Borghemeesters, She=
/ penen etc: ende eeu grote menichte van toehorders,
den 5 Iunij / 1648
Lower L: Wenceslaus Hollar delineavit
Lower R: et fecit Aqua forti, Antverpiæ
21.6 x 33.6
21.9 x 33.8

A peace agreement between Spain and the United
Provinces of The Netherlands was reached in
Münster on May 15, 1648. The agreement was
announced in Antwerp on June 5, eighty years to
the day after the Counts of Egmond and Hoorne
were executed by the Duke of Alva. The United
Provinces wanted their freedom to begin on the
precise day and hour that those noblemen were
beheaded and paid dearly with their lives for their
struggle for freedom. Conforming to the agree-
ment, The Netherlands was divided into a north-
ern section, which was predominantly Protestant,
and a southern section, predominantly Catholic.
One of the conditions for the independence of
the republic was the closing of the Schelde, which
meant an end to the merchant marine of the citi-
zens of Antwerp. The agreement signed in Mün-
ster was part of the Peace of Westphalia, which
concluded the Thirty Years' War.

In this print Hollar borrowed a great deal from
an etching, *Feast on the Market Place in Antwerp*,
dated 1595 by Pieter van der Borcht (ca. 1540–
1608) in a book by Johannes Bochius, *Descriptio
publicæ ogratulationis Spectaculorum in adventu . . .
Principis Ernesti etc.* (Antwerp, 1595).[60] He shows
a large crowd gathered at the Antwerp town hall,
built between 1561 and 1565 by Cornelis Floris
(1514–1575). For these festivities, a platform was
erected with architectural decor designed by
Erasmus Quellinus (1607–1678).

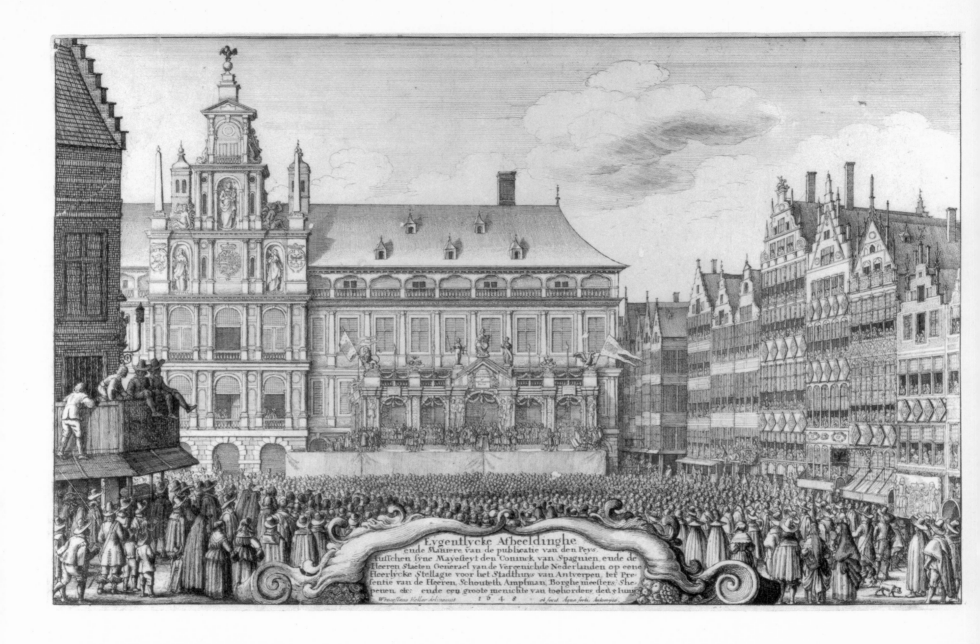

Hendrik van der Borcht the Elder
after Hendrik van der Borcht the Younger
(1614–1654)
P/P 1364 1st state of four
Etching
1650
Below: HENRY VAN DER BORCHT, / De Brusselles
ou il naquit l'an 1583, d'ou il fut emmene en
Allemaigne par les / troubles l'an 1586, et apres il at
appris la Peinture Chez Gilles de Valckenborgh / Estant
retourne d'Italie il a demeure a Franckendael uisques en
l'an 1627 quit est / venu demeurer a Francfort au Pal-
atinat, estant aussi un amateur admirable de / toute
sorte de raretez, et antiquitez auisy, que le Conte
d'Arondell le Cherischoit / pour les rares pieces et Curi-
ositez quil avoit en de luy, tant en Medalles que Peintu
/ res et autre sortes d'Antiquitez, / Henricus van der
Borcht ionior pinxit, W. Hollar fecit, 1650, Ioannes
Meyssens excudit
16.2 x 11.0
16.7 x 11.7

This portrait of Hendrik van der Borcht the Elder
was one of the eight that Hollar did for the collec-
tion of artists' portraits entitled *Images de Divers
Hommes d'Esprit Sublime*, which was published by
Johannes Meyssens starting in 1649. The portrait
of Van der Borcht senior is dated 1650 and was
therefore added in a later edition.

According to biographies under the portrait,
Hendrik van der Borcht (1583–1660) was born in
Brussels, went to Germany, became a student of
Gillis van Valckenborg, lived in Franckendael
until 1627, and later moved to Frankfurt in the
Palatinate. Van der Borcht was an artist, collector,
and dealer. The text relates that Arundel sought
him out for his special collection of coins, medals,
paintings, and other antiquities. When Arundel
was in Frankfurt in 1636, he met Hendrik van der
Borcht the Younger, and perhaps the son's friend
Hollar. The veneration that Hollar felt for the
elder Van der Borcht is apparent in a letter that he
wrote on a proof of the print *Solomon and the
Queen of Sheba* (P/P 74).

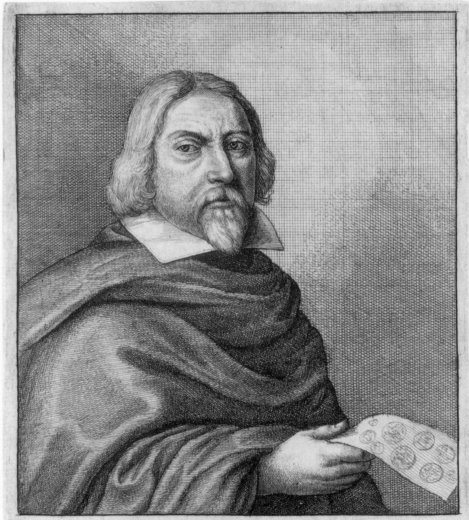

HENRY VAN DER BORCHT,
De Brusselles ou il naquit l'an 1583. d'ou il fut, emmene en Allemaigne par les
troubles l'an 1586. et apres il at appris la Peinture Chez Gilles de Valckenborgh
Estant retourne d'Italie il a demeure a Franckendael uisques en l'an 1627 quil est
venu demeurer a Francfort au Palatinat, estant aussi un amateur admirable de
toute sorte de raretez et antiquitez aussy, que le Conte d'Arondell le Cherischoit
pour les rares pieces et Curiositez quil avoit en de luy, tant en Medalles que Peintu-
res et autre sortes d'Antiquitez,

Henricus van der Borcht iunior pinxit W. Hollar fecit 1650 Ioannes Meyssens excudit

According to the special wish of your son I am forwarding you this proof, made in his presence. Do not think please, that this is a perfect proof of the engraving. I have printed it on paper immediately after removing the acid. But in principle after the acid treatment, corrections on the plate must be done. In this case, however, they were omitted. I am therefore rather reluctant to send you the proof. I never send proofs away unless they are perfect. here in this case, you can only notice and see what the acid has done, but it hasn't been touched by the needle. Hendrick is gone for a rest in the country and asked me to send you his love. You obedient servant, W. Hollar.[61]

This letter is crucial for understanding Hollar's working method. After making a print proof, he perfected the plate with a dry point or a burin.

86
Hendrik van der Borcht the Younger
after Johannes Meyssens (1612–1670)
P/P 1365 2nd state of five
Etching
1648
Below: HENRY VAN DER BORCHT PEINCTRE /
Ne à Franckendael au Palatinat, et a cause de la Guerre venu a Franckfort, en l'an 1636 / passant le Comte d'Arondell Voyagant vers l'Empereur l'emmena et de la l'envoya en Italie / Chez M^r Peti le quel amassa l'Art Pour le dit Comte, de la Passant avec l'arte en Angleterre il / l'a garde jusques au deces du Comte il est Serviteur du Prince de Galles.
Lower L: Iohann Meyssens pinxit et excudit,
Lower R: W: Hollar fecit, 1648
16.2 x 11.3

This portrait of Hendrik van der Borcht junior was also done for *Images de Divers Hommes d'Esprit Sublime* (see cat. no. 85).

The biographical information inscribed at the bottom reports that Van der Borcht, a print artist and ''art historian,'' was born in Franckendael and moved to Frankfurt with his family. Lord Arundel sent him to Italy with William Petty on

HENRY VAN DER BORCHT PEINCTRE,
Ne à Franckendael au Palatinat, et a cause de la Guerre venu a Franckfort, en l an 1636
passant le Comte d'Arondell Voyagant vers l'Empereur l'emmena et de la l'enuoya en Italie
Chez M^r Peti le quel amassa l'Art Pour le dit Comte, de la Passant avec l'art en Angleterre il
l'a garde jusques au deces du Comte il est Serviteur du Prince de Galles,

Iohann: Meyssens pinxit et excudit. W: Hollar fecit, 1648,

the pretext of collecting art. In actuality, the earl had greater plans for the "Dutch youth," according to a letter that Arundel sent to Petty on September 20/30, 1636, from Regensberg.

Good Mr Pettye. I cannot salute you by all occasions and I am sorry that I fea I shall not have the happiness to see you before I go from hence, wch I conceive will be about 19 days hence. I have ordered Henry van de burge, my Dutch youth, to attend at Florence till he hears from you. I will have him only attend to design well, and be bred to see and observe paintings and designs well, that he might be fit another day to take our pictures and collection of Designs at Arundel House, he being apt to love and understand matters of Art.[62]

Van der Borcht was indeed trained by Petty. He copied the complicated nudes by Giorgione and Titian in Venice at the Fondacio dei Tedeschi. Arundel commissioned this project, for he wanted to capture these frescoes, which were badly damaged by the sea air, before it was too late.

After suitable training, Van der Borcht proved capable of managing the Collection Arundeliana. This was a difficult task, because the rooms were open to the public, and he was still bound to make prints of the objects in the collection, particularly the drawings.

With the appointment of Van der Borcht and Hollar, Arundel was following the royal tradition of bringing foreign professionals into their households. Arundel had gotten the idea of employing engravers, in particular, when he saw in Rome the etchings that Goudt had done after paintings by Elsheimer. He considered this the ideal way to reproduce artworks.

Van der Borcht and Hollar maintained a solid relationship that continued when they were both living in Antwerp. There Van der Borcht acted as Hollar's publisher.

87
Giorgione
after Giorgione (1478–1510)
P/P 1408 2nd state of two
Paris 1979, no. 126
Etching
1650
Below: VERO RITRATTO DE GIORGONE DE CASTEL FRANCO / da luy fatto come lo celebra il libro del Vasari
Bottom: W:Hollar fecit ex Collectione Iohannis et Iacobi van Verle, 1650
Lower R: F. van den Wyngarde excudit
25.0 x 18.4
25.9 x 19.3

Giorgione portrayed himself as David with the head of Goliath. Although the original painting has been lost, a copy has been preserved at the Herzog Anton Ulrich-Museum in Braunschweig.

As one of the great painters of the Venetian school, Giorgione was among the first to paint landscapes with an atmospheric radiance. This self-portrait was in the collection of the merchant brothers Johannes and Jacob van Veerle, who owned numerous Italian paintings in Antwerp. The print is part of a series of nine by Hollar, all with approximately the same dimensions and all done after Italian artists.

The copper plate for this print is now in the Chalcographie at the Louvre, Paris (inv. no. 2128).

VERO RITRATTO DE GIORGONE DE CASTEL FRANCO da luy fatto come lo celebra il libro del VASARI.

88
Pietro Aretino
after Titian (1487/1490–1576)
P/P 1348
Etching
1649
Below: VERA EFFIGIE DEL POETA PETRO
ARETINO / CAVATO DA TITIANO SUO
AMICHISSIMO
Bottom: Titianus pinxit, W: Hollar fecit, 1649, Ex
Collectione Iohannis et Iacobi van Verle, Franciscus
van den Wyngarde excudit.
25.5 x 19.0

In this second reproduction of a painting from
the Van Veerle collection, the poet Aretino is
shown in profile. The inscription states that
Aretino was a good friend of Titian. He looks out
meditatively over the undoubtedly symbolic
stump of a small tree, from which a branch with
(laurel?) leaves sprouts. In another portrait of
Aretino that Hollar etched after Titian (P/P
1346), the poet is shown full front. Publisher
Frans van den Wijngaerde (1614–1669), himself
an etcher, had specialized in publishing prints
after Italian paintings. Hollar etched seventeen
prints for him during the time he spent in
Antwerp.

VERA EFFIGIE DEL POETA PETRO ARETINO
CAVATO DA TITIANO SVO AMICHISSIMO.

Titianus pinxit W: Hollar fecit 1649. Ex Collectione Iohannis et Iacobi van Verle, Franciscus van den Wyngarde excudit.

89
Hans von Zürch
after Hans Holbein the Younger (1497/1498–1543)

P/P 1411
Paris 1979, no. 127
Etching
1647
In design, top: HANS VON ZÜRCH GOLTSHMIDT
/ Hans holbein / 1532
Below: Dº MATTHEO MERIANO BASILIENSI,
ARTIS CHALCOGRAPHIÆ PERITIS= / simo, Dº et
Patrono suo dilectissimo, Hanc tabellam dedicat,
Henricus van der Borcht, iunior
Bottom: WHollar fecit, 1647, ex Collectione
Arundeliana
20.0 x 13.1

For this portrait of the goldsmith Hans von
Zürch, Hollar made a beautifully detailed drawing
in reverse to the print (fig. 7). The painting, for-
merly in the collection of the Earl of Arundel and
later in the collection of his wife Aletheia, was
listed among her possessions in Amersfoort,
according to the 1655 inventory.

 After Arundel's death, Van der Borcht stayed
on as manager of the collection. The annotation
to the 1655 inventory reads "Een conterfeytsel
van goldsmith idem (Holbein)."[63] In later years
he was with Hollar in Antwerp, helping him pub-
lish the highlights of the Arundel collection. The
two dedicated this print to Matthaeus Merian the
Elder (see cat. no. 9). It is presumed that Hollar
learned the art of making panoramas and maps at
the workshop that was annexed to the renowned
Merian's publishing house in Frankfurt. In his
youth Van der Borcht also lived in Frankfurt, and
both artists commemorated their master with this
handsome portrait.

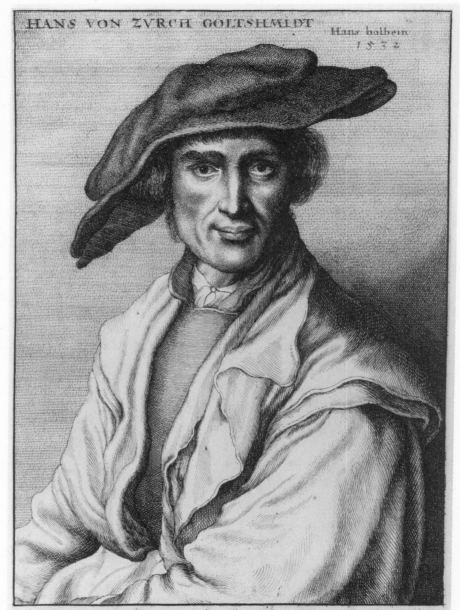

Figure 7
Hans von Zürch
after Hans Holbein
Pen with brown wash
Sprinzels 1938, no. 1
20.5 x 17.1
Narodni Galerie, Prague (Inv. K. 22384)

143

90
Lady Elisabeth Hervey
after Anthony van Dyck (1599–1641)

P/P 1412 2nd state of two
Etching
1646
Below: GENEROSISSIMA Dna ELISABETHA
HARVEY, FILIA DNI HARVEY / BARONIS
KEDBROOCK
Bottom: Antonius van Dyck Eques pinxit H: van der
Borcht iunior exc: WHollar fecit 1646 Antverpiæ
26.0 x 17.9
36.3 x 18.5

Since this portrait was published by Hendrik van
der Borcht in Antwerp, one might wonder who
would be interested in such a typically English
subject. Most likely the portrait's painter,
Anthony van Dyck, was of more interest to the
print publisher than was the sitter.

Lady Elisabeth was the daughter and heiress of
Lord William Hervey of Kidbrooke, who died in
1642. She married John Hervey, the treasurer of
Queen Catherine of Braganza, the spouse of
Charles II. This print is reminiscent of the figures
of women representing the seasons that Hollar
had done in England a few years earlier (see cat.
nos. 24, 33). He may have made this drawing in
England, but the painting was not part of the
Arundel collection, a fact that Van der Borcht and
Hollar should have indicated on the print.

GENEROSISSIMA Dᵃ ELISABETHA HARUEY, FILIA DNI HARUEY
BARONIS KEDBROOCK.

Antonius van Dyck Eques pinxit H: van der Borcht iunior exc: WHollar fecit 1646. Antverpiæ

91

Margaret Lemon
after Anthony van Dyck (1599–1641)

P/P 1456 2nd state of two
Paris 1979, no. 130
Etching
1646
Below: MARGUERITE LEMON ANGLOISE / Flore, Thisbé, Lucresse, & Porcie & Cypris / Ne peuvent en Amour me disputee le pris, / Dans l'Ille d'Albion ie fus presque adoreé, / De mille grands Seigneurs ie me vis honoreé: / Mais ie bruslay pour Eux, Sils pléurerent pour moy / Et mon dernier Amant faict prevue de ma Foy / Par un transport de Flamme & des effects Etranges; Car un foudre de Mars layant privé du jour / D'un mesme traict de feu renflamant on Amour / Ie mimmela moy mesme au blasme & aux Louanges, / R.G. S.ʳD.L.
Beneath: Omnia vincit Amor, & nos Cedamus Amori, Virgil;
Lower L: Anton: van Dyck Eques pinxit,
C: Henr. vander Borcht excudit.
Lower R: W: Hollar fecit 1646
25.6 x 17.5
26.8 x 18.0

The notorious beauty Margaret Lemon is shown here as spring, with the flowers in her hand being associated with love. She was the mistress of Anthony van Dyck, who painted her portrait when he was in London. One line of the French poem below her image places her among the renowned mistresses of classical literature.

The painting has not been preserved, but a drawing in reverse of the print is in the collection of the Fondation Custodia in Paris. Other engravers made prints of the painting in almost exactly the same way, including Adriaan Lommelin (act. 1636–1677) and Jean Morin (1600–1650).[64]

There was an exceptional amount of interest in the temperamental former mistress of Van Dyck. The story goes that, from jealousy and rage over his intended marriage to Maria Ruthven, Margaret bit his thumb so hard that he could no longer paint.

MARGVERITE LEMON ANGLOISE.

Flore, Thisbé, Lucresse, & Porcie & Cypris / Ne peuuent en Amour me disputee le pris, / Dans l'Ille d'Albion ie fus presque adoree, / De mille grands Seigneurs ie me vis honoree: / Mais ie bruslay pour Eux, Sils pleurerent pour moy — Et mon dernier Amant faict preuue de ma Foy / Par vn transport de Flamme & des effects Etranges, / Car vn foudré de Mars layant priué du jour / D'vn mesme traict de feu ren'flamant mon Amour / Ie mimmelar moy mesme au blasme & aux Louanges, / R.G. S.ʳD.L.

Omnia vincit Amor, & nos Cedamus Amori Virgil;

Anton: van Dyck Eques pinxit. Henr. vander Borcht excudit. W: Hollar fecit 1646.

92

Duchess of Lennox
after Anthony van Dyck (1599–1641)

P/P 1457 4th state of six
M.-H. 1956, no. 132
Etching
Below: ILLUSTRISS:ma D:na DOMIna ELISABETHA
VILLIERS DUCESSA DE LENOX ET RICH= /
=MOND, etc: FILIA GEORGIJ VILLIERS DUCIS
ET COMITIS BUCKINGHAMIÆ
Lower L: Ant: van dyck pinxit
C: W: Hollar fecit
Lower R: Ioannes Meysens ex: Antverpiæ
25.0 x 18.4
25.4 x 18.6

Mary Villiers Howard (the name Elisabeth in the
inscription is incorrect), first married Lord Charles
Herbert, and then James Stuart, Duke of Rich-
mond. Here she is shown as the wife of Thomas
Howard Jr. (1622–1685).

 This print was published by Johannes Meyssens
and was part of the *Iconographia*. It is a good
example of a print with numerous states. This
does not happen often in Hollar's work, and
what changes were made usually involved only
the text, the name of the publisher, or the year.
The print, as seen here, acquired more shading
and crosshatching over time as Hollar intended to
deepen the shadows. Such alteration is visible on
the left side of the shawl, on her right hand, in
the area under the roses, and in the shaded parts
of her breast. In the background, details of the
tree trail off into a tangle of shading.

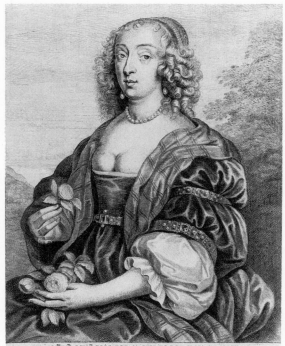

ILLVSTRISS.ma D:DOMI.na ELISABETHA VILLIERS DVCESSA DE LENOX ET RICH-
MOND. etc: FILIA GEORGIJ VILLIERS DVCIS ET COMITIS BVCKINGHAMIÆ.

Ant: van dyck pinxit W: Hollar fecit Ioannes Meysens ex: Antverpiæ

93

Theatrum Mulierum and *Aula Veneris*

As in the seventeenth century, Hollar's work is
today particularly prized for his portraits of
women dressed in various kinds of regional attire
or fashions from different parts of Bohemia, Ger-
many, England, and The Netherlands. He was a
master in depicting fabrics, lace, and fur, as is clear
from these examples taken from a series of 105
costume prints, almost all of which have the same
dimensions. All of them have Latin inscriptions,
and some have English or German translations.

 In 1640, Hollar produced a series of twenty-six
fashion prints of English women for publisher
Peter Stent, which was entitled *Ornatus Muliebris
Anglicanus, or the Severall Habits of English Women,
from the nobilitie to the Country Woman as they are in
these times* (P/P 1778–1803). Two title pages are
known, one from 1643, *Theatrum Mulierum* (The
Theater of Women, P/P 1804), and one dated
1644, with the title *Aula Veneris* (The Court of
Venus, P/P 1805, cat. no. 93A). It is believed
that the *Theatrum* print introduces the first part of
the series, which includes some forty-nine works.

 Most of the prints have English inscriptions
and are dated 1642, when Hollar was still living in
England but after his patron Arundel had gone to
the Continent. Hollar probably felt suddenly lost.
With Arundel he had always been free to do as he
pleased, as attested by his many prints that have
nothing to do with the Arundel collection. Hav-
ing to provide for himself now, Hollar took up
what he did best: miniatures and figures of
women. Most prints from the *Aula* series, which
form a sequel to the *Theatrum* prints, were etched
in Antwerp and were based on sketches done in
earlier years. Prints dealing with Bohemian
women's clothing are often associated with the
year 1636. Nevertheless, it is impossible to make a
clear distinction between prints from the *Theat-
rum* series and those from *Aula*. No single bound
or numbered series is arranged in the same order.

93A
Title page, *Aula Veneris*
P/P 1805 1st state of four without address of publisher
Etching
1644
In design: AULA VENERIS / sive / Varietas Foeminini / Sexus, diversarum Europæ / Nationum, differentiag, habi = / tuum, ut in quælibet Provincia / sunt apud illas nunc vsitati. / quas Wenceslaus Hollar, Bohemus, ex maiori / parte in ipsis locis ad vivas delineavit, cæterasque / per alios delineari curavit, & Aqua forti æri in = / sculpsit, Londini Aº 1644.
9.2 x 5.7

93B
A Servant Girl from Cologne
P/P 1844 1st state of two
Etching
1643
In design, lower L: WHollar inu [1643]
Below: Ancilla Coloniensis.
9.2 x 5.7

Standing nearly full front, this young woman wears a cape over her head. Her simple dress is protected by a large apron.

In the second edition, "a servant Maid of Cologn" and the number "27" are found on the print, but they are not in Hollar's handwriting.

93C
A Noblewoman from Bohemia
P/P 1806 2nd state of three
Etching
1649
In design, upper R.: Ein Böhmische vom Adell, / 1636
In design, lower L.: WHollar fecit 1649
Below: Nobilis Mulier Bohemica
9.0 x 6.0

Wearing a fur-trimmed cape that extends to her knees, this woman wears on her head a pointed fur cap typical of Bohemia. Her outer clothing is raised so that her inner garments extend below it. Hollar noted the date of this drawing as 1636, the year in which he returned to his homeland with Arundel and his entourage for the last time. This print was added to the series starting in 1649.

147

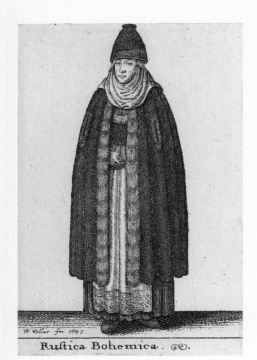

Rustica Bohemica.

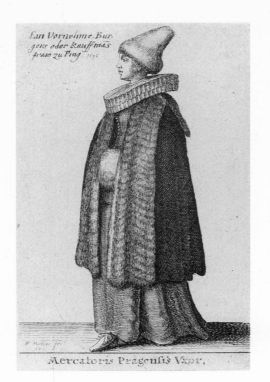

Ein Vornehme Bur
gers oder kauffmas
fraw zu Prag 1636

Mercatoris Pragensis Vxor,

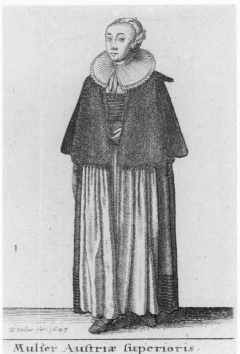

Mulier Austriæ superioris.

93D

A Peasant Woman from Bohemia

P/P 1807 1st state of three
Etching
1643
In design, lower L: W. Hollar fec. 1643
Below: Rustica Bohemica.
9.0 x 6.0

In the second state of the print, Hollar added "Ein Böhmishe / Bawrin 1636" in the upper left corner. The peasant woman is clothed in a cape with narrow fur trim. Her skirt extends to her ankles. She wears a pointed cap and an apron over the ensemble.

93E

Wife of a Prague Merchant

P/P 1808 2nd state of two
Etching
1642
In design, upper L: Ein Vornehme Bur. / gers oder Kauffmas / fraw zu Prag 1636
In design, lower L: W Hollar fec. / 1642
Below: Mercatoris Pragensis Uxor,
9.2 x 5.7

Viewed from the side, this woman also wears a typical Bohemian hat. What is less common is the old-fashioned ruff she wears around her neck. Her cape is trimmed with fur, and she has her hands in a fur muff. The subject for this print also stems from Hollar's journey to Prague.

93F

A Woman from Hungary

P/P 1812 1st state of two
Etching
1643
In design, lower L: W. Hollar fec. 1643
Below: Mulier Austriæ superioris
9.2 x 5.7

In the second state, "a Woman of Upper Austria" was added at the upper left, along with a "9" at the bottom right. Nowhere on the design is it reported that Hollar used drawings from 1636, but in 1643 he was in England. It may be that this print belongs to the 1643 edition of the *Theatrum* series instead of the *Aula* series, and the English subtitle was added for a later English edition.

148

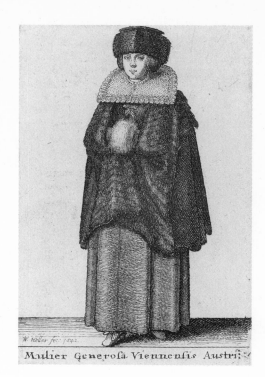

Mulier Generofa Viennenfis Austri:

Mulier Wiennenfis, Auftri

Mulier Pragenfis,

93G

A Viennese Woman

P/P 1813 1st state of two
Etching
1642
In design, lower L: W. Hollar fec: 1642
Below: Mulier Generosa Viennensis Austri:æ
9.2 x 5.7

Facing left, the woman wears an angular hat and a small muff. Her three-quarter-length cape has a wide strip of fur on the front with a rounded square collar. In the subsequent edition, Hollar added to the upper left "Ein Osterreicherin / 1636."

93H

A Viennese Woman

P/P 1814
Etching
1643
In design, lower L: W. Hollar fecit 1643
Below: Mulier Wiennensis Austri
9.3 x 6.0

Viewed from the side, the woman wears a broad-brimmed hat and a cape with open sleeves. This is clearly a summer outfit since, instead of a muff, she wears elaborate gloves.

93I

A Woman from Prague

P/P 1810 1st state of three
Etching
1643
In design, lower L: W. Hollar fecit 1643
Below: Mulier Pragensis
9.2 x 5.7

Like cat. no. 93G, this print has a German title—"Ein Pragerin"—in the second state and the date 1636.

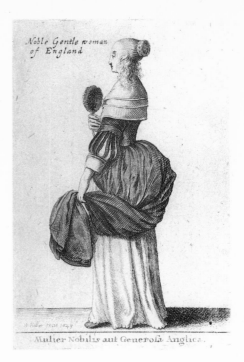

94A

A Noble Englishwoman
after Anthony van Dyck (1599–1641)
P/P 1883
Etching
In design, top: Ein Englische von Adell, 1644
In design, bottom: Ant: van Dyck pin: WHollar
fecit 1649
Below: Nobilis Mulier Anglica.
9.0 x 6.0

This print was done after a painting by Van Dyck,
probably one of his studies for a female figure that
was part of a larger painting.

The woman, in a low-necked summer dress
with a tight bodice, is bareheaded and holds a fan
in her hand.

94B

A Noble Englishwoman
P/P 1885 2nd state of three
In design, upper L: Noble woman of / England
In design, lower L: W. Hollar inu et fecit
Below: Nobilis Mulier Anglicana
9.0 x 6.0

This is one of the few times that Hollar did not
provide a date for his print. While the English
caption is not in Hollar's handwriting, it does
match that on other prints with English transla-
tions. It seems likely that this print was added to
the series by Peter Stent in England.

The woman wears the same clothes and hair-
style as Hollar shows her in his seasons (cat. no.
24). A transparent lace collar covers her low-
necked dress, and in her hand she holds a feather
fan attached by a ribbon to her bodice.

94C

A Noble Englishwoman
P/P 1886 2nd state of three
Etching
In design, upper L: Noble Gentle woman / of England
In design, lower L: W Hollar fecit 1643
Below: Mulier Nobilis aut Generosa Anglica
9.0 x 6.0

This print was probably part of Peter Stent's ini-
tial publication of the first part of the *Theatrum*
series. The print suffered at the hands of a reviser.
Shading was added rather coarsely to the back of
the head. The line under the nose was deepened,
causing the print to become overly dark there,
and the hand holding the fan was carelessly
retouched between the fingers. As a result, the
face has scarcely any expression, a stark contrast to
cat. no. 94A, in which the whole point was indi-
viduality. The handwriting of the English text is
the same as in cat. no. 94B. The number "13"
was added in the third edition.

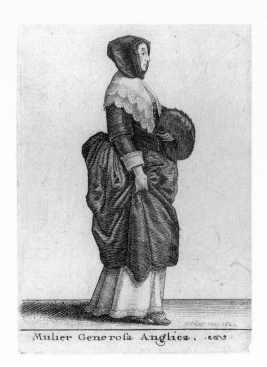

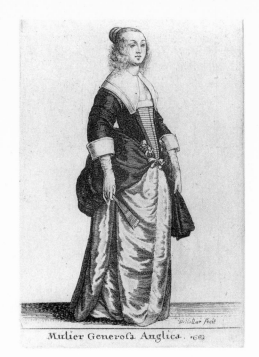

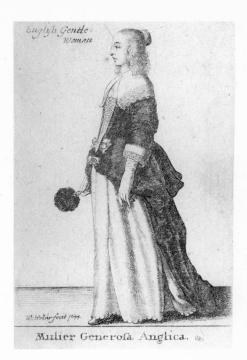

94D

An Englishwoman

P/P 1888 1st state of four
Etching
1642
In design, lower R: W.Hollar inu: 1642
Below: Mulier Generosa Anglica.
9.0 x 6.0

Based on its date of 1642, the drawing for this print was done in England. In the second state, "English = Gentle-woman" was added in the same handwriting as in cat. nos. 94B and 94C. The woman wears the same hood-like cap as seen in the representation of autumn in Hollar's series of the seasons (cat. no. 24C). She also wears a double lace collar and *the* muff. The stereotypical face is striking in its lack of personality. Perhaps Hollar occasionally thought a costume print should be anonymous so that more attention would be paid to the clothing. Whenever he drew this type of face, he based his work on a classical ideal of beauty, one that favored connecting the forehead and the nose in a straight line.

94E

An Englishwoman

P/P 1889[65]
Etching
In design, lower R: W: Hollar fecit
Below: Mulier Generosa Anglica
9.0 x 6.0

The print in the Museum Boymans-van Beuningen is undated. Dressed in a walking costume, her outer garment gathered at the back, the woman wears a very simple collar and holds a fan in her right hand.

94F

An Englishwoman

P/P 1890 2nd state of three
Etching
1644
In design, upper L: English Gentle= / woman
In design, lower L: W:Hollar fecit 1644
Below: Mulier Generosa Anglica.
9.0 x 6.0

The handwriting in the upper left may be by Hollar himself. Dressed in a summer outfit, the woman has a feather fan in her gloved right hand, and a lace collar is draped over her shoulders. The hem of her dress is scalloped.

151

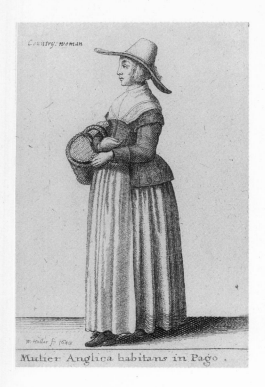

Mulier Anglica habitans in Pago.

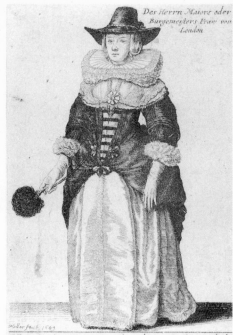

D: Maioris sive Pretoris Londinensis Uxoris hab.

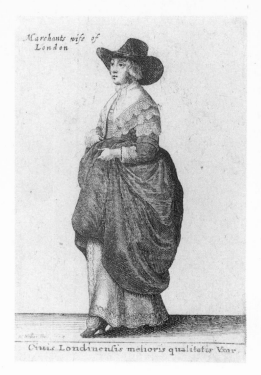

Ciuis Londinensis melioris qualitatis Uxor.

94G

English Country Woman

P/P 1891 2nd state of three
Etching
1643
In design, upper L: Country:woman
In design, lower L: W. Hollar f. 1643
Below: Mulier Anglia habitans in Pago
9.0 x 6.0

This print probably belongs to the first edition, which was published in 1643 under the title *Theatrum Mulierum*.

94H

Wife of the Mayor of London

P/P 1892 2nd state of two
Etching
1649
In design, upper R: Des Herrn Maiors oder / Burgemeisters Fraw von / London
In design, lower L: Hollar fecit 1649
Below: D:mus Maioris sive Pretoris Londinensis Uxoris hab.
9.0 x 5.7

This ornately dressed woman is seen in her finery, from her tall, broad-brimmed hat and her two collars to her feather fan attached by a ribbon to her bodice. Her outer clothing is gathered at the back to reveal the sheen of her skirts beneath.

The drawing for this print is in the Springell collection.[65]

94I

Wife of a London Merchant

P/P 1893 5th state of six
Etching
1643
In design, upper L: Marchants wife of / London
In design, lower L: W.Hollar fec 1643
Below: Ciuis Londinensis melioris qualitatis Uxor
9.0 x 6.0

The English title has been etched in by the same, although unknown, hand. Wearing a lace collar and a tall hat with a broad brim, the woman lifts her skirt to show a petticoat with an embroidered hem. Her shoe with its rosette resembles those seen in the still life on the title page of the *Aula* series (cat. no. 93A). Interestingly, this still life features all the accessories that appear in the costume prints.

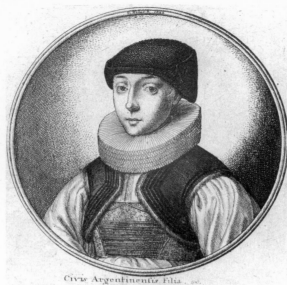

Civis Argentinensis Filia.

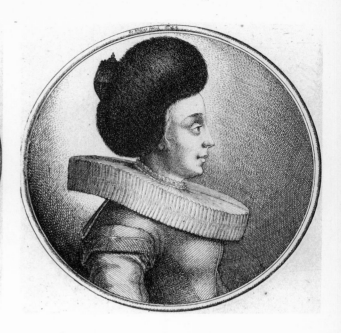

95A
Woman with Fur Hat
P/P 1939 2nd state
Etching
1645
Lower R: W.Hollar fecit / Antverpiæ 1645
10.1 x 9.4

The head covering and face of this model bear a striking resemblance to those in cat. no. 93G (P/P 1813). Hollar did this print after the series of women's costumes, and he apparently produced close-up versions of certain prints from the *Aula* and the *Theatrum* series. Those figures seen in the series "women's heads in circles" (P/P 1908–1944) are either true portraits or the heads of models. The identity of some of them is known. For example, P/P 1910 is the Duchess of Lennox, and P/P 1913 is Henrietta Maria.

95B
Woman with Fur Hat from Strasbourg
P/P 1934 2nd state of two
Etching
1642
In circular frame, top: W.Hollar f. 1642
Below: Civis Argentinensis Filia
9.9 x 9.3

These four etchings of women (cat. nos. 95A-D) are essentially studies of head coverings. This woman from Strasbourg wears a small cap with side flaps that turn down. Her traditional clothing, featuring a small bolero and an elaborate, high bodice, are characteristic of the region around Strasbourg.

95C
Woman with Fur Hat in Profile
P/P 1938 1st state of two
Etching
1642
In round frame, top: WHollar fecit 1642
9.2 x 9.2

Seen in profile, this woman wears a ruffled lace collar and an unusual fur head covering with an ornament at the back. "Mercatoris Francofurtensis Uxor" (Wife of a Frankfurt merchant) was added in the second state of the print.

153

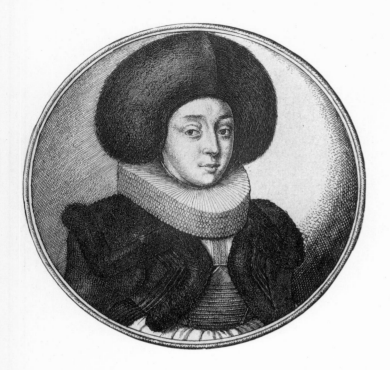

95D
Woman with Fur Hat
P/P 1935
Etching
1643
Lower L: W. Hollar fecit / Londini 1643
9.2 x 9.2

This woman's fur hat encircles her head like an
aureola. Her clothing is reminiscent of the tradi-
tional costume from Strasbourg and resembles
that worn by the woman in cat. no. 95B. With
her eyes directed toward the viewer, her face
retains its personal features.

96
Three Portraits of Women
after Parmigianino (1503–1540)

When reviewing his entire production of prints,
Hollar created a proportionately great number of
works after Parmigianino: four portraits of
women (P/P 1622–1625; cat. no. 96), six designs
for helmets (P/P 1916–1921; cat. no. 97), a sleep-
ing Hercules (P/P 275; cat. no. 65), and two
standing women (P/P 601, 602). In the 1655
inventory list of the Arundel collection, twenty-
six paintings, but no drawings, by Parmigianino
are mentioned. At one time Arundel did own a
large number of drawings by Parmigianino. Per-
haps they were all sold by the countess, who often
needed money to get her son, Lord Stafford, out
of debt. As a true admirer of drawings, Arundel
frequently paid more attention to the manner in
which the drawing was done, rather than to the
image itself. He purchased various versions of the
same subject by certain artists, such as Parmi-
gianino. It is also uncertain why Hollar did not
note on these etchings the source for the models.

Girolamo Francesco Mazzola, called Parmi-
gianino, was born in Parma. During his residence
in Rome (1523–1527), he was greatly influenced
by the art of Raphael. His distinct, mannerist style
is recognizable from his gracefully elegant, drawn-
out figures with small heads and pointed fingers.
His inventive spirit revealed itself particularly in
his drawings, which were made into prints until
the eighteenth century. Through the efforts of
engravers Hendrik Goltzius (1558–1617) and
Bartholomeus Spranger (1546–1611/1617), the
drawings and prints were of great importance for
the development of mannerism in The
Netherlands.

On rare occasion Parmigianino drew a portrait
or a pair of stylized self-portraits. Heads such as
these are among the exceptions, and these etch-
ings serve to illustrate various hairstyles. All the
prints after Parmigianino by Hollar bear the year

1645, with the exception of P/P 1624, which was done right after the new year. In none of these prints after Parmigianino is the publisher named. As was his practice, Hollar adhered quite strictly to his model and omitted nothing from Parmigianino's paintings. Hollar's manner of etching was so personal, however, that his work is always recognizable.

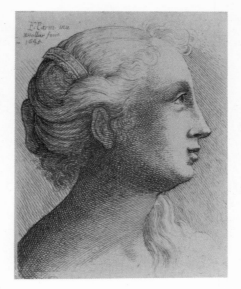

96A
Head of a Young Girl
after Parmigianino
P/P 1622
Etching
1645
In design, upper L: F.Parm inu / WHollar fecit / 1645
6.8 x 5.3
7.1 x 5.5

This portrait is of a woman in profile, facing right. A sort of diadem at the back of her head holds her hair in place. A long section of her hair falls over her left shoulder.

Another female portrait, printed in the same year that Hollar did his etchings after Parmigianino, bears an unmistakable likeness with this image (fig. 8). A string of pearls binds up the woman's hair, and pearls hold her braid in place at the back of her head.

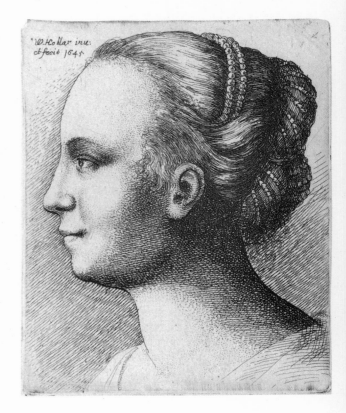

Figure 8
Portrait of a Young Woman
P/P 1714
Etching
1645
In design, upper L: W. Hollar inu: / et fecit 1645
11.3 x 8.2

155

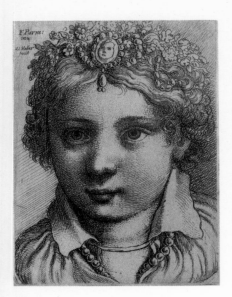

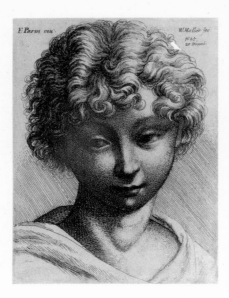

97

Five Designs for Helmets
after Parmigianino (1503–1540)

In this series of five men's heads with designs for
helmets, the emphasis is placed on the helmets,
each of which is different in shape and decoration.
All the heads face right. These works could be
classified under the term "ornamental prints,"
since the helmets are so fancifully designed that
they clearly function as models. Only one edition
of all six prints is known. Designs for helmets are
much less common than designs for daggers or
swords.[67]

96B
Head of a Young Girl
after Parmigianino
P/P 1623
Etching
1645
In design, upper L: F Parm: / inu: / W. Hollar / fecit
7.1 x 5.3

On her head this young girl has a crown of flowers
and a strand of pearls with a cameo at the center.
Her expression is particularly personal, and her
eyes focus somewhat inquiringly on the artist.

96C
Head of a Young Girl
after Parmigianino
P/P 1625
Etching
1645
In design, upper L: F:Parm inu:
In design, upper R: W.Hollar fec: / 1645 / 29 Decemb:
9.2 x 6.8
9.4 x 6.9

With much of the head and shoulders in shadow,
this figure closely approximates the characteriza-
tion of Parmigianino. The face is stylized in shape,
and the features are stereotypical. The neck
appears too narrow for the head. It is clear how
much Hollar borrowed from Parmigianino in
those portraits of women that the printmaker
described as having designed himself.

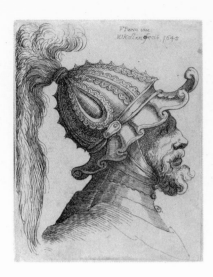

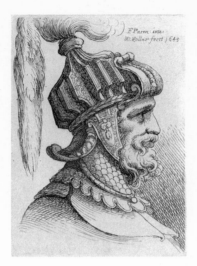

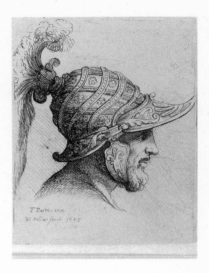

97A
Helmeted Head
after Parmigianino
P/P 1617
Etching
1645
In design, upper R: FParm inu: / WHollar fecit 1645
6.9 x 4.9

This man's helmet has an undulating border. Pointed bands run vertically to the back and meet at a tuft that leads to a handsome ponytail. The helmet is fastened under the chin.

97B
Helmeted Head
after Parmigianino
P/P 1618
Etching
1645
In design, upper R: FParm: inu: / W. Hollar fecit 1645
6.9 x 5.1

The helmet worn by this bearded man has decorated ear guards. A rear flap curves outward to protect his neck. The helmet consists of segments with deep notches, as in a ruff. In the front, the man wears a cuirass made of overlapping plates that extend high up on his neck.

97C
Helmeted Head
after Parmigianino
P/P 1619
Etching
1645
In design, lower L: F Parm. inu: / W.Hollar fecit 1645
6.8 x 5.4

A free-moving flap over the forehead is embellished with stylized plant motifs. The man's neck is protected by metal that curves outward and is decorated with the same plant motifs. The head and neck pieces are connected by bands. Undulating bands run across the helmet on top of the vertical bands. A plume is attached at the top.

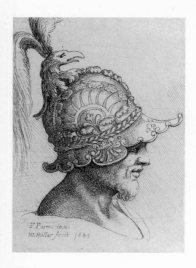

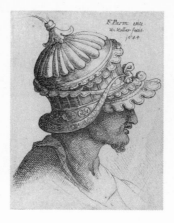

97D
Helmeted Head
after Parmigianino
P/P 1620
Etching
1645
In design, lower L: F Parm: inu: / W. Hollar fecit 1645
6.8 x 4.8

On this helmet with a scalloped edge, stylized acanthus leaves project outward from the band of the helmet. On the side appears a sun design with curved rays. A plume rises from the head of an eagle, which decorates the top of the helmet.

97E
Helmeted Head
after Parmigianino
P/P 1621
Etching
1645
In design, upper R: F.Parm: inu. / W. Hollar fecit. / 1645
5.8 x 4.3

The shape and decoration of the helmet is strikingly rich in scalloped borders. The top, with a shell motif, ends with the suggestion of a plume. Shadows cast by the helmet's edge hide the man's features.

98, 99
Caricatures
after Leonardo da Vinci (1452–1519)

Hollar was the first engraver to be commissioned to make reproductions of an initial sketch, the *prima idea*. This series of prints after Leonardo was something new in the history of art. In the fifteenth century, science was occupied with describing the differences in human nature. A versatile artist and scientist such as Leonardo wanted his art, which was then largely considered good craftsmanship, to be based on his knowledge of nature.

Medieval physiology taught that the body consisted of four kinds of humors that determined a person's temperament. The organs that secreted these substances were in turn influenced by the power of the planets. One's character thus lay in the stars. Temperaments were also interconnected with animal species and the four elements.

Phlegm—phlegmatic—lamb—water
Blood—optimistic—monkey—air
Yellow bile (cholera)—irascible—lion—fire
Black bile—melancholy—earth

Leonardo subscribed to the idea that a person's physiognomy revealed the nature of the individual, including bad qualities and temperament. In Renaissance art, and thus in Leonardo's work, a common subject was the irritable, or choleric individual, who is mainly shown as a naked warrior with a lion's mane or is accompanied by a lion. The melancholy individual also appealed as the ideal contemplative man. The personification of melancholy was made famous particularly through a print by Dürer (Bartsch, 74).

Leonardo was almost obsessed with the deterioration of beauty due to age. The following works are not so much caricatures as they are studies of the heads of older men whose faces have been distorted with the passing years, and they often have become toothless caricatures of themselves.[68]

Kenneth Clark noted that these drawings may be repulsive to the modern viewer, yet they were the first of Leonardo's drawings to be appreciated in the seventeenth and eighteenth centuries.[69] Leonardo's uncompromising depiction of human decay proved to be especially popular during the Renaissance. In his notebooks, the Italian master mentioned that he sought out people for their "fantastic" features. Most of the heads were done from life, although some of the features were exaggerated.

An album of Leonardo's drawings, now in the collection of the Royal Library of Windsor, must have been in Arundel's possession by 1637. From then until 1642, Hollar worked on these drawings, although they were made into prints in Antwerp. Strangely enough, with the exception of P/P 1604 and P/P 1609, Hollar did not include the words "Ex Collectione Arundeliana" on these prints. This series of prints underwent two subsequent editions, one in 1648 and another in 1666.

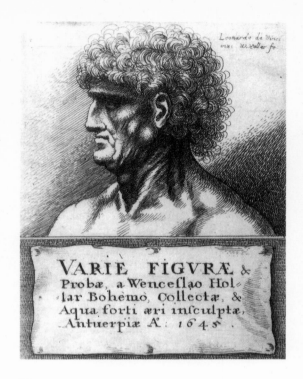

98
Title page, *Varie Figuræ*
after Leonardo
P/P 1558 1st state of two
Etching
1645
In design, upper R: Leonardo da Vinci / inu: W.Hollar fe:
In design, below: VARIE FIGURÆ & / Probæ, a Wenceslao Hol= / lar Bohemo, Collectæ, & / Aqua forti æri insculptæ / Antverpiæ Aº: 1645
9.4 x 7.1

This title page introduces a series of fifty-two heads, mainly of men whose features are misshapen or have been converted into caricatures (P/P 1558–1610B). Leonardo often used this profile of a middle-aged man, sometimes showing him with a shock of curly hair, at other times, as in cat no. **99C**, with long hair flowing back. Neither a sense of caricature nor misshapen features

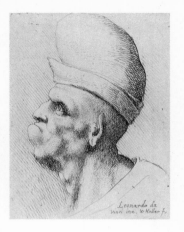

detract attention from the greatly exaggerated muscles of the neck. This man, with his proud facial expression, is undoubtedly a choleric type.

99A
Caricature
after Leonardo
P/P 1570
Etching
In design, lower R: Leonardo da / Vinci inu, WHollar f.
5.6 x 4.2

This man is deformed in a variety of ways: he has a high back, multiple chins, a lower lip that sticks out, and large ears. Whether he has a pointed head under his pointed cap will remain a mystery for all time.

159

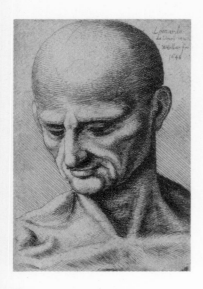

99B
Caricature
after Leonardo
P/P 1578
Etching
1648
In design, upper R: Leonardo / da Vinci inu, / WHollar
/ fec. / 1648
6.7 x 4.7

An older, bald man with pronounced features is
shown with a bare torso, thus emphasizing his
neck and chest muscles. The man is apparently at
rest, yet his muscles are tensed. Since this etching
is not a caricature, it fits better with Leonardo's
series of anatomical prints (see cat. no. 58). This
figure is taken from an annotated anatomical
drawing of the muscles of the neck, head, and
arms of several figures (Royal Library, London).[70]

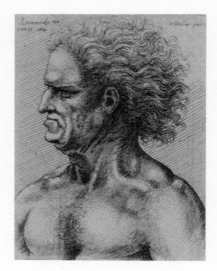

99C
Caricature
after Leonardo
P/P 1579A
Etching
In design, upper L: Leonardo da / Vinci inu
In design, upper R: WHollar fec:
6.2 x 4.7

This figure shares much in common with that of a
helmeted warrior in a silver pencil drawing in the
British Museum.[71] Leonardo did several varia-
tions on this "Roman emperor" type. In his
drawings, this type of bellicose warrior appears
frequently with a lion's mane. This person is
clearly to be considered choleric, and he closely
resembles the figure in cat. no. 98.

 Leonardo subscribed to the belief that facial
features in part revealed the nature of the person.

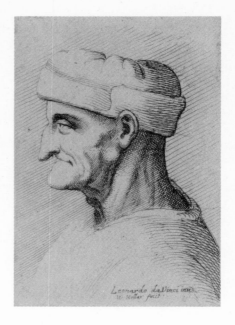

99D
Caricature
after Leonardo
P/P 1581
Etching
In design, lower R: Leonardo daVinci inu, / W. Hollar
fecit:
7.7 x 5.3

Taken by itself, this print is reminiscent of a cari-
cature. It seems to summarize all old men drawn
by Leonardo. They share the long, curved nose
that almost touches the jutting chin, and the
heavily accentuated yet toothless mouth. In addi-
tion, this figure has a flat head. Time and again
these sorts of chins and lower jaws that close
above the upper jaws appear in Leonardo's
sketches.[72]

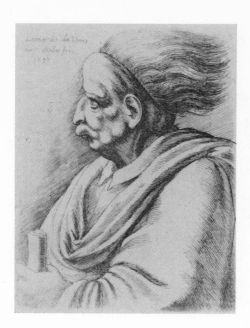

99E
Caricature
after Leonardo
P/P 1576
Etching
1648
In design, upper L: Leonardo da Vinci / inu. WHollar
fec: / 1648
7.8 x 5.8

Hollar dated this print 1648, which means that he
added this sketch for the second edition. The man
has a protruding upper lip. Hair flows back from
his wig as if it were blown by a strong wind.

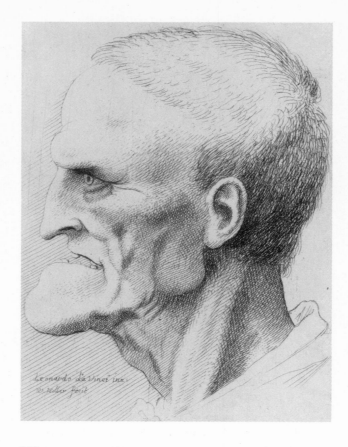

99F
Caricature
after Leonardo
P/P 1577
Etching
Below L: Leonardo da Vinci inu: / W.Hollar fecit
11.1 x 7.9

This man with a protruding chin is a variation on
the type of old man who so fascinated Leonardo.
The artist was intrigued by the physical decline
that occurs as people grow older.

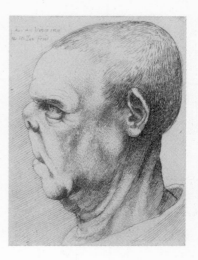

99G
Caricature
after Leonardo
P/P 1573
Etching
In design, upper L: L. da Vinci inu / W.Hollar fecit
6.4 x 4.8

This print, which definitely shows a case of mal-
formation, best fits in with the category of carica-
tures. The drawing by Leonardo on which the
print was based was described in 1963 in a Chris-
tie's auction catalogue.[73]

161

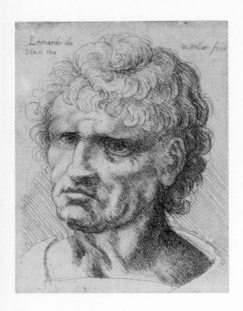

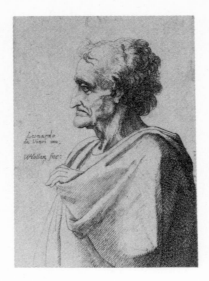

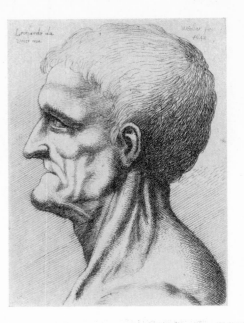

99H
Caricature
after Leonardo
P/P 1579
Etching
In design, upper L: Leonardo da / Vinci inu
In design, upper R: W.Hollar fecit
6.2 x 4.7

Within the series of so-called caricatures, this head is the most normal. It may portray a melancholy individual. The features express a somber state of mind.

99I
Caricature
after Leonardo
P/P 1580
Etching
In design, center L: Leonardo / da Vinci inu: / WHollars fec.
6.2 x 4.5

Hollar's signature has acquired a letter *s*. All the characteristic elements of Leonardo's portraits of old men are present in this handsome head. Here they are drawn within acceptable proportions, resulting in a realistic portrait.

It is evident in this etching that Hollar remained faithful to the idea of a sketch. As is often seen in sketches, part of the drawing is finished in detail while other sections are indicated with just a few lines. Hollar did not attempt to make a completed drawing of the original work.

99J
Caricature
after Leonardo
P/P 1582
Etching
1648
In design, upper L: Leonardo da / Vinci inu
In design, upper R: WHollar fec: / 1648
7.8 x 5.7

This head resembles that of the other old men. The group of muscles from the neck to the shoulders is striking. Clearly muscles were not involved in decline, according to Leonardo. The strength of the muscles contrasts sharply with the weary eyes and sunken cheeks.

100–104
Ornamental prints
after Hans Holbein the Younger (1497/1498–1543)

A variety of ornamental work developed and flowered in sixteenth-century Italy, Germany, and particularly The Netherlands. Publication of ornamental prints accounted for much of this rise in interest. Such works were used exhaustively by stone masons, wood cutters, silver- and goldsmiths, armorers, carpet weavers, and makers of plates and dishes. They found these ornamental prints to be a valuable resource from which they could choose their designs. Motifs came from various sources. For example, in late medieval book illustrations, monkeys and bears symbolized the female and male sexes. These figures, which were shown amid flowers, fruits, and grotesques (Italian *groteschi*, or grotto paintings), were taken from wall decorations of houses that dated from Roman antiquity, which were excavated around 1490. The grotesques consist of elegantly thin tendrils with human figures, satyrs, animals, fruits, trophies, and architectural elements between them. Scrollwork, a typical embellishment in the north, greatly influenced the ornamental arts. Its origins can be traced to thirteenth-century art, where bands of clouds were used to indicate the separation between heaven and earth.

Hans Holbein designed vases, jugs, and ornamental arms probably for Henry VIII. The drawings from the Arundel collection, which were used as a source for these prints, have not been found. One drawing in the British Museum for a design of a ceremonial sword does bear some resemblance to cat. no. 104.[74]

In the decorations for three jugs (cat. nos. 100–102), Holbein adapted the arabesque motif with its continuous stylized plants and flowers. Its origins are in Islamic architecture around the year 1000, and it was added to the store of ornaments during the classical and Renaissance periods. Hol-

lar made eleven prints of plates and dishes after models by Holbein (P/P 2626–2637).

100
Jug with a Narrow Spout
after Hans Holbein
P/P 2637
Etching
In design, lower L: HHolbein delin: WHollar fecit.
15.5 x 14.3

Arabesques decorate the foot and encircle the jug itself. The narrow spout ends in a snake's head. The handle curves gracefully and ends at the top and bottom with a plant motif. An elaborate knob tops the lid.

101
Jug with Arabesques on the Base
after Hans Holbein
P/P 2635
Amsterdam 1988, p. 175, no. 333.6
Etching
In design, lower R: HHolbein inu: / W.Hollar fecit
16.6 x 11.4

Both ends of the handle on this simply shaped jug
end in a graceful curl. The bottom part of the jug
and the lid are decorated with arabesques.

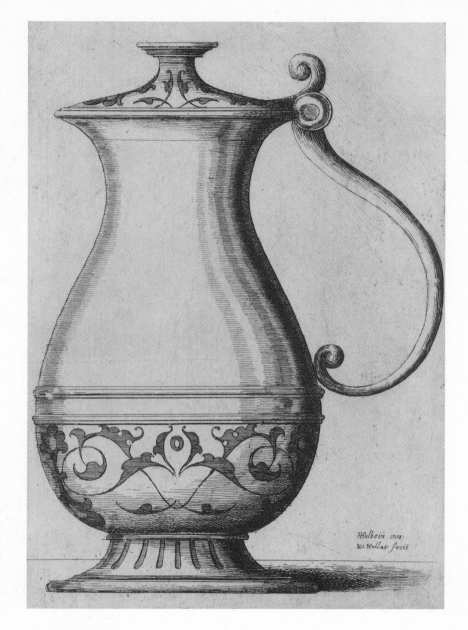

102
Jug with Arabesques
after Hans Holbein
P/P 2634
Etching
1645
In design, lower L: HHolbein inu: / W.Hollar fec:
1645
15.2 x 11.3

Heavily decorated with arabesques, this wide jug
has a handle and lid but no spout. Hollar did this
print in Antwerp and omitted any indication of
the provenance of the original object. Prints made
after these jugs date between 1642 and 1649, and
no publisher is mentioned. It is unclear whether
they can be grouped as a series.

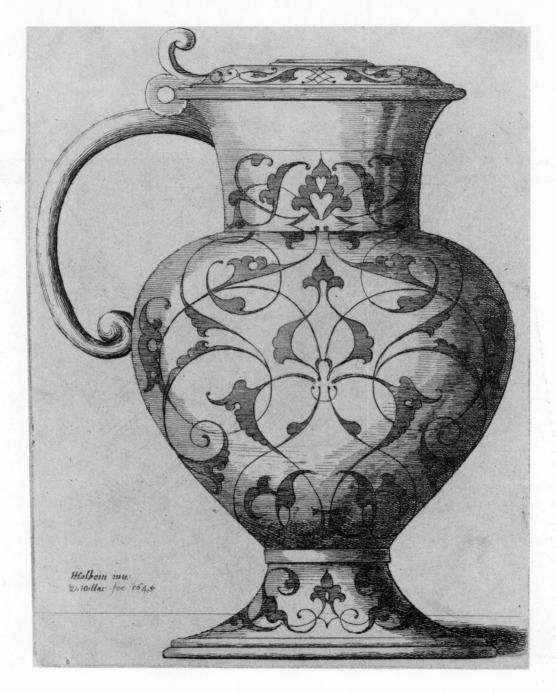

103
Ornate Goblet
after Hans Holbein
P/P 2631
Amsterdam 1988, p. 175, no. 333.2
Etching
1642
In design, lower R: H. Holbein delin: W.Hollar fecit
Londini. 1642, secundum / Originale quod habet
Comes Arundeliæ
19.4 x 13.5

Hollar etched this print while still in England
with the intention of publishing it as part of the
catalogue of Arundel's collections, as the earl had
intended. Unlike the previous entries (cat. nos.
100–102), more than arabesques decorate this
ornate goblet. It stands on a foot formed from
three paws with claws. Above that rests a bracket
with the heads of satyrs.[75] The bowl of the goblet
is decorated with basketwork, and above that a
frieze with a garland of flowers. Arabesques
enliven the lid's surface and draw attention to the
central medallion of three seated female nudes. A
nude couple embracing forms the knob of the lid.

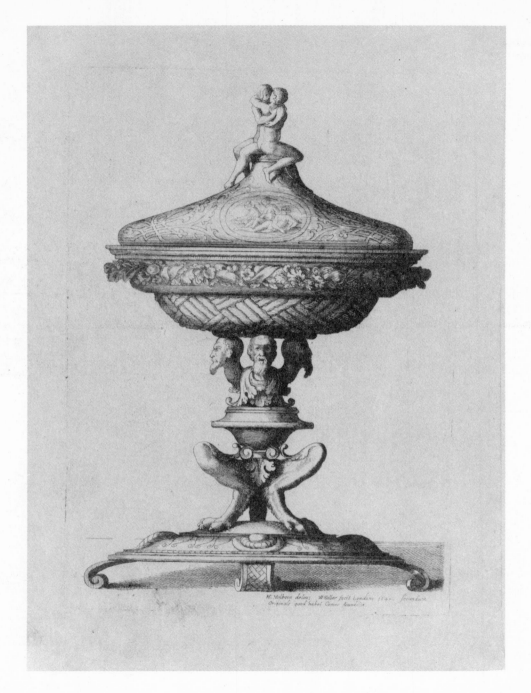

104
Dagger and Scabbard
after Hans Holbein
P/P 2597
Amsterdam 1988, p. 174, no. 332.2
Etching
1645
In design, left C: HHolbein olim delineavit, / W: Hollar fecit Antverpiæ, Aº 1645 / ex Collectione
Arundeliana
15.6 x 11.5

This print explores the classical motifs of acanthus
leaves, masks and figures, a ram's head, and satyrs
that decorate this scabbard and dagger.

Seen in its scabbard, the hilt of a dagger is
formed by two flute-playing satyrs that recline
atop protruding tendrils. A ram's head is drawn
between them. The hilt, decorated with tendrils,
the faces of women, and a mask, fits into a scabbard onto which two chains are attached. The
knob of the dagger, shown to the left, consists of
a herm with its arms bent up to its ears. The arms,
in turn, are framed by acanthus leaves. The young
male figure carries a basket of apples on his head.

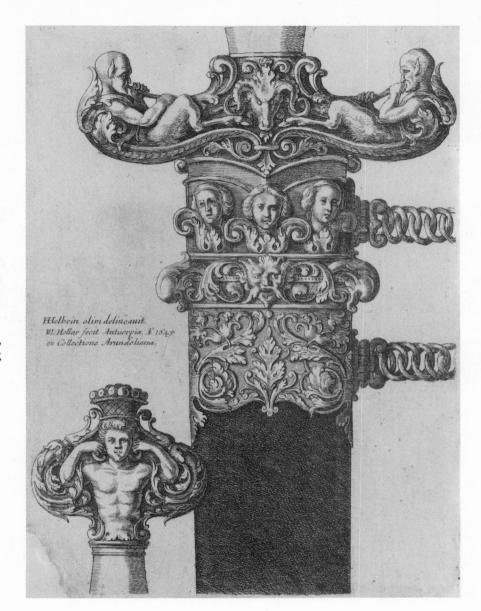

105
Antique Bust of a Woman
P/P 590 1st state of two
Etching
1645
In design, upper R: W: Hollar delin: in Domo Arun-
deliana, Londini, / et sculpsit A° 1645
11.5 x 7.7
11.7 x 7.9

In 1645, Hollar was in Antwerp, where this print
was done from an older drawing. It shows a mar-
ble bust of a woman from Arundel's famous col-
lection of ancient sculpture. This drawing is
reversed with respect to the statue, which is now
in the Ashmolean Museum at Oxford, England.
In the second edition, the print bore the inscrip-
tion "FAUSTINA impera / trice Marcus Aure /
lus Uxor" in the lower left corner of the image. In
reality, the bust consists of two parts. The ideal-
ized head matches the portrait of a goddess,
although the bare breast is consistent with the
portrayal of an Amazon. The head is found to the
right, on the ground, in cat. no. 83.

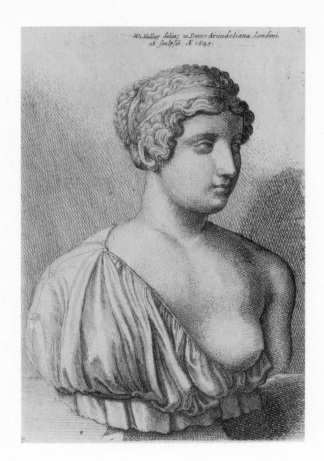

106
Strasbourg Cathedral

P/P 892
Paris 1979, no. 91
Etching
1645
In design, lower L: W Hollar fecit 1645
Below: TURRIS ET ÆDES ECCLESIÆ CATHE-
DRALIS ARGENTINENSIS. / à Wenceslao Bohèmo,
primo ad vivum delineata, et aqua forti æri insculpta,
A⁹ 1630. denuoque, facta Antverpiæ, A⁹ 1645.
22.2 x 18.0

Hollar again describes in detail the history of this
print. He was in Strasbourg in 1630 and did many
drawings of the city and its features at that time
(see cat. nos. 1, 3, and 123). He probably left the
copper plate in Strasbourg, which required him,
as he notes in the inscription, to etch the print
again. He also signed the plate at the lower left:
"W; Hollar fecit 1645." The exact preliminary
drawing for this print has not been found,
although there is a drawing in the printroom at
Berlin-Dahlem in which the cathedral is seen from
the west.[76]

The construction of the cathedral lasted from
the twelfth to the fourteenth centuries. Hollar
drew Notre Dame Cathedral from the northwest,
where the tower with its spire dominates the west
facade and the north side. The cathedral has three
doors, with an enormous rose window above the
central one. Two galleries with large windows pro-
vide light in the nave. To the side are the sacristy
and the entrance to the transept, toward which a
procession of the faithful is moving. Small stands
that sell goods are located around the cathedral.

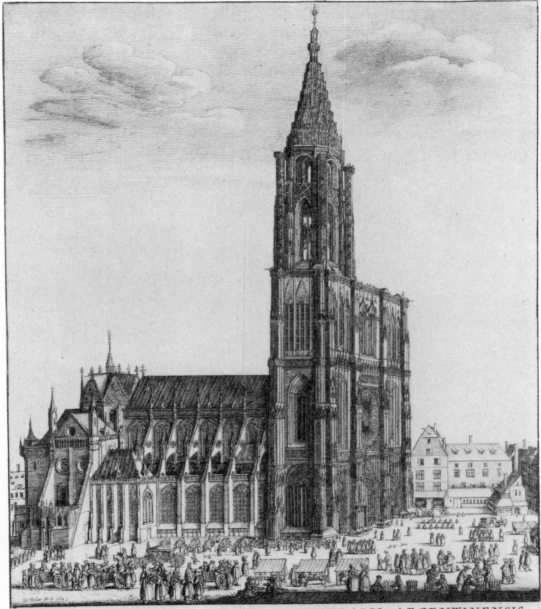

TVRRIS ET ÆDES ECCLESIÆ CATHEDRALIS ARGENTINENSIS.
à Wenceslao Hollar Bohèmo, primo ad vivum delineata, et aqua forti æri insculpta, A⁹ 1630. denuoq, facta Antverpiæ, A⁹ 1645.

107
Antwerp Cathedral

P/P 824 1st state of five
Paris 1979, no. 82
Berlin 1984, nos. 78, 79
Etching
1649
In design, lower L: Wenceslaus Hollar delineavit, et
fecit, 1649
Below: PROSPECTUS TURRIS ECCLESIÆ CATHE-
DRALIS, BEATISSIMÆ VIRGINIS MARIÆ DEI
PARÆ, ANTVERPIÆ, OCCIDENTEM VERSUS
46.5 x 33.0

The Notre Dame Cathedral on Groenplaats
[Green Square] in Antwerp is the largest Gothic
church in Belgium. Its construction lasted from
approximately 1352 to 1530. The south tower
was never completed due to lack of funds. This
print shows the west facade in great detail. In the
tympanum above the west entrance is seen *The
Last Judgment*. At the farthest right buttress of the
north tower stands the sepulchral monument to
the painter Quinten Matsys (1466–1530). A pro-
cession of the faithful crosses the square and
enters the church from the right.

Hollar did various drawings for this difficult
subject. Two of them are in the Kupferstich-
kabinett in Berlin-Dahlem.[77] Other drawings of
the Antwerp Cathedral are in the Springell collec-
tion in Portinscale, Keswick.[78]

The darker section at the bottom right is a typ-
ically Hollaresque feature that acts as a repoussoir
for the main motif.

PROSPECTVS TVRRIS ECCLESIÆ CATHEDRALIS, BEATISSIMÆ VIRGINIS MARIÆ DEI PARÆ ANTVERPIÆ, OCCIDENTEM VERSVS

LEGIA, *sive* LEODIVM; *Vulgo*. LIEGE.

108

Liege

P/P 862 1st state of two
Etching
In design, top: LEGIA, sive LEODIUM; Vulgo
LIEGE.
In design of map, lower L: WHollar fe:
Below: key to celebrated places in the city
32.6 x 48.0
33.0 x 49.0

The first state of this bird's-eye view of Liege
appeared in *Urbium totius Germaniæ superioris . . .*
tabulæ, Pars prior, which was published in
Amsterdam in 1657 by Joannes Janssonius. Hol-
lar did forty-eight plates for atlases in folio format,
which were published by Janssonius. In 1653,
Janssonius acquired the copper plates of *Civitates*
orbis 50 terrarum, previously published by Braun/
Hogenberg. Janssonius removed the small figures
in traditional regional costume from the plates,
and in most cases added a new cartouche. He also
had copies made of plates engraved by the cartog-
rapher Bleau and combined them with small per-
spectives at the top of the plate. These and other
revisions of maps and plans were published in
deluxe editions in the mid-seventeenth century.
Hollar, who often contributed to the aerial views,
must have arranged this from London.

The upper section of this print is a bird's-eye
view of Liege, positioned in the bend in the river
with two suburbs on islands. A medallion is
located in each of the upper corners. The left-
hand one is empty; in the right appears a column
flanked by the letters *L* and *G*. The lower portion
of the image is divided into sections, with an
explanatory list and three more small plates: a
hoist for a mine shaft, a castle, and a scene from
country life.

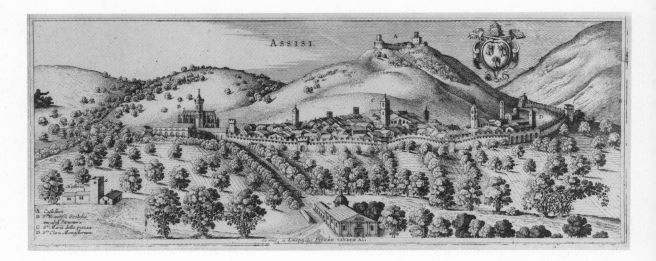

109

Assisi

P/P 1120B 3rd state of three
Etching
In design, upper C: Assisi
In design, lower L: key to buildings
Below: Se vend A LEIDE chez PIERRE VANDER AA
/ Avec Privilege
18.4 x 46.1

In this third state, the print was part of *La Galerie*
agréable du Monde, published by Pierre van der Aa
in Leiden. The second state was used for *Illus-*
triorum Italiæ urbium tabulæ, published in 1650
by Joannes Janssonius.

This print is a reprint of the lower half of a plate
with a view of Assisi. The upper half was devoted
to a view of the town of Radicafoni (P/P 1120A).
The old fort Rocca Maggiore is seen on the hill,
and to the left is the two-story church of St.
Francis, dating from the thirteenth century. Dat-
ing from the same period is the church of St.
Claire with the tomb of St. Claire, which stands
to the right, and in the foreground, outside the
city walls, is Santa Maria degli Angeli. A small
scene of the miraculous moment when St. Francis

received the stigmata is shown in the upper left.

In the upper right corner is a coat of arms with
three bees, crowned with the papal tiara and the
keys of the priesthood. The manner in which the
scene is presented—as if seen from a high vantage
point out over a hilly landscape—and the way the
small trees are etched are reminiscent of land-
scapes after Pieter Bruegel, as they were made into
prints by the brothers Duetecum.[79] Letters keyed
to the image are explained in the lower left in a
separate column.

Iacques van Artois pinxit, W: Hollar fecit, 1648. Antuerpiæ. Petrus van Avont excudit,

110
Bridge over a Waterfall
after Jacques van Artois (1613–1686)

P/P 1208 1st state of three
Etching
1648
Lower L: Iacques van Artois pinxit,
C: W: Hollar fecit, 1648. Antverpiæ,
Lower R: Petrus van Avont excudit
14.8 x 20.9

In Antwerp, Hollar did twenty-two prints after designs by landscape artists who were well known at the time (P/P 1205–1226). Jacques van Artois was one such famous artist. He worked not so much in the innovative lyrical manner of Rubens, but more in the tradition of painters who also created designs for the carpet industry, such as Gillis van Coninxloo.[80] These landscapes, or *verdures*, were composed according to a fixed pattern. On one side (usually the left) stands a massive group of trees, and the other side opens onto a brightly lit area. Artois adhered to sixteenth-century traditions in regard to color: reddish colors are in the foreground, with green-yellow leaves in the background. Artois' landscapes are true to nature, reflecting the environs of Brussels. The publisher, Pieter van Avont, specialized in publishing landscape prints. In 1620, he was a member of the guild in Mechlin. He worked with Vinckboons, Artois, and Jan Bruegel.

111
The Stone Bridge
after Adam Elsheimer (1574/1578–1620)
P/P 1222
Etching
1649
Lower L: AElsheimer inu: W. Hollar fecit. 1649.
Lower R: F. van den Wijngaerde exc.
20.4 x 27.4

This print shows a road that traverses a rocky mountainside and ends at a river. A stone bridge with a single arch crosses a side stream. Small, delicate lines indicate the contours of the clouds rather than set them off against a darker background. Hollar made eighteen prints after works by Elsheimer, only three of which are landscapes. Because Elsheimer was a famous painter, he was included in Johannes Meyssens' 1649 publication *Images de Divers Hommes d'Esprit Sublime* in a portrait engraved by Hollar (P/P 1397).

Born in Frankfurt in 1574 or 1578, Adam Elsheimer spent most of his life in Rome. While he did make etchings, Elsheimer is famous for the rich, sensuous atmosphere that he achieved in his paintings. Frans van den Wijngaerde was an Antwerp engraver and print dealer who specialized primarily in prints after Italian paintings. He published seventeen prints by Hollar, and Hollar created a portrait of him (P/P 1527).

Iac: van Artois pinxit, W. Hollar fecit, 1649. P: van Avont exc:

112
The Beggar
after Jacques van Artois (1613–1686)
P/P 1211 1st state of three
Etching
1649
Lower L: Iac: van Artois pinxit,
C: W. Hollar fecit, 1649.
Lower R: P: van Avont exc:
15.4 x 21.2
15.7 x 21.7

Publishers frequently specialized in one particular genre, and Hollar provided them with appropriate material. For Pieter van Avont, he produced primarily landscapes, such as this romantic imaginary scene after Jacques van Artois. Parts of it were certainly done from sketches after nature, and the ensemble was carefully arranged. Standard compositional elements are present: the darker area to the right serves as a repoussoir to the brightly lit area behind it, as well as to the foreground spot where a small transaction is taking place. To the left stands a group of lightly colored trees that do not contrast with each other. Between the hills is a glimpse of a distant plain.

113
St. Paul's. The nave.

P/P 1025 1st state of two
Hind 1922, no. 42
Etching
1658
Upper L: 167
In design, upper L: Coleus Deum et Regem
In design, top: NAVIS ECCLESIÆ CATHEDRALIS
S. PAULI / PROSPECTUS INTERIOR.
In design, upper L: Sacrum Memoriæ / SAMUELIS
COLLINS / in Med: Doct: nuper / Coll: S.Sta et
Indum. Trinit: / Ac: Cantab: Prisei Iuris / Socy qua Effi-
giem / hane proprus sumpli= / bus ære cudendam /
curavit.
Below: Sit rediviva mater Ecclesia, et pereant Sacrilegi
ut navis Ecclesra temporum fluctibus immersura / salu-
taribus Dei auspicijs conservetur: Majorum pietatem
imitando mirentur posteri, ut stupenda hæc Basilica /
antiquitus sundata etjamjam collapsura tanquam sac-
rum Religionis Christianæ Monumentum in æternum
sufflaminetur, / Wenceslaus Hollar, Bohemus, hujus
Ecclesiæ (quotidie casum expectantis) delineator et
olim admirator memoriam sic preservavit, Aº 1658
39.2 x 34.5
42.0 x 34.7

With amazing cleverness Hollar managed to show the length of the church's interior, including the area behind the rood screen. This print was used in the *History of St. Paul's Cathedral*, published by William Dugdale in 1658. The plates that Hollar did during this period were all in folio format.

After his return to London in 1652, Hollar worked mainly with John Ogilby (1600–1676), the Virgil translator and publisher, and Sir William Dugdale (1605–1686), for whom Hollar did several architectural prints over many years. They probably met through Arundel's librarian Francis Junius. Dugdale, a gentleman from Warwickshire, was an antiquarian and a passionate admirer of the architecture of the Middle Ages. Along with his work for Ogilby, Hollar's collaboration with Dugdale provided his financial base. Hollar contributed to a series of Dugdale's publications on medieval monasteries in England, *Monasticon*

Anglicanum . . . Per Rogerum Dodworth . . . Gulielmum Dugdale. Publication of its three parts ran from 1655 to 1673.

In drawing the plan for this plate, Hollar, by his own account, was exposed to the danger that the roof might collapse.

Byrsa Londinensis vulgo the Royal Exchange,

114
Royal Exchange
P/P 907
Hind 1922, no. 28
Etching
Ca. 1650
In design, top: Byrsa Londinensis vulgo the Royal Exchange,
In design, lower R: WHollar fecit
14.6 x 25.2

The print depicts the interior of the old exchange in London, built from 1566 to 1571 at the initiative of Sir Thomas Gresham. The layout bears considerable resemblance to the exchange at Amsterdam at the time. Niches with statues of the kings of England appear above the colonnades. The exchange was destroyed in the Great Fire of 1666.

This print is part of a series of four views of London (P/P 907–910), which are all in the same format, have a title in the sky, and were framed by Hollar with a black line (see also cat. nos. 50 and 115). They also appear as a series in a 1662 catalogue by Peter Stent as "One book containing four plats. viz The Tower, The Piazza, St. Mary-Overy and the Royal Exchange." Later, in 1672, the prints are found with the same text in a sales list by John Overton.

115

Covent Garden

P/P 909 2nd state of two
Hind 1922, no. 79
Paris 1979, no. 94
Etching
Ca. 1647
In design, top: PIAZZA in Coventgarden
In design, lower R: WHollar fecit
Lower R: 2
14.8 x 25.8

The only year that Hollar indicates in this series, that of 1647, appears on the print *St. Mary Overy*

(P/P 910), so these prints must have been done about that time in Antwerp. The piazza is shown as it probably appeared before Hollar left England. At the center stands the church of St. Paul, built from 1630 to 1636 after plans by the classical architect Inigo Jones. The square, designed according to the Italian model of the piazza with the surrounding arcades in strict symmetry, resembles the Place des Vosges in Paris.

Much time passed between the making of these prints and their announcement in a catalogue. It

is not known whether they appeared earlier than Stent's catalogue of 1662. It may be that Hollar, who naturally did not know that he would not return to London until 1652, worked in advance from his own drawings.

Supporting the 1647 date is another series of views of London, dated 1647 (P/P 1037–1040, cat. nos. 47–49), which at one time was abridged to form a series of eight with the *Covent Garden* series. The etching style and manner of placing the title are similar in both series.

116
Venus Brings Aeneas his Weapons
after Frans Cleyn (1582–1658)
P/P 321 6th state of six
Etching
1653
In design, lower L: F. Cleyn inv
In design, C: Æ.8.1.825.
In design, lower R: W. Hollar fecit, 1653
Below: To Sʳ Godfry Kneller Knight / Principall Painter
to his Majesty
30.1 x 20.0
35.5 x 23.2

In the *Aeneid* (I:314–371), Virgil describes how
Aeneas, a Trojan prince, fled from the burning
citadel of Troy. After much wandering, he and his
companions finally reached Latium in Italy, where
they took up residence. They were considered the
legendary forefathers of the Romans. The *Aeneid*
tells the story of how Venus, the mother of
Aeneas, appeared to him on two occasions. The
first time was in the burning citadel of Troy when
she urged him to flee. The second time was in
Carthage, after the Trojans were driven ashore
there. When Aeneas and his friend Achates recon-
noitered, Venus appeared in the guise of a god-
dess of the hunt, with bow and arrow, to give
him arms and to lead him to Dido's palace. The
shield she hands to Aeneas in this print is deco-
rated with scenes from the history of Rome and
includes images of Romulus and Remus.

Hollar did numerous illustrations for a publica-
tion of John Ogilby's translation of Virgil (P/P
290–332). In 1649 and 1650, Ogilby had pub-
lished his translation without illustrations. In
1654, a deluxe edition was produced with illustra-
tions by Hollar after designs by Frans Cleyn.
Ogilby wanted to match Michel de Marolles, who
had published a splendid edition titled *Les oeuvres
de Virgile traduites en prose enrichies de figures* in Paris
in 1649. The plates in the Marolles edition are
signed "F.C. in et sc," and some decorated ini-
tials and titles also bear Hollar's signature. If that

is not the signature of Frans Cleyn, then Hollar relied heavily on the illustrations in the Paris edition. In 1658, Ogilby published the *Aeneid* in Latin, with the same illustrations by Hollar. A reprint of the Latin text and Hollar's prints was done in 1663. Five years later the illustrated translation by Ogilby was reprinted.

Apparently in the 1690s a need was felt for a new translation. In 1697–1698, *The works of Virgil . . . translated into English verse by mr Dryden* was published by Jacob Tonson and featured the plates by Hollar. The only thing that changed in the image was Aeneas' nose, which, in honor of William III, was made to conform with the contours of his nose. The inscriptions and dedications in the margins also changed considerably.

The painter and engraver Frans Cleyn was born in Rostock in 1582 and served as the court painter of Christian IV of Denmark from 1611 to 1624. From 1625 until his death in 1658, he lived in England, where, among other things, he provided designs for the carpet industry in Mortlake (see cat. no. 23).

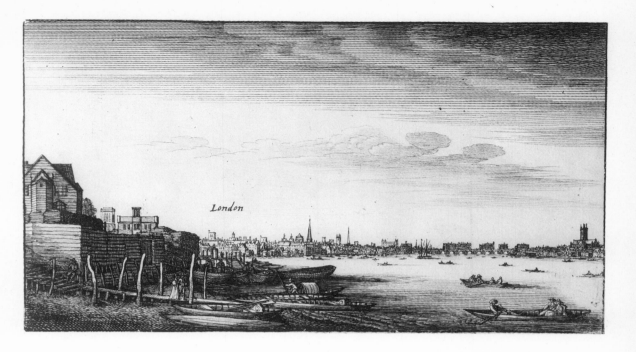

117

London Viewed from Milford Stairs

P/P 911 2nd state of two
Hind 1922, no. 80
Paris 1979, no. 96
Etching
In design, C: London
9.4 x 17.1

At one time Milford Stairs stood just below Arundel House, and the part that lies on the waterfront can still be seen. Hollar was quite familiar with these surroundings. This print shows the north bank of the Thames from Blackfriars to London Bridge, with the Tower to the left. In the background, just before the bridge, are the "eel ships," which can also be seen in the *Long View of London* (cat. no. 46). On the opposite bank of the Thames stands the tower of the monastery church of St. Mary Overy. In the foreground a rowboat ferries passengers to a wooden dock.

In his *Notebook* of 1745 (vol. III, nos. 11–14 [P/P 911–914]), Vertue placed this print in a series of views of London that are of approximately the same format (see cat. no. 118). The preliminary pen and ink drawing is in the Pepysian Library at Magdelene College in Cambridge, England.[81]

118
Tothill Fields

P/P 913 1st state of two
Hind 1922, no. 106
Etching
In design, C: Tootehill fields
In design, above buildings: S: Peter in Westmister / S:
Paul in London
9.0 x 16.1
9.4 x 17.1

Hollar's panoramic views echo the tradition of
Hendrick Goltzius. Around 1600, ideas on how
the landscape should be depicted changed. Of
course, some painters, such as Jacques van Artois
(see cat. no. 110) and Adam Elsheimer (see cat.
no. 111), remained faithful to the old tradition.
They continued to compose their landscapes as
stage pieces, with the standard composition of
rocks and trees. Other artists rendered the land-
scape more realistically by including pleasant
scenes of pastures with sheds, small rivers, or, as
here, a gully surrounded by a ring of small trees
and recognizable buildings on the horizon. After
the rediscovery of Bruegel's drawings and the
revival of interest in his prints, artists returned to
drawing in the open air, which is exactly what
Hollar had always done. A small figure who draws
in the landscape is often found in Hollar's prints.
Here, two rather dark figures sit on the small
ridge to the left, and as in many prints, one of
them seems to be drawing. Indeed, the most
important Dutch landscape painters of the seven-
teenth century—Willem Buytewech (1591–1624),
Claes Jansz. Visscher (1587–1652), and Jan van
de Velde II (see cat. no. 6)—were accomplished

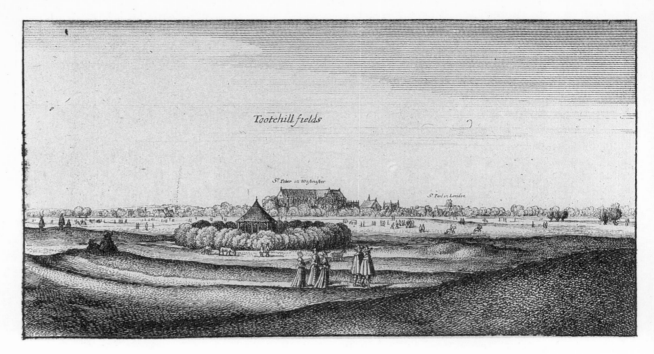

printmakers, and through their prints they circu-
lated this new current very quickly. Hollar, par-
ticularly in his foregrounds, employed the
whiplash lines, which start out thin and broaden
into a wider line, that were so characteristic of
these engravers (see cat. no. 119). Hollar was
influenced by Goltzius and Jacob Matham (1571–
1631), and particularly by Jacques De Gheyn II
(1565–1629).[82]

The foreground is a sloping field that rises to a
darker area used as a repoussoir. A few couples are
out walking. On the horizon is an abbey, with its
name given above: "St. Peter in Westmister"
[*sic*]. In the distance and to the right is a church
building marked "St. Paul in London."

119
By Islington
P/P 916 1st state of two
Hind 1922, no. 73
Etching
1665
Below, C: By Islington
Lower R: W: Hollar delin: et sculp. 1665.
8.5 x 12.4
9.1 x 12.7

This is one of a series of six views of or in the area
surrounding Islington, an uncultivated piece of
land to the north of London.[83] In the foreground
are the erratic land formations of a nearly dried-up
stream, which Hollar drew as a pattern of lines
with his etching needle. People stroll over the bar-
ren land, and the city lies close by. St. Paul's
Cathedral is clearly visible, with the tower of St.
Sepulchre behind it. Over the roof of a large shed
rise the towers of St. Mary-le-Bow and St.
Michael's Cornhill Church. In looking at this
print, one must realize that these churches no
longer stood one year later! Hollar did this series
just before the Great Fire of 1666. Further to the
right are the Thames and the south bank.

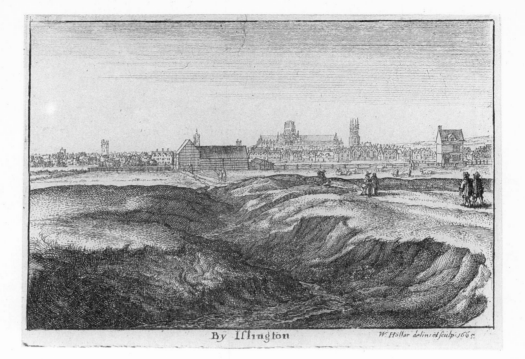

By Islington

120
The Waterhouse

P/P 920 1st state of three
Hind 1922, no. 77
Paris 1979, no. 98
Etching
1665
Below, C: Yᶜ Waterhouse
Lower R: WHollar fecit 1665
8.3 x 12.2
8.9 x 12.5

The background buildings seen in this etching have much in common with those in the previous print (cat. no. 119). The viewpoint lies farther to the west. The shed that was so prominent in the previous etching now stands in the background to the right. This arrangement places emphasis on the waterhouse near a spring of mineral water, which was one of the few found to the north of London. A wall and a canal or pond surround the building.

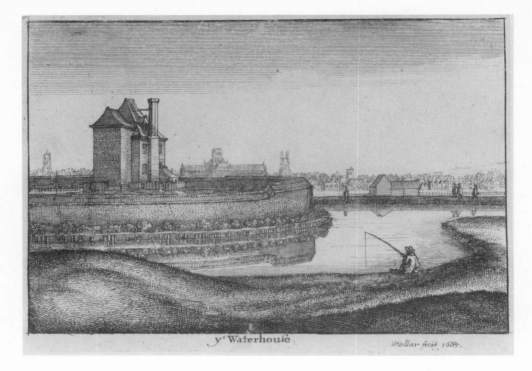

184

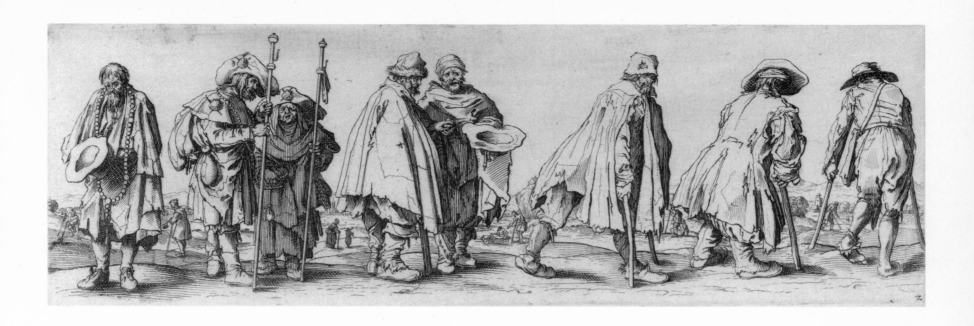

121A
Eight Beggars
after Jacques Callot (1592/1593–1635)
P/P 2025
Etching
In design, lower R: 2
8.5 x 25.5
9.0 x 26.1

For ten years, from 1611 to 1621, Jacques Callot lived in Italy, where he worked at the court of Cosimo II in Florence, among other places. Callot was esteemed for his handsome, graceful use of line and the expressive power of his etchings. He enjoyed unprecedented popularity with his depiction of figures and scenes from the Commedia dell'Arte and his Capricci. Back in France, he worked on commissions from Louis XIII and Cardinal Richelieu. His etchings in the series *Les Misères de la Guerre* are both atrocious and breathtakingly beautiful. These true-to-life prints delineate the cruelties of the Thirty Years' War. Hollar

was never so realistic when he set about making a print of a battlefield.

These twenty-five Italian beggars were etched by Callot in Nancy in 1622, based on drawings that he had done in Italy. They may have been impoverished figures that Callot had seen in the Lorraine. Due to the enormous number of refugees who fled to France, and particularly to the region around Nancy, regulations were devised to deal with the onslaught of beggars and lepers. These victims of the Thirty Years' War are striking in that Callot was the first to make an effort to show some emotion in their faces. Many artists copied these beggars by Callot, including Rembrandt. At the time of Rembrandt's bankruptcy, the inventory of his possessions mentioned a portfolio of etchings by Callot.

Hollar did very few etchings after models by his illustrious colleague Callot. He did produce four plates with beggars, and one set of eight plates,

each with six full-length figures from the Commedia dell'Arte (P/P 2027A).[84]

Peter Stent's 1622 sales catalogue advertises a "Lame crew of Beggars," and the same list mentions "Twenty-four plats, Callot's Anticks."[85] The series is not found in later catalogues. Apparently sales of the prints had fallen off.

Callot began this series of beggars in 1622, preparing a separate print of each beggar (see cat. no. 122). Hollar copied them, some in reverse image and others facing the same direction. He made a coherent group of these figures standing in a landscape, with some figures repeated in small format in the background.

The beggar at the far left has a large rosary around his neck. Next to him stand two pilgrims holding pilgrims' staffs, with a Jacob's shell on their hats.[86] Two men converse next to them, as the three men to the right try to move ahead with canes and crutches.

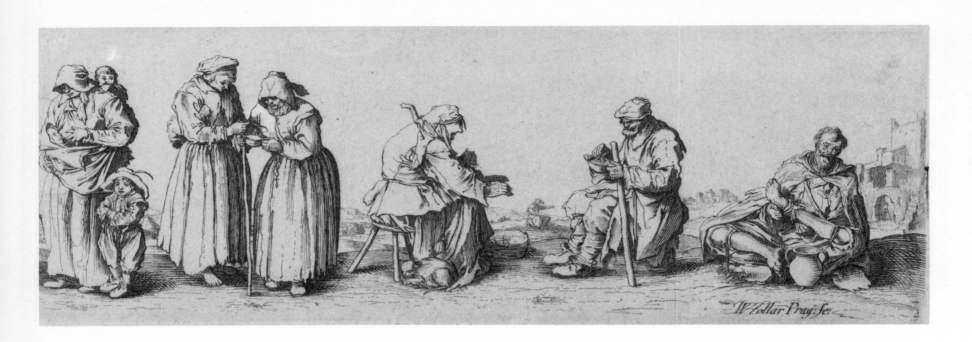

121B
Men and Women Beggars
after Jacques Callot
P/P 2027
Etching
In design, lower R: WHollar Prag^e: fe: / 4
8.5 x 25.5
8.9 x 25.7

The woman at the center warms herself by a small
container of hot coals. In the background, a small
figure sits in almost the same position. As in the
previous print (cat. no. 121A), Hollar arranged
Callot's beggars into a linear composition. He
also imitated Callot's etching style, using wide,
deep lines that resemble those engraved with a
burin. More than is seen in other "reproduc-
tions," Hollar adapted his technique to that of
his model.

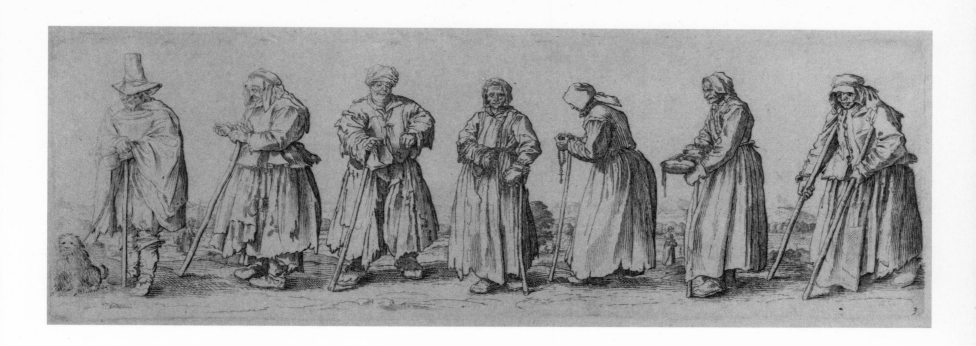

121C
Seven Men and Women Beggars
after Jacques Callot
P/P 2026
Etching
In design, lower R: 3
8.5 x 24.5
8.8 x 24.6

Seven beggars stand in a row, as if posing. Three
women are exact copies after those seen in other
prints (see cat. no. 122). The second woman from
the left is the same figure who just received alms
in cat. no. 122C. Second from the right stands
the woman with a rosary and bowl, in a reverse
image to cat. no. 122B. Between them is the bent
woman in cat. no. 122A.

The vagabonds are etched close up, so that they
give the impression of being giants placed against
an immensely vast background with a low
horizon.

187

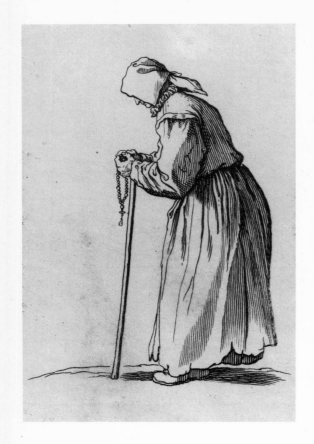

122A
Beggar, from "Les Gueux"
by Jacques Callot
Lieure, 485 1st state of two
Etching
13.8 x 8.2

122B
Woman with a Bowl, from "Les Gueux"
by Jacques Callot
Lieure, 498 1st state of two
Etching
13.7 x 8.7

122C
Woman with Alms, from "Les Gueux"
by Jacques Callot
Lieure, 501
Etching
13.7 x 8.7

123A
View of the Covered Bridge at Strasbourg
P/P 756
Hirschoff 1931, no. 16
Paris 1979, no. 62
Etching
1665
In design, C: die gedeckte Bruck zu Strasburg
Lower L: W. Hollar delin: 1630. et sculp: 1665
5.1 x 10.9
5.3 x 11.2

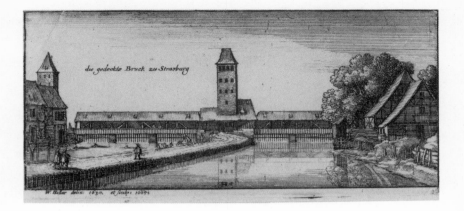

This print was done after a drawing that Hollar had made thirty-five years earlier, a fact that he states quite clearly in the margin of the print. One reason for adding the note may be that Strasbourg may have no longer looked the way it did when the drawing was first done. The style of this etching echoes that in cat. nos. 118–120. Just as in the seasons with views of Strasbourg, people swim in a branch of the river Ill (see cat. no. 1B). This print was part of a series of twelve views of German cities, with all the prints having the same dimensions. The dates are far apart.

In a series of these prints in the Narodni Galerie in Warsaw, two plates are printed on a single sheet. Thus, this etching of the covered bridge appears on the same sheet as *Strasbourg: A Distant View* (P/P 751), which has not been mentioned before.

123B
Strasbourg: The Shooting Range
P/P 752
Hirschoff 1931, no. 12
Paris 1979, no. 59
Etching
1665
In design, C: Bey dem Shiessrein zu Strasburg
In design, R: Spittel muhl.
Lower R: WHollar delin: 1630 et sculp: 1665
5.1 x 11.1
5.3 x 11.3

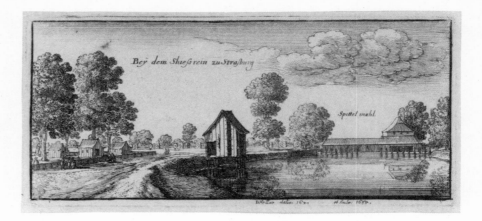

The shooting range in Strasbourg, with its targets set out in a field, is visible in the distance (see also cat. no. 1A). A tree-lined avenue leads from the left foreground to a watermill on the river Aar, a branch of the Ill. In Warsaw, this work is printed on a single sheet of paper with P/P 753. The drawing for the print, dated 1629, is in the Sternberg Palace in Prague, now home to the Narodni Galerie (fig. 9).

Figure 9
Strasbourg: The Shooting Range
Pen with sepia wash
1629
Sprinzels 1938, no. 113
9.7 x 11.3
Narodni Galerie, Prague (Inv. K. 31238)

124–127
Four Prints of a Storm at Sea

Hollar did forty-three prints featuring the sea, boats, naval battles, and ships during a storm (P/P 1244–1286, see cat. nos. 79, 80). Maritime scenes were extremely popular in the seventeenth century, when the seas hosted a great deal of activity. Expeditions set off, merchant ships sailed to and fro, and three maritime wars were fought between England and The Netherlands alone. The first English maritime war of 1652–1654 arose because of the Navigation Act, in which England ordered that all goods from distant parts of the world could be brought to England only by English ships. The second English maritime war broke out after England occupied parts of Guinea and New Netherlands in the west. The third maritime war, 1672–1674, was more of an all-out war between England, France, and Münster on one side, and Holland on the other.

These four prints with ships on an angry sea do not specifically depict scenes of war, although Hollar must have seen many warships during his travels by sea. The first war broke out in 1652, the year he returned to England. These prints are dated 1665, when the second maritime war began. Hollar probably based the drawings for these prints on sketches that he made during his travels. He may also have composed them from elements in his store of fantasy pieces.

124
A Yacht and Three Warships in a Storm
P/P 1273 1st state of two
Etching
1665
Lower L: W: Hollar inu: et fec: 1665.
11.6 x 27.2
12.5 x 27.6

A storm causes the sea to rise up in high waves. Immediately behind the ship at the far left, the sea is calm and smooth, and on the horizon a ship glides along as though it were above the water. To the right, however, the ships dip over dangerously, and the sky is as dark as night.

Hollar's predilection for miniatures is well demonstrated in the small figures of the sailors on board. Despite their minute size, their positions and actions remain quite clear. This sort of print, as is so often the case, must be viewed with a magnifying glass to do full justice to it.

191

W. Hollar inu: et fec: 1665. Iohn Overton excudit. Are to be Sould at y.e white Horse in little.Brittaine.

125
Warship in the Trough of a Wave
P/P 1274 1st state of three
Etching
1665
Lower R: W: Hollar inu: et fec: 1665. Iohn Overton
excudit. Are to be Sould at y.e white Horse in little
Brittaine
11.6 x 26.8
12.5 x 27.3

In this print, the storm has taken a serious turn.
Tall waves endanger warships as far as the eye can
see.

W: Hollar inu:et sculp: 1665. Peter Stent exc:

126

Warships and a Spouting Whale

P/P 1275 1st state of two
Etching
1665
Lower R: W: Hollar inu:et sculp: 1665. Peter Stent
exc:
11.6 x 26.8
12.2 x 26.8

Again, warships are caught in a heavy storm.
Sailors have climbed the mast to tie down the sails
of the center ship. A spouting whale swims at the
lower right.

193

W. Hollar inu: et sculp: 1665. Peter Stent exc:

127
The Galley
P/P 1276 1st state of two
Etching
1665
Lower L: W. Hollar inu: et sculp: 1665. Peter Stent
exc:
11.6 x 26.8
12.4 x 27.2

These ships bear the brunt of the storm with its heavy rains. To the right a galley tries to row against a wave, while to the left a merchant vessel holds its own on the crest of a wave. Interestingly, Hollar's treatment of the undulating water in the foreground closely resembles his depiction of a

dune landscape (see cat. nos. 118, 119). Light and darkness, and towering and low-lying areas are indicated through the gradation of shadings and crosshatchings. Because Hollar shows the contours of a hill, meadow, or wave in the same way, and even accentuates them with small protruding strokes, the foreground of this print should not to be interpreted exclusively as water. If a few houses replaced the ships, this foreground could well serve as a piece of land.

It is said that an angry sea is a symbol of the uncertainties of life: every ship is directed where nature (or God) wants. Such symbolic considera-

tions did not bode well with Hollar, and it is more likely that he was simply fascinated by the power of nature. He was also well aware of how popular this subject was with his public. This series as shown here was reprinted many times until the end of the eighteenth century.

128
Title page, *Hunting, Hawking, and Fishing*
after Francis Barlow (ca. 1626–1704)
Etching
1671
In ornamental cartouche: Severall Wayes / of / HUNT-
ING, HAWKING, AND FISH = / =ING ACORD-
ING TO THE ENGLISH MANNER / invented by /
Francis Barlow / Etched by W: Hollar. / And are to be
sould by Iohn Overton, at the White Horse, without
Newgate, London. A.º 1671.
Below: If Hunting Hawking, Fishing, pleasure yeald, /
How much may Art exceede, as if in Feild, / You vew'd
each Sport, by figure so Exprest, / The severall wayes
they take, Fowle, Fish, & Beast
17.3 x 28.3

This cartouche, which is the first of a seris of thir-
teen plates, is a splendid example of an ornamen-
tal border that integrates plant motifs and
elements reminiscent of scrollwork. The publisher
used Hollar's name to entice purchasers. In fact,
only four of the plates were etched by Hollar. The
others are unsigned, and it is suspected that they
were done by Robert Gaywood or by Frances Bar-
low himself. (For Hollar's relationship to Gay-
wood and Barlow see cat. nos. 19–21). The
cooperation between Barlow and Hollar began in
1654, when Hollar contributed a print to Bar-
low's *Diversæ avium species* (P/P 2124–2163).

This series of hunting scenes was quite long-
lived in popularity. In 1717, it was republished by
Overton's son Henry.[87] Then Robert Sayer pub-
lished four prints from the series in 1766, and in
1795, the set appears in a sales list of Laurie and
Whittle.

Judging from the romantic settings in which
the fishermen and hunters have been placed, Bar-
low, in his compositions, and Hollar, in his man-
ner of etching, were primarily interested in the
landscapes and in showing people in various
stances.

129
Hare Hunting

P/P 2029 1st state of two
Etching
In design, lower C: F. Barlow inu: W Hollar sculp:
Below: The timorous Hare, when started from her
seat, / by bloody hounds, to save her life soe sweet, /
HARE HUNTING. / With severall shifts, much ter-
rour and great payne, / yet dyes she by their mouths, all
prove's but vayne,
16.4 x 22.1

A pack of hounds is being urged by the beater to
chase the hare at the upper left.

In this print, Hollar left more areas white than
formerly, which gives these prints an elegant light-
ness. The dogs, horses, and people are modeled
with fuzzy contours. In his earlier prints, and par-
ticularly in those of his own design, he would
have defined the people's clothing and the
hounds' coats with shading. Unworked areas are
almost completely absent from his earlier work.
Here, too, he probably followed Barlow's manner
of drawing very closely.

The timorous Hare, when Started from her seat,
by bloody hounds, to saue her life soe Sweet, | HARE HVNTING. | with Seuerall Shifts, much terrour and great payne,
yet dyes she by their mouths, all proue's but vayne,

130
Angling

P/P 2033 1st state of three
Paris 1979, no. 168
Etching
In design, lower L: F. Barlow inu: W.Hollar fecit
Below: Angling on river banks, trowling for pike, / Is noble Sport, when as the fish doth strike, / ANGLING. / And when your pleasure's over, then at night / You and your freinds, doe eate them with delight,
16.5 x 22.1

In one of Hollar's most handsome prints, fisher-men angle in a small river. The foreground is arranged as a still life with baskets and plants that stand out against the river bed on the other side.

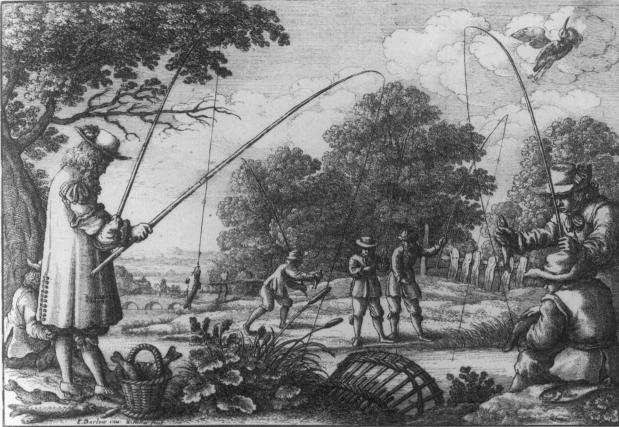

F. Barlow inu: W.Hollar fecit

Angling on river banks, trowling for pike,
Is noble Sport, when as the fish doth strike,

ANGLING.

And when your pleasure's over, then at night
You and your freinds, doe eate them with deligh

131
Salmon Fishing

P/P 2032 1st state of two
Etching
1671
In design, lower L: F. Barlow in: W: Hollar fecit
Below: In Rivers swift, your Salmon are great store, /
where with vast nets, they often bring to Shore, /
SALMON FISHING. / many of them, and divers
other Fish, / which when well drest, fit for A Princes
dish,
16.4 x 21.9

Set in an idyllic landscape, fishermen strain to get
the salmon aboard their rowboat. To the right,
the dead fish are laid out as if in a still life.

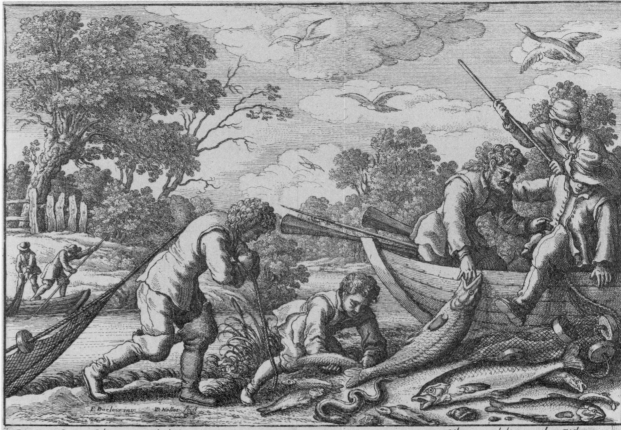

In Rivers swift, your Salmon are great store,
where with vast nets, they often bring to Shore,

SALMON FISHING.

many of them, and divers other Fish,
which when well drest, fit for A Princes dish,

132
River Fishing
P/P 2031 1st state of three
Etching
1671
In design, lower L: F.Barlow inv. W.Hollar sculps
Below: With slu and codnet in your Swifter Streame, /
Pike, Pearch, and Chub they take, with store of
Breame, / RIVER FISHING. / and many smaller Fish,
they plunge with poles, / great Shoeles to nett from
harbering in their holes,
16.3 x 21.9

Here, men fish with poles and bring the dead fish
out of the river with a net. To the left is a view
out over a rolling valley.

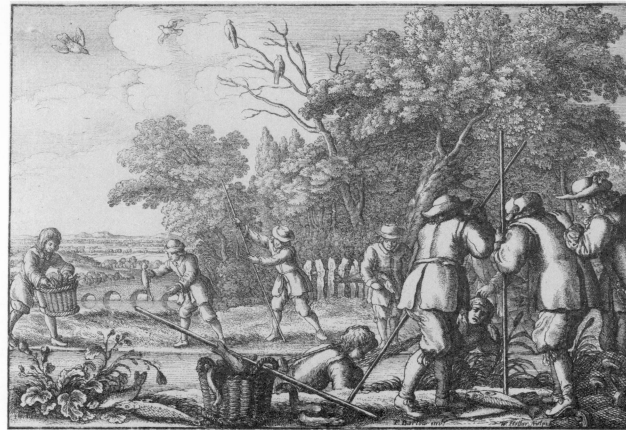

With slu and Codnet in your Swifter Streame, | RIVER FISHING | and many smaller Fish, they plunge with poles,
Pike, Pearch, and Chub they take, with store of Breame, | | great Shoeles to nett from harbering in their holes,

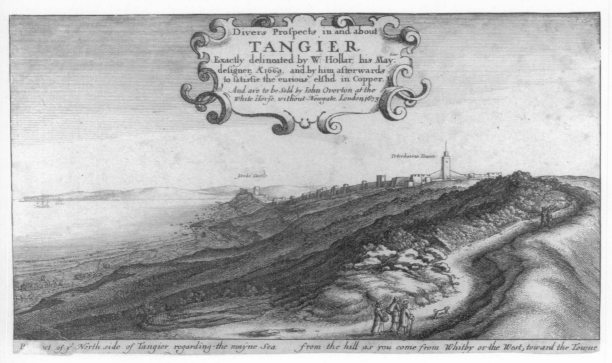

In cartouche, top C: Divers Prospects in and about / TANGIER / Exactly delineated by W: Hollar; his May:^{ties} / designer, A° 1669, and by him afterwards / to satisfie the curious, etshd in Copper, / And are to be Sold by Iohn Overton at the / White Horse, without Newgate, London, 1673

In design, C: Yorke Castle / Peterborow Tower

Below: Prospect of y^e North side of Tangier regarding the mayne Sea from the hill as you come from Whitby or the West, toward the Towne.

133
Tangier, Series title
P/P 1187
Etching
1673
In cartouche, top C: Divers Prospects in and about /
TANGIER / Exactly delineated by W: Hollar; his
May:^{ties} / designer, A° 1669, and by him afterwards /
to satisfie the curious, etshd in Copper, / And are to be
Sold by Iohn Overton at the / White Horse, without
Newgate, London, 1673
In design, C: Yorke Castle / Peterborow Tower
Below: Prospect of y^e North side of Tangier regarding
the mayne Sea from the hill as you come from Whitby
or the West, toward the Towne.
12.8 x 21.3

Tangier became a British possession as part of the dowry of Catherine of Braganza, the daughter of the king of Portugal, when she married Charles II in 1662. The English tried to transform it into a strategic and commercial stronghold, but the government of England did not have enough funds and the local officials fell prey to corruption.

In 1668, an expedition was organized under the direction of Henry Howard, a grandson of the Earl of Arundel, to mediate between the colonists and the local inhabitants. Two years earlier Hollar had obtained the title *Scenographus Regis* at his own request, and he took part in the expedition in that capacity. He lived on Tangier for a year and a half, and the results of his stay are sixteen prints and as many drawings.[88]

The mission itself met with no avail. The English abandoned the colony in 1684, and as they left, they destroyed their own forts, which Hollar had so carefully detailed in his prints. This series was published many years after the prints were made. John Overton advertised them for the first time in 1673. The second editions were published by Henry Overton in 1717, by Sayer in 1766, and finally in 1795 by Laurie and Whittle.

The landscape under the title plate cartouche is reminiscent of Hollar's landscapes around Islington (cat. nos. 119, 120). A winding path along a rocky coast leads to a walled city in the distance. Two buildings are specified by name: in the distant left is York Castle, and to the right is Peterborow Tower.

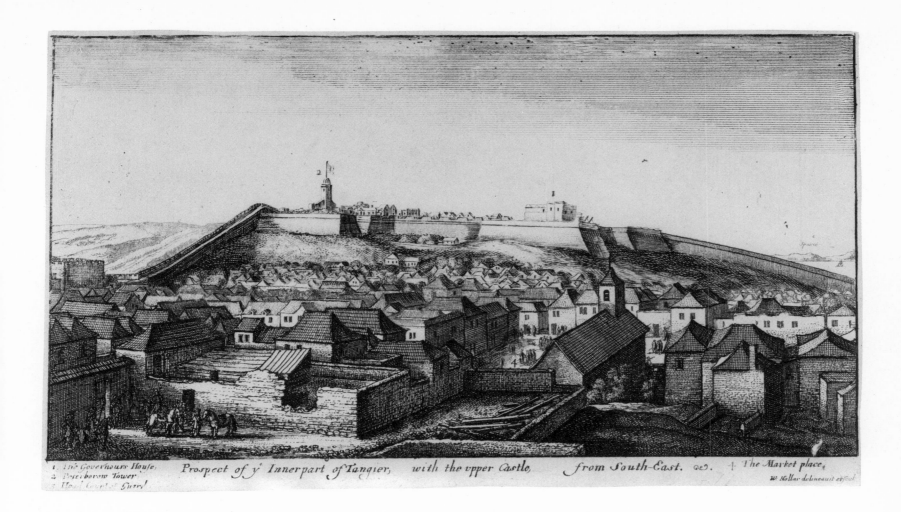

Within the image:

1. The Governours House,
2. Peterborrow Tower,
3. Head Court of Guard

Prospect of yͤ Innerpart of Tangier, with the vpper Castle, from South-East. ꝏ. 4 The Market place,

W: Hollar delineauit et scul.

134

Prospect of the Inner Part of Tangier

P/P 1192 1st state of two

Etching

Lower L: 1 The Governours House, / 2 Peterborrow
Tower / 3 Head Court of Guard

C: Prospect of yͨ Innerpart of Tangier, with the upper
Castle, from South-East. / The Market place

Lower R: W: Hollar delineavit et scul.

12.5 x 21.5

In the design are numbers that correspond to the
explanatory key given in the left margin. The city
is seen from above in the foreground. On the hill
are buildings that stand inside the fortified walls.
In the far distant right is a coastline with the word
"Spaine" above it.

201

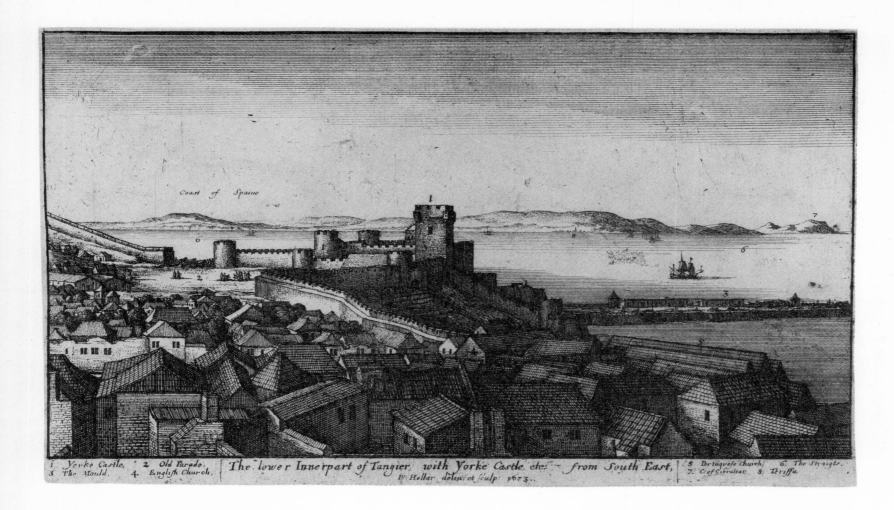

Within the image:
Coast of Spaine

1 Yorke Castle. 2 Old Parado. The lower Innerpart of Tangier, with Yorke Castle. etc: from South East, 5 Portuguese Church, 6 The Straigts.
3 The Mould. 4 English Church, W: Hollar delin: et sculp: 1673. 7 Cros Gibraltar. 8 Teriffa.

135
Prospect of the Lower Innerpart of Tangier
P/P 1195
Etching
1673
In design, R: Cost of Spaine
Lower L: 1 Yorke Castel 2 Old Parado / 3 The
Mould 4 English Church
C: The lower Innerpart of Tangier, with Yorke Castle.
etc: from South East, / W: Hollar delin. et sculp. 1673
Lower R: 5 Portuguese Church 6 The Straigts / 7
Cros Gibraltar 8 Teriffa

Numbers in design refer to key in margin
12.4 x 21.5

Over the rooftops of the city is a castle numbered
"1." On the other side of the Strait of Gibraltar
lies the coast of Spain, with Gibraltar to the far
right.

NOTES

1. Literature on the entire series includes Hirschoff 1931, nos. 1–4; Sprinzels 1938, p. 73, nos. 111 and 113; and Paris 1979, pp. 30–31, nos. 27–30.

2. Dated sketches from this period are included in the sketchbook at the John Rylands Library in Manchester, England.

3. Sprinzels 1938, no. 113.

4. Wüthrich 1966, p. 83, no. 357.

5. Ludwig Münz, *A Critical Catalogue of Rembrandt's Etchings*, 2 vols. (London, 1952).

6. For the relationship between Rembrandt and Hollar see Regteren Altena in *Kroniek van het Rembrandthuis* (1959), p. 81ff.

7. See Pennington 1989, p. XXXIII.

8. These include *The Elephant* (P/P 2119), the series of seasons (P/P 622–625, cat. nos. 1, 2), and *Tower with Clock in Strasbourg* (P/P 893).

9. The title translates as *Travel booklet from all kinds of places and foreign costumes for the young beginners to practice. Cologne, by Wentzeslaus Hollar from Prague, Anno, 1636 Abraham Hogenberg publisher.*

10. The following prints by Hollar were also published by Hogenberg: *Relics in Aix-la-Chapelle* (P/P 230); *Battle at Philipsburg* (P/P 540); *Amoenissimae Effigies* (P/P 695–718; see cat. no. 10); *Small Scenes in Germany* (P/P 782–791); *View of Prague* (P/P 782); *Church of the Blessed Virgin in Aix-la-Chapelle* (P/P 820); *Cologne* (P/P 856); *Portrait of Jan de Weert* (P/P 1519); the title page of the *Reisbüchlein* of 1636 (P/P 1646); and *Bowing Gentleman and Lady* (P/P 1997 and 1998).

11. For Hollar's use of the literary tradition to depict nature see Braunschweig 1987, p. 96.

12. For the painting of Oliver see *The Tudor, Stuart and Early Georgian Pictures in the Collection of Her Majesty The Queen*, vol. 1 (London, 1963), no. 214, pl. 13.

13. For these portraits see O'Donoghue, *Catalogue of engraved British portraits*.

14. This author would be the last to label prints as a substitution for paintings, but the truth is that this was an important aspect of the art form.

15. Vorsterman engraved two portraits of Thomas Howard, Earl of Arundel, after Anthony van Dyck. See M.-H. 1991, nos. 136, 137.

16. See Rowlands, *Master Drawings*, p. 34, pl. LXV.

17. The inscription reads:
Who viewes not on this reverend aspect
Wisdome and Maiesty theire rayes reflect:
Under whome Faiths defence hath florisht ever
Under whome Peace and vertue aye persever
Whose cost and care in heathen lands doe place
Gods word; whose workes foule heresie deface
Each where admir'd each where renown'd abroad
Deere to his Subiects, deerest to his God:
Long live, and when in heaven thy soule shall raigne
May stil thy name; thy love; on earth remaine.
And thou (great Prince) enrich with prudent heart
So form'd by nature soe well fram'd by art
In truths right way stil (as thou doest) goe on
that thou mays't prove an inspir'd Solomon
Passe Davids valour, and thy Sires loud fame
And that through all the world may sound thy name.
Anno Doni / 1621

18. David Howarth writes that Arundel met Hollar in Nuremberg. This contrasts with the common view that their initial meeting occurred in Cologne. See Howarth, *Lord Arundel and his Circle*, p. 172.

19. Pennington 1982, p. XXIII.

20. Although Parthey attributed this to Hollar, it is now generally acknowledged as being in the hand of Francis Place.

21. In the letter Place emphasized that "Hollar was a person I was intimately acquainted withal but never his disciple nor anybody elses, which was my misfortune." See George Vertue, "A description of the works of Wenceslaus Hollar . . . with some account of his life" (1745), in his *Notebook*, vol. 18 (1930), pp. 34–35.

22. The others are John Aubrey's *Brief Lives*, John Evelyn's *Sculptura, or the history and art of chalcography and engraving in copper*, and the text under the portrait of Hollar in Johannes Meyssens' *Images de Divers Hommes . . . etc.*

23. Parthey attributed this print to Hollar because he had the edition that omits the name of the etcher and cites William Faithorne alone as publisher. In addition, Pennington describes an edition that has "F. Barlow Inuen: R Gaywood fecit" in the lower left corner of the design. It would take us too far afield to engage in this topic here, although it is interesting that Pennington claims that P/P 1148, 1479, 2282A, and 2317A may have been done by Gaywood and Hollar. Pennington describes P/P 478, 1747, 1776, 2030, 2076–2079, 2492, and 2623 as in Gaywood's hand.

24. Pepys, *The Shorter Pepys*, p. 171.

25. Pepys, *The Shorter Pepys*, p. 689.

26. Pepys, *The Shorter Pepys*, p. 699.

27. The Protestant theologian Jeremias Taylor (1613–1667) held several positions in the Church of England. In 1660, he was named bishop of Down and Connor (Northern Ireland). His devotional poetry was characteristic of moderate Anglican spirituality then practiced.

28. According to Bierens de Haan, *L'Oeuvre gravé de Cornelis Cort*, no. 80, Cornelis Cort is a possible model. In my view, the prints by Cort and Faithorne differ so much that one can scarcely consider Faithorne's work to be a copy of Cort's print. Faithorne's model is more likely *The Arrest of Christ* by Albrecht Dürer.

29. George Vertue, "A description of the work of Wenceslaus Hollar . . .," (1745), in his *Notebook*, vol. 18 (1930), in which he arranges the prints by subject but does not give any numbers.

30. Aubrey, *Brief Lives*, 1898.

31. Mary Hervey, *Life . . . of Thomas Howard*. The original inventory was published in 1911 in the article "Notes on the collections formed by Thomas Howard, earl of Arundel and Surrey" by Lionel Cust, in *Burlington Magazine* (November 1911), pp. 97–101.

32. Sprinzels 1938, no. 363.

33. This sixth state is not in Parthey-Pennington.

34. The five variations include one at Wilton House, one at Warwick Castle, one at the National Portrait Gallery in London, the painting that was formerly in the Pereire Collection, and the canvas in the collection of the Barberini family in Rome.

35. M.-H. 1991, no. 142.

36. Sprinzels 1938, no. 6.

37. The attribution to Mantegna is now in dispute.

38. Henry Peacham (ca. 1576–1643) was a teacher and author of *The Compleat Gentleman* (1622), in which he stated his ideas on education. He was part of the

Arundel household and probably was employed as governor for the earl's sons.

39. A memorial plaque to the artist was placed in the northwest corner of the church in 1972.

40. William Laud (1573–1645) was archbishop of Canterbury and a religious advisor to Charles I. He was a keen persecutor of Puritans and religious dissidents. This made him very unpopular with the people, and the House of Commons tried and executed him. Hollar produced a print of his trial (P/P 555).

41. Sprinzels 1938, no. 311

42. Sprinzels 1938, no. 340.

43. Pennington calls the identity of this cathedral into question because Hollar lived in Antwerp at the time, and this cathedral does not look like the one in Prague.

44. Pennington, *A descriptive catalogue*, 1989, p. 414.

45. Hervey 1921, p. 281.

46. Gachet, *Lettres Inédites de Pierre Paul Rubens*, pp. 228, 232.

47. Hervey 1921, p. 282.

48. Hervey 1921, p. 483.

49. For the provenance of this group of drawings see *Leonardo Da Vinci*, exh. cat., Hayward Gallery, London, 1989, nos. 95, 96.

50. This etching shows some relationship with drawings in the Leoni album at Windsor. See *Pictured in London*, 1989, nos. 95, 96.

51. The inventory from 1655 lists: Brother Matthias (watercolor), portrait of a woman (drawing), portrait of the Bishop of Bamberg, two portraits of women (watercolor), two portraits in black chalk, Christ with the crown of thorns, a head of a man (drawing), a head of a woman (drawing), a madonna (drawing), a portrait by Dürer, Henry Morley (watercolor), Christ carrying the cross, two coats of arms, a landscape, Veronica, and Madonna.

52. Hervey 1921, p. 385.

53. See Münz, *Bruegel*, 1961, pl. 200. For more on this print see Miedema, "Feestende boeren, lachende dorpers," 1981.

54. For more on this drawing see Sprinzels 1938, no. 21, and White and Stainton, *Drawings in England*, p. 107, no. 17.

55. At the Narodni Galerie in Warsaw there is a second state not described before, with the number "2" in the lower R corner.

56. At the Narodni Galerie in Warsaw there is a second state not described before, with the number "1" in the lower R corner.

57. The second edition was published by Clement de Jonghe, the third edition by Frederik de Wit, the fourth edition by Cleynhens at Haarlem, and the fifth edition by Gerard Valck. For more on the series see Berge, *Eloque de la navigation Hollandaise*, 1989.

58. See Paris 1989, no. 111, n. 1.

59. Howarth, *Lord Arundel*, 1985, pp. 209–210.

60. Hollstein 1949, III, p. 102, nos. 397–431.

61. The letter is quoted in E. Dostàl, *Vàclav Hollar* (Prague, 1924) and was translated for publication in Springell 1963, p. 160, n. 110; see also Pennington, *A descriptive catalogue*, 1989, p. xxv.

62. Springell 1963, p. 255.

63. Weijtens, *De Arundel-Collectie*, 1971, p. 30, no. 17.

64. On Lommelin see Hollstein 1949, XI, p. 98, no. 55; on Morin see Robert-Dumesnil, vol. I, part 2, pp. 58–59, no. 62.

65. Parthey and Pennington describe the first state as having a German text in Hollar's handwriting in the upper left: "Ein Englishe vom adell, 1644." This print is before the first described state.

66. Sprinzels 1938, no. 24.

67. At the time Parmigianino designed these helmets, Heinrich Vogther produced a series of fifty-one woodcuts that were published in Germany in 1538. This series of prints included models of head coverings, hairstyles, weapons, cuirasses, capitals, and candelabra for use by artisans. See Amsterdam 1988, no. 498.

68. See London 1989, p. 164, no. 90.

69. Clark, *Drawings of Leonardo*, 1935, appendix B, p. XLVII.

70. Popham, *Catalogue of Drawings*, 1946, pl. 245.

71. Popham, *Catalogue of Drawings*, 1946, pl. 10.

72. See also Popham, *Catalogue of Drawings*, 1946, pl. 24, of five men (Royal Library, Windsor).

73. F.G. Grossmann in a foreword to Grossmann,

Wenceslaus Hollar, 1963, an exhibition catalogue published by the City of Manchester Art Gallery.

74. British Museum 1874–8–8–33, illustrated in Rowlands, *Master Drawings*, 1984.

75. Literature on the piece mentions three heads, but this author conjectures that a fourth head is hidden behind the head seen full front.

76. Sprinzels 1938, no. 110.

77. Sprinzels 1938, nos. 345 and 346, with no. 346 most closely matching this print.

78. Sprinzels 1938, no. 343.

79. See Lebeer 1969, nos. 6 and 7.

80. For more information see *Le siècle de Rubens*, 1965, nos. 4–7.

81. This drawing, which shows somewhat more of the foreground, was included by Samuel Pepys in his *Volume I of the collection of Prints and Drawings relating to London* (Sprinzels 1938, no. 331).

82. On this topic see also Rotterdam 1990, no. 23.

83. In his *Notebook* (vol. III, nos. 15–20), Vertue describes as a series six prints with the same dimensions and subjects. Parthey and Pennington followed suit.

84. These are not mentioned by Parthey, but Pennington found them in the Fitzwilliam Museum in Cambridge, England. According to Pennington, the first print from this series of figures from the Commedia dell'Arte is signed in ink, at the upper right, in Hollar's handwriting: "WHolar fec: / 1630."

85. Stent's catalogue is in the Bodleian Library, Oxford, England, Gough maps 46 f. 160, and in the British Museum, London, Ms. Add. 2378 (36).

86. A Jacob's shell is a scallop shell (coquille St. Jacques) that was used as a symbol by pilgrims heading to St. James in Compostella, Spain.

87. According to Pennington, the plates were reworked with more diagonal lines, perhaps in a second state.

88. For these prints and drawings see Sprinzels 1938, nos. 373–389, and Springell 1964, p. 69.

Select Bibliography

Aubrey, John. *Brief Lives*. Edited by A. Clark. 2 vols. Oxford, England, 1898.

Bartsch, Adam. *Le Peintre-graveur*. 21 vols. Vienna and Leipzig, 1803–1831.

Bastelaer, René van. *Les Estampes de Peter Bruegel l'ancien*. Brussels, 1931.

Berge, Maria van. *Wenzel Hollar 1606–1677, Dessins gravures cuivres*. Exh. cat., Exposition Institut Néerlandais, Paris, 1979.

Berge, Maria van. *Elogue de la navogation Hollandaise au XVIIe siècle, Tableaux, Dessins et gravures de la Mer et de ses Rivages dans la collection Frits Lugt*. Exh. cat., Exposition Institut Néerlandais, Paris, 1989.

Bierens de Haan, J.C.J. *L'Oeuvre gravé de Cornelis Cort, graveur hollandais 1533–1578*. The Hague, 1948.

Boon, K.G. *Rembrandt: The Complete Etchings*. Amsterdam, 1963.

Borovsky, F.A. "Wenzel Hollar." In Thieme and Becker. *Algemeines Lexicon der bildenden Künstler*. Leipzig, 1906–1950.

Bosse, Abraham. *Traicté des manières de graver en taille douce (etc.)*. Paris, 1645.

Boxer, C.R. *The Dutch Seaborne Empire 1600–1800*. London, 1965.

Clark, Kenneth. *A Catalogue of the Drawings of Leonardo at Windsor Castle*. Cambridge, England, 1935.

De Jong, M., and I. De Groot. *Ornamentprenten in het Rijksprentenkaninet I 15de & 16e eeuw*. The Hague, 1988.

Diechhoff, Reiner. *Wenzel Hollar. Die Kölner Jahre. 1632–1636*. Cologne, 1992.

Dresch, Juta. *Radierungen aus dem Kupferstichkabinett der Staatliche Kunsthalle Karslruhe*. Exh. cat., Staatliche Kunsthalle Karslruhe, Karlsruhe, 1990.

Duitse grafiek 1450–1700. Exh. cat., Museum Boymans-van Beuningen, Rotterdam, 1973.

Evelyn, John. *Sculptura: or the history, and art of chalcography and engraving in copper*. 1662.

Fagan, Louis. *A descriptive catalogue of the engraved work of William Faithorne*. 1888.

Faithorne, William. *The art of graveing and etching*. London, 1662.

Franken, D. Dz. *L'Oeuvre gravé des Van de Passe Catalogue raisonné des estampes de Crispijn Senior et Junior, Simon, Willem, Magdalena et Crispijn III van de Passe, graveurs Néerlandais des XVIe XVIIe siècles*. Amsterdam and Paris, 1881. Reprint, 1975.

Franken, D. and J.Ph. van der Kellen. *L'Oeuvre de Jan van de Velde. Graveur hollandais, 1593–1641*. Amsterdam and Paris, 1883.

Gachet, Emile. *Lettres inédites de Pierre-Paul Rubens Publiées d'après ses autographes, et précédés d'une introduction sur la vie de ce grand peintre et sur la politique de son temps*. Brussels, 1840.

Gombrich, E.H., Martin Kemp, and Jane Roberts. *Leonardo da Vinci*. Exh. cat., Hayward Gallery, London, 1989.

Grossmann, F.G. *Wenceslaus Hollar (1607–1677). Drawings, paintings and etchings*. Exh. cat., City of Manchester Art Gallery, Manchester, England, 1963.

Hake, Henry M. *Some contemporary records related to Francis Place . . . with a catalogue of his work*. Walpole Society Publications, Oxford, England, 1922.

Hervey, Mary Frederica Sophia. *The life, correspondence, and collection of Thomas Howard, earl of Arundel*. Cambridge, England, 1921.

Heusinger, Christiaan von. *Das gestochene Bild, Von der Zeichnung zum Kupferstich*. Exh. cat., Herzog Anton Ulrich-Museum, Braunschweig, 1987.

Hind, Arthur Mayger. *Wenceslaus Hollar and his views of London and Windsor in the seventeenth century*. London, 1922.

Hind, Arthur Mayger. *Engraving in England in the sixteenth and seventeenth centuries*. Cambridge, England, 1952–1955.

Hirschoff, Alexander. *Wenzel Hollar. Strassburger Ansichten und Trachtenbilder aus der Zeit der dreissigjährigen Krieges*. Frankfurt, 1931.

Hollstein, F.W.H. *Dutch and Flemish Etchings, Engravings, and Woodcuts, ca. 1450–1700*. Vol. I. Amsterdam, 1949.

Hollstein, F.W.H. *German Engravings, Etchings and Woodcuts ca. 1450–1700*. Vol. I. Amsterdam, 1954.

Howarth, David. *Lord Arundel and his Circle*. New Haven and London, 1985.

Hütt, Wolfgang. *Albrecht Dürer 1471 bis 1528 das gesamte graphische Werk vol 2 Druckgraphik*. Munich, 1971.

Hymans, H. *Lucas Vosterman Catalogue raisonné de son l'oeuvre précédé d'une notice sur la vie et les ouvrages du Maitre*. Brussels, 1893.

Laurie & Whittle. *A catalogue of new and interesting prints*. London, 1795.

Lebeer, L. *Beredeerde catalogus van de prenten naar Pieter Bruegel de Oude*. Brussels, 1969.

Le Blanc, Ch. *Manuel de l'amateur d'estampes*. 3 vols. 1856–1888.

Le siècle de Rubens. Exh. cat., Royal Museum of Fine Arts of Belgium, Brussels, 1965.

Lieure, J. *Jacques Callot*. 5 vols. Paris, 1924–1927.

Luijten, Ger, and A.W.F.M. Meij. *From Pisanello to Cézanne: Master Drawings from the Museum Boymans-van Beuningen, Rotterdam*. Exh. cat., ASI, Alexandria, Virginia, 1990.

Luijten, Ger, and A.W.F.M. Meij. *Van Pisanello tot Cézanne, Keuze uit de verzameling tekeningen in het Museum Boymans-van Beuningen*. Exh. cat., Museum Boymans-van Beuningen, Rotterdam, 1990.

Mariette, Pierre Jean. *Abecedario de P.J. Mariette et autres notes . . . sur l'art et les artistes*. Annotated by Mm. Ph. de Chennevières and A. de Montaiglon. 6 vols. Paris, 1851–1860.

Mauquoy-Hendrickx, Marie. *L'Iconographie d'Antoine van Dyck. Catalogue raisonné*. 2 vols. Brussels, 1956.

Mauquoy-Hendrickx, Marie. *L'Iconographie d'Antoine van Dyck. Catalogue raisonné*. 2 vols. 2nd ed. Brussels, 1991.

Miedema, H. "Feestende boeren, lachende dorpers. Bij twee recente aanwinsten van het Rijksprentenkabinet" [Feasting farmers, laughing boors. On two recent acquisitions of the Rijksprentenkabinet]. *Bulletin van het Rijksmuseum*, vol. 29, no. 4 (1981).

Mielke, Hans. *Wenzel Hollar. Radierungen und Zeichnungen aus dem Berliner Kupferstichkabinett*. Exh. cat., Kupferstichkabinett, Berlin, 1984.

Münz, Ludwig. *Pieter Bruegel: The Drawings*. London, 1961.

O'Donoghue, Freeman Marius. *Catalogue of engraved British portraits . . . in the British Museum*. 6 vols. London, 1908–1925.

Parthey, Gustav. *Kurzes Verzeichniss der Hollar'schen Kupferstiche*. Berlin, 1853.

Pav, J.L. "Wenceslaus Hollar in Germany 1627–1636." *Art Bulletin*, vol. 55, no. 1 (1973).

Pennington, Richard. *A descriptive catalogue of the etched work of Wenceslaus Hollar 1607–1677*. Cambridge, England, 1989.

Pepys, Samuel. *The Shorter Pepys*. Selected and edited by Robert Latham. London, 1985.

Popham, Arthur Ewart. *Catalogue of Drawings by Dutch and Flemish Artists . . . in the British Museum*. London, 1932.

Regteren Altena, J.Q. van. "Rembrandt en Wenzel Hollar." *Kroniek van het Rembrandthuis*. Amsterdam, 1959.

Robert-Dumesnil, A.P.F. *Catalogue raisonné des estampes gravées par les Peintres et les dessinateurs de l'Ecole française, Ouvrage faisant suite au peintre-graveur de Bartsch*. 11 vols. Paris, 1835–1871.

Rowlands, John. *Master Drawings and Watercolours in the British Museum*. London, 1984.

Springell, Francis C. *Connoisseur and diplomat. The earl of Arundel's embassy to Germany in 1636*. London, 1963.

Springell, Francis C. "Unpublished Drawings of Tangier by W. Hollar." *Burlington Magazine*, vol. 106 (1964).

Sprinzels, F. [Francis C. Springell]. *Hollars Handzeichnungen*. Vienna, 1938.

Urzidil, Johannes. *Hollar: a Czech emigré in England*. London, 1942.

Vertue, George. *A description of the works of . . . Wenceslaus Hollar . . . with some account of his life*. London, 1745.

Vertue, George. *Notebooks*. Vols. 18, 20, 22, 24, 26, 29, 30. Walpole Society Publications, Oxford, England, 1930–1955.

Weijtens, F.H.C. *De Arundel-Collectie. Commencement de la fin Amersfoort 1655*. Utrecht, 1971.

White, Christopher, and Lindsay Stainton. *Drawings in England from Hilliard to Hogarth*. Exh. cat., British Museum, London, 1987.

Wurzbach, V. *Niederlandische Künstler-Lexikon auf Grund archivalischer Forschunger bearbeit*. 3 vols. Vienna and Leipzig, 1906–1911.

Wüthrich, Lucas Heinrich. *Das druckgraphische Werk von Matthaeus Merian D. AE*. 2 vols. Basel, 1966, 1972.